# THE ART OF
# DRAWING

HOLT, RINEHART AND WINSTON, INC.

*New York   Chicago   San Francisco*

*Atlanta   Dallas   Montreal*

*Toronto   London   Sydney*

# BERNARD CHAET / YALE UNIVERSITY

# THE ART OF
# DRAWING

*To the students whose talent and enthusiasm motivated the experiences described on the following pages.*

*Editor*   Dan W. Wheeler
*Production editor*   Rita Gilbert
*Picture editor*   Joan Curtis
*Designer*   Marlene Rothkin Vine
*Associate designer*   John Macellari
*Production supervisor*   Vic Calderon

Library of Congress Catalogue Card Number: 78-120910
**College ISBN: 0–03–077125–0**
**Trade ISBN: 0–03–085266–8**
All rights reserved. No part of the contents of this book
may be reproduced without the written permission of the publishers,
Holt, Rinehart and Winston, Inc., New York.
Printed in black-and-white gravure by Conzett & Huber, Zurich, Switzerland;
color offset printing by Fabag Printers and Publishers, Inc., Zurich, Switzerland.
Color separations prepared by Gebrüder Fretz AG, Zurich, Switzerland.
Bound by G. Wolfensberger, Zurich, Switzerland.

# PREFACE

In *The Art of Drawing* it has been my purpose to share with students and
generally interested readers the experience I and my own classes at Yale
have had in resolving through the process we call drawing a variety
of problems which have seemed relevant to the kind of seeing and
revisualization that is art, whether created in our own time or in periods
long since established as historical. The book I now offer is indeed intended
to be an introduction to drawing, but it is not a manual of formulas for
how to render accurately, to simulate perspective convincingly, or to
perfect any of the other technical devices that draftsmen can employ to make
their drawing serve such objectives as illustration, narration, and
representation. I hope the book will teach and assist the reader—student,
artist, or connoisseur—to expand his awareness of art, its processes, and
purposes, but such is my point of view that I have not meant to prescribe
a set of lesson plans, delimit procedure, or establish absolute answers
to questions of artistic significance. Instead, the book recapitulates in essence
the attempt I and my students have made to discover a general rationale
for the art and act of drawing. The resulting point of view, which informs
the whole of the book, is that drawing from natural forms is basic to all
personal explorations in art and that the assimilation into the artist's memory
and complex of sensibilities of all the forms of nature, including man
and his environment, should provide the best support for the artist's search
in behalf of his own individual expression.

This, then, is the approach of the present book, but I have not presented
it as more than one means that has brought a measure of satisfactory results
to a certain number of artists. Art is as various as the people who practice it,
and within this multiplicity certainly there are other and eminently
promising ways available to the draftsman intent on finding his own artistic
solutions—concepts that I would applaud rather than proscribe.

To help and encourage those who for the first time are drawing and
examining drawings in a serious way, I have prepared an opening section on
some of the very primary means and materials typically used in the
drawing art. Here, there are chapters on attitudes and goals, on the
properties and potentials of graphic expression in two dimensions, on media,
and on those formal considerations we call composition.

Following this, in Part II, is a much longer section—on the process
of visualization. It is the heart of the book and consists of chapters that offer
sequences of problems and the evidence of student response to the challenges
presented. Each sequence was designed to be flexible so as to elicit

maximum integrity in the students' individual responses. Groups of students vary, and the sequences as now transcribed represent to a minor degree a cumulative experience but in a major way the character of the last class I worked with before the manuscript was edited. The sequences draw the student's attention to specific forms—such as a tree, a shoe, a paper bag— and then cause him to analyze, in drawing, the form in itself and in relation to the space it occupies and to other analogous and adjacent forms. Progressively, through this central section, the forms become more complex, requiring the artist constantly to experiment with new and different attitudes toward form and with techniques for reconceptualizing forms and compositions into convincing artistic statements. This series of chapters leads to a sequence, at the end of Part II, in which the subject is independent study of self-determined projects with still greater expansion of visual vocabulary and the true beginning of personal development.

Part III concludes the book with an examination of a portfolio of master drawings, related to which are a reconsideration of instrumentation in drawing and the very rewarding art of copying from the works of the great draftsmen of all ages.

I cannot complete my preface without confessing that in seventeen years of teaching drawing I have been blessed with gifted and devoted students. Their work is liberally represented along with the master drawings reproduced throughout the book. The student drawings I finally selected for illustration in the sequences represent about half of all the works saved in my classes at Yale. Among them are drawings not only by professional art students—majors in painting, sculpture, printmaking, and graphic design— but also students in architecture and undergraduates with professional interests in disciplines quite alien to art. The student artists are all identified in the legends accompanying their drawings, except wherever a missing signature or my failing memory have defeated attribution. All the student work remains the property of Yale University.

As artist, teacher, and author my debts are many, and I want to acknowledge several of the most important sources of the help I received in preparing *The Art of Drawing*. I must thank the many museums and individuals that granted permission for the reproduction here of works from their collections. Dwight W. Webb was immensely helpful to me as I prepared the final draft of the manuscript. It was the National Foundation on the Arts and the Humanities which provided the funds that enabled me to take a sabbatical leave from teaching and complete the writing. Ninon Lacey typed the manuscript, and I express my gratitude for the excellence of her work.

New Haven                                                        B. C.
March 1970

# CONTENTS

*Preface*     v

PART ONE / DRAWING: THE MEANS
AND MATERIALS OF VISION

1  *Directions*     3

2  *The Expressive Means of Drawing*     12

3  *Media*     26

4  *Composition*     53

PART TWO / DRAWING: THE PROCESS
OF VISUALIZATION

5  *Landscape*     81

6  *Forms from Nature*     104

7    *Interiors and Man-Made Objects*    126

8    *Skulls*    159

9    *Animals*    181

10    *Introduction to the Figure*    192

11    *Individual Projects*    217

## PART THREE / DRAWING: THE VISION OF THE MASTERS

12    *Instrumentation and Copying*    239

13    *Attitudes and Summary*    265

*Index*    279

*Photographic Sources*    288

# I

# DRAWING:
# THE MEANS
# AND MATERIALS
# OF VISION

# 1

# DIRECTIONS

Since the Renaissance the art of drawing has increasingly come
to be considered a unique graphic experience rather than simply the
making of preliminary sketches to be translated into other media.
The working drawings of the Old Masters give us an intimate
glimpse of the artist's search and experimentation with ideas and
forms, for they often suggest the initial impulse that subsequently
gave birth to a fully developed artistic concept. Today we admire
not only the immediacy of these studies but also the individual
handwriting that the drawing itself reveals, which may later be
hidden or lost in the transposition to another medium.

Each generation invents new functions for drawing and
resurrects old ones. For example, some modern artists use drawing
to create an expressive division of space or to build spatial
relationships; for others it serves as a compositional search for the
unknown. Many artists still regard drawing as a rehearsal for more
formal works, while others consider it as simply form-making
in black and white. In fact, drawing can be all these things and

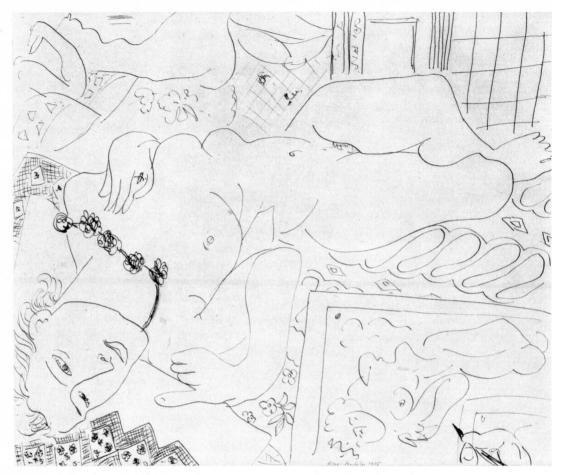

1. Henri Matisse (1869–1954; French). *Nude in the Studio.* 1935.
Pen and ink on paper, $17\frac{3}{4}$ x $22\frac{3}{8}''$. Private Collection, New York.

more, individually or in combination. The vision of each artist
determines the function of his drawing and the direction it will take.

The genius of Henri Matisse makes the line drawing *Nude in the
Studio* (Fig. 1) seem, at first glance, very easy to do. But careful
study reveals that line has been skillfully manipulated to perform
three functions: It projects the forms into space, and it both controls
and energizes the entire composition. Obviously, this is a
masterful use of line, and it is the result of long experience. The
beginning artist cannot expect to have such ability at his command.

In a much earlier drawing by Matisse, *The Plumed Hat* (Fig. 2),
we can examine a part of the process by which a young
draftsman develops his individual style. An artist "invents" himself

by trying out many attitudes toward form. In this pencil drawing the incised features (eyes, nose, and mouth) testify to the study of such masters as Hans Holbein, who created simplified, individual, and seemingly rounded forms in drawing. This sculptural quality is combined by Matisse with a personal preference for arabesque rhythm, as in the hair, hat, and bodice. The plastic form is contained within these linear movements. Matisse often played such apparently contradictory styles against one another.

2. HENRI MATISSE
(1869–1954; French).
*The Plumed Hat.* 1919.
Pencil, 19¼ x 14¼″.
Baltimore Museum of Art
(Cone Collection).

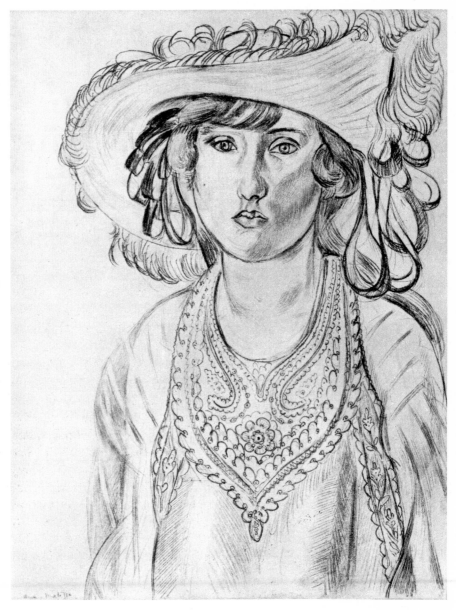

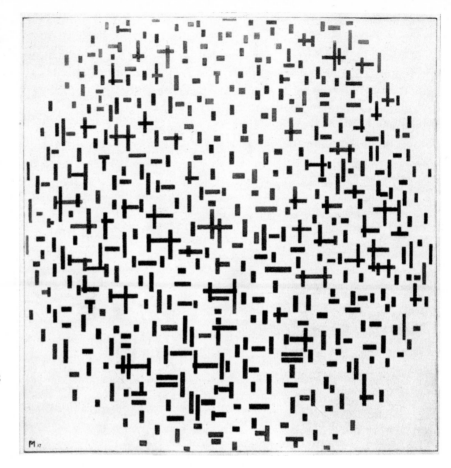

3. PIET MONDRIAN (1872–1944;
Dutch). *Composition in
Black and White.* 1917.
Oil on canvas, 42$\frac{1}{8}$″
square. Rijksmuseum
Kröller-Müller, Otterlo.

*Composition in Black and White* (Fig. 3) by Piet Mondrian is
a visual dance. The dancers, horizontal and vertical strokes (or
shapes), interact in concert with the white space between them.
This work demonstrates that art deals with abstract ideas as
well as with unique perceptions of the natural world. Mondrian
evolved these motifs from his experience in drawing natural forms,
as in *The River Amstel in the Evening* (Fig. 4). Here the
major horizontal thrust of the horizon is countered by
the gently waving verticals of the tree forms. Mondrian also
drew many of his ideas from concepts initiated by Paul
Cézanne (see Fig. 54).

Jean Arp's *Automatic Drawing* (Fig. 5) reflects in visual terms
an interest in an immediate, unrehearsed "stream of consciousness"
performance. Yet this "automatism" is under the control of the

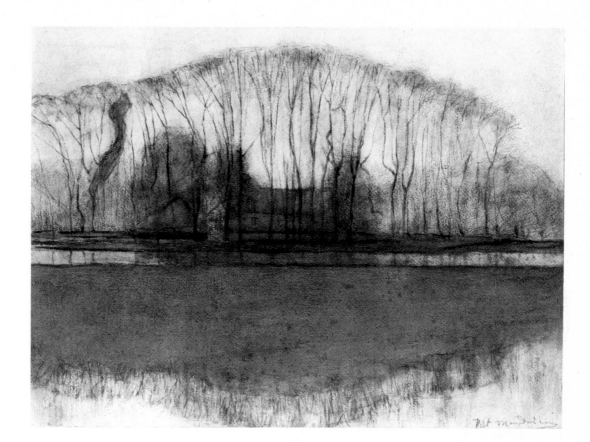

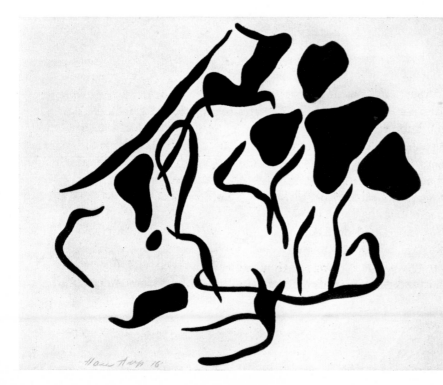

above: 4. PIET MONDRIAN
(1872–1944; Dutch).
*The River Amstel
in the Evening.* c. 1907.
Black crayon, watercolor,
and pastel, 18⅞ x 26¼".
Frans Hals Museum, Haarlem.

left: 5. JEAN (HANS) ARP
(1887–1966; French).
*Automatic Drawing.* 1916.
Brush and ink on brown
paper, 16¾ x 21¼".
Museum of Modern Art,
New York.

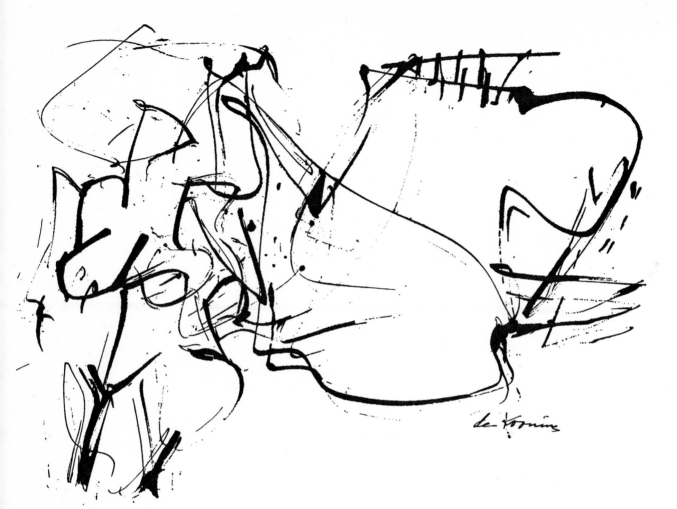

6. WILLEM DE KOONING (1904– ; Dutch-American). *Figure and Landscape.* 1954.
Pen and ink, 16 x 20″. Courtesy Martha Jackson Gallery, New York.

artist's innate feeling for order and his previously selected form-shapes.
The large black organic shapes (upper right) group and act together
because of their proximity and similarity, while the diagonal
line (upper left) anchors the whole composition and serves as a magnet
to attract all the gently moving and changing shapes. This cohesion
is possible because Arp directs it, whether consciously or
subconsciously.

In Willem de Kooning's *Figure and Landscape* (Fig. 6) an
effect of immediacy is produced by whiplash strokes speeding
through the compositional space. The individual shapes of woman
and landscape mirror each other within these pyrotechnics. Unlike

Arp's *Automatic Drawing*, this work has no anchor to slow down
its constant and allover motion.

Pierre Bonnard is essentially a colorist, and in *Canaries* (Fig. 7)
he alludes to this interest through his choice of materials. Using
partly dried ink and a comparatively rough brush Bonnard produces
a texture that suggests an atmospheric haze, an almost
coloristic effect.

7. Pierre Bonnard (1876–1947; French). *Canaries*. 1904. Brush, 12 x 7½″.
Phillips Collection, Washington, D.C.

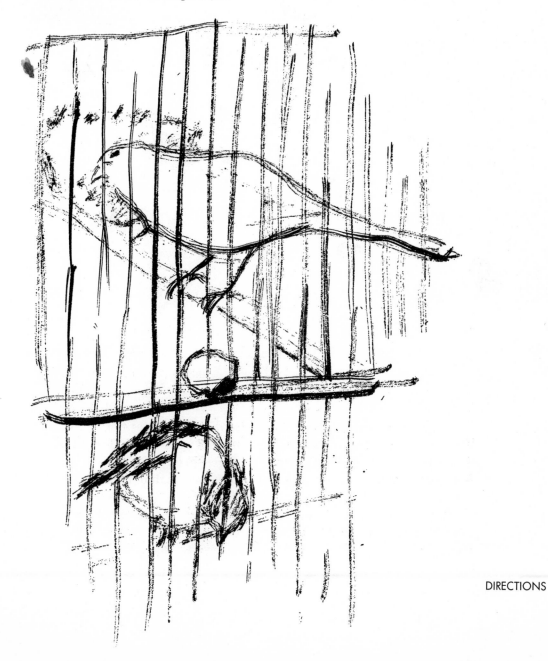

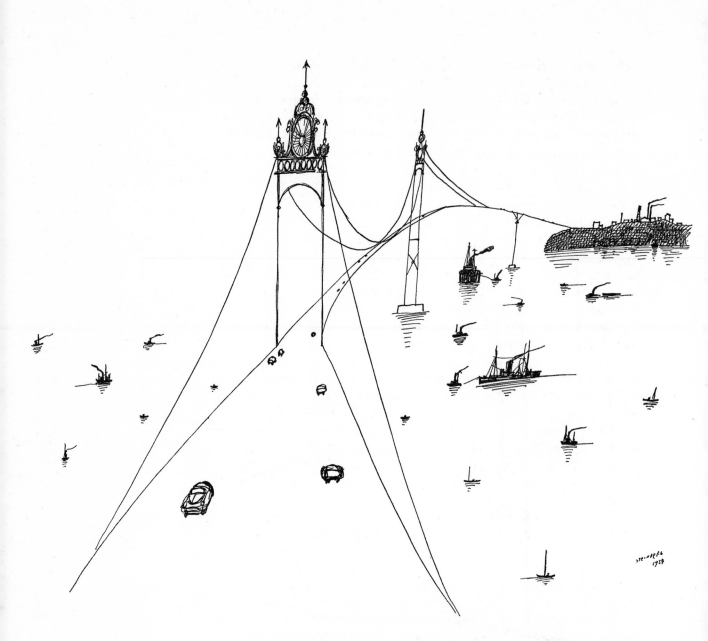

Saul Steinberg's *Bridge Perspective* (Fig. 8) creates the illusion of vast space with a few economical pen strokes. The artist has used a fine line, daring distortion of perspective, and subtly placed detail to conjure up a vision out of thin air, and the effect is almost magical.

The drawings that the individual reader will find most appealing are the ones that come closest to his own sense of what is esthetically satisfying. To those who strive for the perfect

adjustment of elements functioning simultaneously, Mondrian's work will be of particular interest. To the colorist, Bonnard's suggestion of atmosphere will invite study. The artist who believes in the automatic release of subconscious impulses will be attracted to Arp, while Steinberg will find his audience among students who see economy as a goal. Those who prefer speed and spontaneity will be moved by de Kooning's style.

Each of these illustrations exhibits the natural flow of a personally developed attitude. It is our hope initially to make the young artist aware of personal preferences and to encourage him to keep them always in mind. At the same time, the student must realize that the art of drawing does not possess one set of principles which, if properly exercised, will turn him into a master. But an understanding of the expressive means of drawing (form, line, texture, composition, and so forth), as well as the mechanical tools artists use, is essential to the development of a personal vision which, in turn, gives birth to an individual style.

The specific knowledge required for drawing depends upon the attitudes of the individual draftsman and the task he has set himself. The creative artist learns what he needs to know to fulfill his vision and discards the rest; in short, he absorbs only that which is personally meaningful. In learning to draw, the student must address himself to problems that can challenge his image-making capacity. At the same time, it is true that much basic education in the visual arts consists of game-problems that produce results without the conscious involvement of the participants. To speak about texture or line, for example, divorced from all other considerations within a work of art, can be misleading, for texture, line, value, and the rest are tools in the service of a vision and not an end in themselves. And to discuss these qualities without reference to a particular drawing leads to the inevitable pseudoscientific diagram that delivers generalities which may or may not be pertinent. Thus, in this preliminary consideration of means, materials, and composition in drawing, we will isolate and examine certain qualities in the drawings illustrated, but this will serve only to highlight for purposes of study elements that belong to a total artistic statement and have meaning only within the context of a specific work of art.

*opposite:* 8. SAUL STEINBERG (1914– ; American). *Bridge Perspective.* 1954. Pen and ink, 22½ x 28½". Brooklyn Museum.

# 2 THE EXPRESSIVE MEANS OF DRAWING

Form, line, texture, value, and color are the plastic means by which the artist can express his graphic ideas. Although the term *plastic* denotes something formed or molded, as in the three dimensions of sculpture, the draftsman can, by a skillful use of line, texture, and value, create a very real sense of plasticity within the two dimensions of a flat surface. The "flat" arts of drawing and printmaking are generally considered to be the *graphic* arts, rather than the plastic one of sculpture. Color also is, in the pure sense, often alien to these graphic arts, and while real color is certainly used by some artists in their drawing, the effect of color can be realized by exploiting in monochrome the variations that are possible in line, value, and texture.

LINE    A traditional definition of *line* is that of a dot moving across the surface of a ground, or paper. Once put down, the line can establish boundaries and separate areas. It can, by its direction and weight on the page, generate a sense of movement. By applying

9. Jean-Auguste-Dominique Ingres
(1780–1867; French).
*Study for Stratonice.* 1834–40.
Pencil, 15½ x 8⅝″. Museum
Boymans–van Beuningen, Rotterdam.

lines in patterns of parallel and cross-hatched marks, the draftsman
can, with line alone, simulate texture on a perfectly smooth
paper surface. Indeed, using line exclusively—that simplest and
most subtle of graphic means—the artist can realize almost any
visual effect he may wish to achieve.

A frequent association with the verb "to draw" is the verb
"to sketch," and within this definition the most common tool is the
graphite pencil, familiar to everyone by the inaccurate term "lead"
pencil. Pencils are available in various degrees of hardness and
softness, and they can be made to produce both the long,
clean, unbroken lines and the tonal shading seen in Jean-Auguste-
Dominique Ingres' *Study for Stratonice* (Fig. 9). Here, the
line has great tensile strength, contouring the nude form
with almost seismographic accuracy, but the line also becomes a
subtle gray modeling of the form's volumes. Ingres has thus

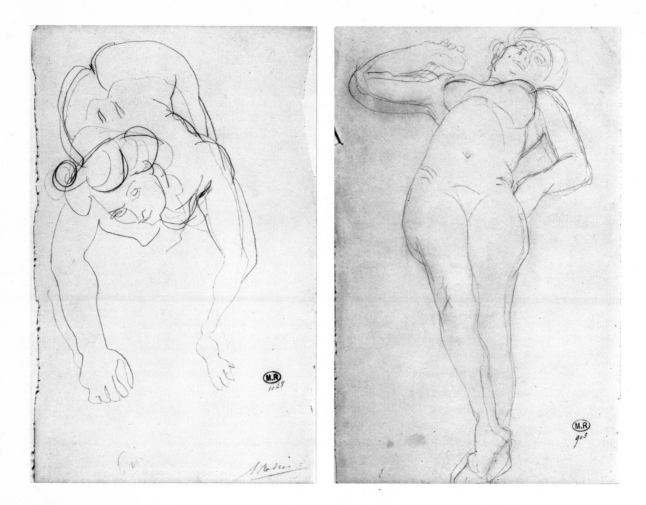

*above left:* 10. AUGUSTE RODIN
(1840–1917; French).
*Figure Sketch.* Pencil.
Rodin Museum, Paris.

*above right:* 11. AUGUSTE RODIN
(1840–1917; French).
*Figure Sketch.* Pencil.
Rodin Museum, Paris.

*opposite:* 12. AMEDEO MODIGLIANI
(1884–1920; Italian-French).
*Mario the Musician.* 1920.
Pencil, 19¼ x 12″. Museum of
Modern Art, New York.

achieved a perfect marriage of two kinds of action: One is not conscious of where the line ends and where the forming tone begins.

In Auguste Rodin's *Figure Sketch* (Fig. 10) the pencil seems never to have left the paper, but rather gives the impression of a continuous, instantaneous gesture. However, in another *Figure Sketch* (Fig. 11) Rodin carefully studies the volumes of the nude form as they tip into space. The use of line, then, like any action, depends on the function it is supposed to perform and not on a preconceived stylistic device. The artist's purposes determine the application he makes of the drawing tool he selects.

A similar contrast is evident in two drawings by Amedeo Modigliani. In *Mario the Musician* (Fig. 12) Modigliani's pencil

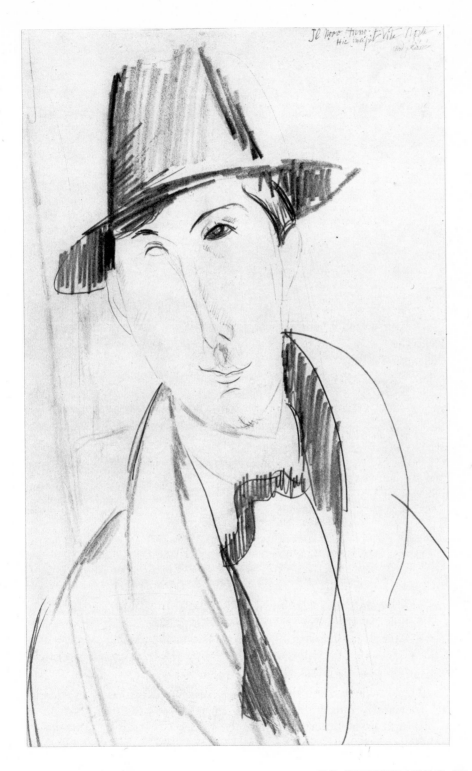

13. Amedeo Modigliani
(1884–1920; Italian-French).
*Portrait of Mme. Zborowska.*
Crayon and pencil, $19\frac{3}{8}$ x $12\frac{1}{2}$″.
Museum of Art, Rhode Island
School of Design, Providence.

expresses a quick, direct gesture, yet within this sketchiness the
artist molds the planes of the hat around the head and those of the
coat around the neck. The same instrument defines the contours
of the forms in a more severe, self-conscious line in *Portrait of Mme.
Zborowska* (Fig. 13).

The drawings illustrated here were executed primarily in line and
with the most ordinary, but most elastic, of tools—the graphite
pencil—and in each example the means mirror the artist's intention.
Technique or style is simply a natural by-product.

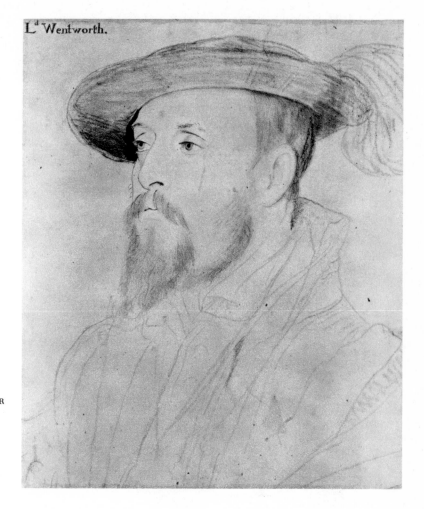

L<sup>d</sup> Wentworth.

14. HANS HOLBEIN THE YOUNGER
(1497/8–1543; German)
or School of Holbein.
*Lord Wentworth.* c. 1539–43.
Chalk, 12½ x 11⅛″.
Royal Collection, Windsor
(copyright reserved).

TONE AND VALUE     *Values* are the gradations of tone that the artist
can work from white to absolute black. Central as the line may be
to the draftsman's art, highly expressive work can be done
altogether in tone. Throughout this book, we will speak of
the various modes of graphic expression and the qualities they
produce in a work of art.

The academies of the past taught that each drawing should
possess a full range of values from very light to very dark. In reality,
it is the artist's vision that dictates the choice of a particular
range of light, and not a set of rules. For example, in Holbein's
portrait of *Lord Wentworth* (Fig. 14) the very paleness
of the drawing creates a unique mood—a particular light.

Lucas Cranach's *Portrait of Princess Elizabeth of Saxony* (Fig. 15) is a wash drawing on rose-colored paper, and here, too, there is an absence of a full range of values. The features are spotlighted: The darkest forms, the eyes, penetrate the soft pallor of the page, and the mouth, the next-darkest form, is seen after the eyes in a succession of focuses. This direction of focus makes the work unique.

In the pencil drawing *Portrait of Lethière's Son* (Fig. 16) Ingres uses a full range of values, but he does not distribute his darks according to the actual appearance of the model. Ingres has

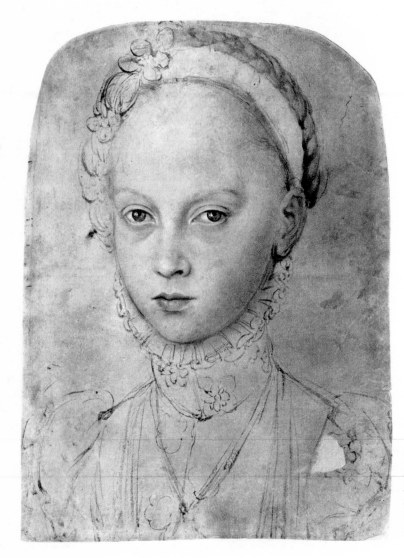

15. LUCAS CRANACH THE YOUNGER (1515–1586; German).
*Portrait of Princess Elizabeth of Saxony.* c. 1564.
Wash on rose-colored paper.
Kupferstichkabinett, Berlin.

decided that in this work the head is the center of interest, and he
purposely keeps the greatest contrast of values in this area. The
range closes as the eye moves down into the drawing. At the bottom
we see clear but briefly stated notes, and yet these lowest areas
are solid and convincing. This is because the key has been
established in the head. These directed clues guide us and deceive
us into seeing that which is only suggested. Had Ingres used
equal contrasts in the coat, hat, and cane, the effect would have
been over-flattened, and the viewer would have been prevented from
participating in the experience directed by the artist.

16. JEAN-AUGUSTE-DOMINIQUE
INGRES (1780–1867; French).
*Portrait of Lethière's Son.*
Graphite pencil, 10½ x 8¼".
Musée Bonnat, Bayonne.

The heightened contrast of darks in *Head of an Infant* (Fig. 17) by Francesco Ubertini presents a unique vision, not just an exercise in values. The dramatic value scale, with its predominance of very dark areas (broken by a few medium and light tones as transitions to the bright light of the paper) creates a psychological, even physical, impression on the viewer. The artist has moved the volumes closer to us by diminishing the range of values that define the surfaces and contours of the head.

TEXTURE    The term *texture,* quite properly, suggests the characteristics of rough or smooth. It is the tactile quality, the sense of touch, that we perceive in art. A textural effect can, as we have seen, be fabricated from the artist's use of lines and tonal values, or it can be the real physical nature of the surface the artist works on or of the medium, such as grainy chalk, that he draws with.

17. FRANCESCO UBERTINI (1494–1557; Italian). *Head of an Infant.* Chalk, 12 x 8⅜″. Albertina, Vienna.

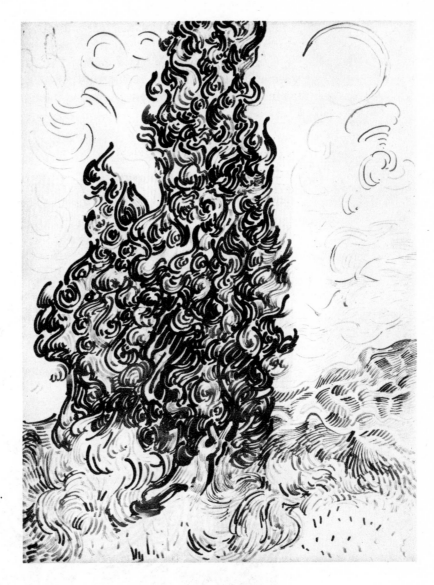

18. VINCENT VAN GOGH
(1853–1890; Dutch-French).
*Cypresses*. 1889. Reed pen
and bistre-colored ink,
$32\frac{1}{2}$ x $24\frac{3}{4}$".
Brooklyn Museum.

Texture, like value, is more than just an added attraction in
a work of art. Texture is automatically created when we draw
a dark line across a page. The violent opposition of black and white
creates a vibration similar to that caused by complementary
colors. Texture, like any natural by-product of a process, must be
absorbed into a larger context so that it enhances an idea.

Vincent van Gogh's *Cypresses* (Fig. 18) is conceived as one
continuous rhythm of pen strokes which, although drawn in

different widths and values, creates a vibrating pattern and a unified texture throughout the drawing.

In another Van Gogh drawing, *The Zouave* (Fig. 19), we see an interaction of different kinds of marks (or groups of textures) which create different wave lengths. Each group of distinct

19. VINCENT VAN GOGH (1853–1890; Dutch-French). *The Zouave*. 1888. Ink, 12⅝ x 9½″. Thannhauser Collection, New York (Thannhauser Foundation).

20. REMBRANDT VAN RIJN (1606–1669; Dutch). *Christ Carrying the Cross.* c. 1635. Pen and ink with wash, 5⅝ x 10⅛". Kupferstichkabinett, Berlin.

marks acts upon its neighbors: The face composed of tiny dots plays against the cross-hatching of the hat, and both interact with the vertical strokes of the background. These separate textures are, in a sense, stand-ins for the color relationships in the painting to which this study was ultimately applied. But the drawing exists as a work of art in its own right. The interaction of textures serves as a light-giving exercise, a concert of opposing marks that create a unified vibration.

Similarly, in Rembrandt's *Christ Carrying the Cross* (Fig. 20) different kinds of marks create different textures. Here, however, two distinct instruments have been used—pen and brush. The dry brush, which has been dragged across the rough paper, attaches itself to the fluid wash figure on the left to create an L-shaped frontal plane. The plane thus formed frames the center of interest, the head of Christ. (The value of the pen strokes in the head keeps it in place behind the frontal plane even though it is the center of interest.) Finally, the rest of the drawing is

21. EUGÈNE DELACROIX (1798–1863; French). *Christ with Mary Magdalen.* 1862.
Pen and ink, 8 x 5¼″. Louvre, Paris.

accomplished with lightly sketched lines, with but one spot of wet wash to counter the dark figure pulling to the left. Texture, then, not only creates a special light with the play of different kinds of surface marks—wet, dry, sketchy, and loose strokes—but it also indicates planes in space.

One burst of textural energy is used to express the idea of a halo in *Christ with Mary Magdalen* by Eugène Delacroix (Fig. 21). The whole composition reflects this light with irregular sketchy lines that echo each other.

FORM    Form is the shape of the images the artist defines in his work, and even the volume his treatment of shapes may suggest. Often, we speak of the "formal" qualities in art, and this usually refers to the full range of the visual elements—line, tone, texture, color, etc.—that may characterize an artist's style or his performance in a given work. Drawing, as opposed to painting and sculpture, is itself one of the forms in art, as is the shape of the surface the draftsman works on, which usually is paper.

SPACE    Space is a still more complex factor in the graphic, two-dimensional arts than is form. There is the space on the surface of the draftsman's paper, which, in visual terms, is often referred to as the *picture plane*. There is also the deep space, or environmental space, that the artist knows to exist in the natural world, a space that contains forms and permits them to move about in it. It is the artist's experience of space and of the placement of forms in it that compels him to work the surfaces of his drawing ground so as to give graphic expression to his vision of forms organized in spatial relationships to one another, to the surface and shape (the field) of the ground he places the forms on, and to his idea of space in depth—that is, space in recession beyond the picture plane.

Form and space will be dealt with in Chapter 4, "Composition," as well as throughout the book.

*Ground, support, page,* and *sheet* are all terms that draftsmen use in identifying the surface, or field, on which they place their marks.

In sum, then, we can say that drawing is a graphic linear production in black and white on a paper support, but, as we have seen and shall observe in the course of this narrative, the art of drawing is almost infinite in its expressive range and in the means that make this variety possible.

# MEDIA

Drawing is a unique art that employs special tools and materials. The
artist imagines future work in terms of these familiar materials,
but his interest in them is not carried to the point of preoccupation
with "technique" as an end, separated from subject matter.
If a tool or a type of paper excites him, it is absorbed into the whole
concept of the drawing.

In our examination of line in Chapter 2, we saw the
relevance of the medium the artist chooses to this expressive purpose.
There, we considered primarily the graphite pencil,
which is a dry medium, but draftsmen work with a great many
kinds of substances, some dry and a number of them liquid. A
feeling for media, an awareness of their physical, sensual qualities
and their expressive potential, is native to most artists, who
savor in selecting and manipulating the materials they work with—
the silver gray of pencil, the velvety blackness of charcoal, the
intensity and brilliance of pastels, and the transparent fluidity of ink
wash. In this chapter, our concern will be for the marking

22. PAVEL TCHELITCHEW (1898–1957;
Russian-American). *Two Figures*.
Silverpoint, $19\frac{3}{16}$ x $12\frac{3}{16}''$.
Yale University Art Gallery,
New Haven, Conn. (bequest of
Oliver Burr Jennings, B.A. 1917,
in memory of Annie Burr Jennings).

instruments—the media—of drawing, rather than the grounds and
surfaces that the artist may choose to work upon.

## DRY MEDIA

SILVERPOINT    Each stroke shows in Pavel Tchelitchew's drawing
*Two Figures* (Fig. 22). The medium here is silverpoint, one of the
oldest of the drawing media, surviving from antiquity. It is closely

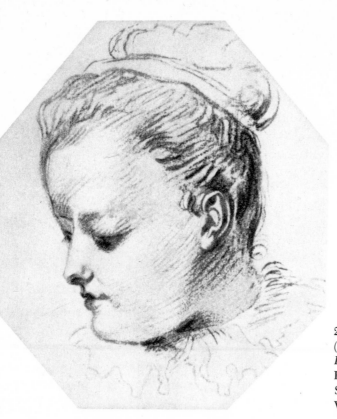

23. JEAN-ANTOINE WATTEAU
(1684–1721; French).
*Head of a Maiden.*
Red chalk with touches of black.
Staatliche Kunstsammlungen,
Weimar.

related to etching in both its directness and its grouping of lines to
produce tones. Silverpoint cannot be used on ordinary paper,
but only on a surface that has been specially prepared to "hold" the
silver left by the draftsman's marking action. The ground for
silverpoint drawing is prepared by coating the surface with casein,
watercolor (Chinese) white, or a thin size of glue, mixed with a fine
abrasive material, such as bone dust. The medium itself is a long
silver wire placed in a modern mechanical pencil and shaped to a
fine point. The lines produced by silverpoint are uniformly delicate
and gray, oxidizing ultimately to a brownish color.

In this drawing Tchelitchew has used the medium in a flowing,
direct manner that belies the impossibility of erasing the
lines once they are incised. Of course, corrections can be made
by reapplying the ground.

CHALK    The term *chalk* as it is used today usually refers to conté
crayon, which comes in many shades, from red to brown to black.
Conté crayon can be sharpened with a sandpaper stick or left fairly
blunt. (Chalk may also refer to pastel, a much softer medium.
Because of its coloristic effects, pastel will be discussed
separately.) Crayon includes the ordinary wax crayon and the

greasy stick or pencil known as the lithographic crayon, so-called because it works well in the water-and-grease technique of making prints by the process of lithography. In *Head of a Maiden* (Fig. 23) Antoine Watteau uses red chalk, called *sanguine*, with touches of black to achieve a softness of modeling that is usually associated with wash or with oil paint. Yet the drawing differs from an oil in that Watteau lets us see the individual modeling strokes, rather than blending them together.

Jacopo Pontormo's *Study of Legs* (Fig. 24) was also drawn with sharpened chalk, but the touch is much softer, to the point of

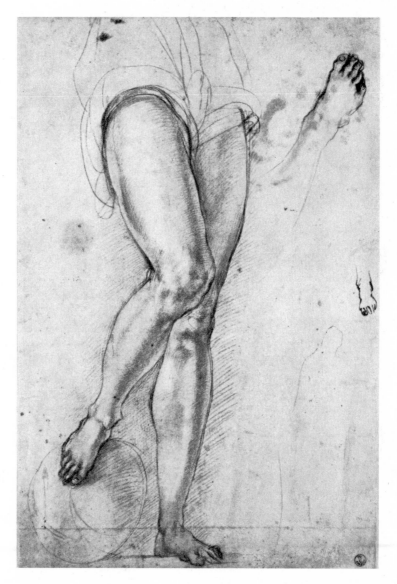

24. Jacopo Pontormo (1494–1556; Italian). *Study of Legs.* Chalk. Uffizi, Florence.

29

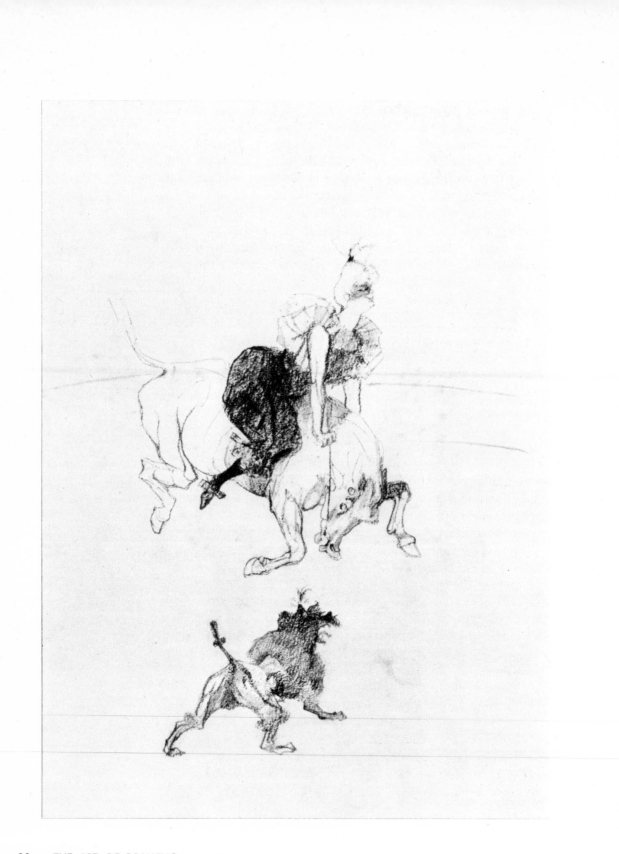

becoming a visual whisper. We can sense the artist delicately rubbing these fine tones (perhaps with his finger) into the fabric of the paper. Line blends into tone to bring out, in this case, a hint of the planar mass.

In Henri de Toulouse-Lautrec's *Lady Clown* (Fig. 25) line and plane are combined, and although the separation is a bit more distinct than in the Pontormo drawing, the artist's technical mastery does not let us see the separation. The horse is essentially linear, while the dog and rider are seen as masses that only secondarily reveal their linear substructure. The particular instrument—conté crayon—that the artist used was dictated by his form-conception, and he explores its possibilities to the fullest dimension.

The Pontormo and Toulouse-Lautrec drawings were both executed with a sharpened point. John Flannagan, by contrast, uses the blunt edge of a lithographic crayon in *Dog Curled Up* (Fig. 26). The artist, a sculptor, captures the dog's posture in one direct gesture. Although the planes are defined only in terms of contour, we do not feel cheated. The concept, again, dictates the use of the tool.

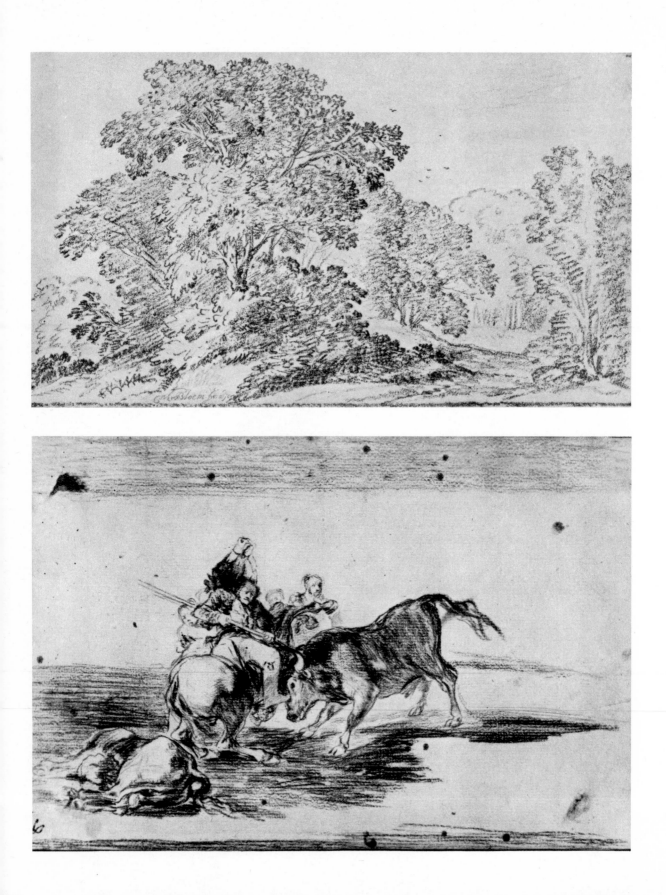

A straightforward use of the conté crayon is seen in *Group of Old Trees* by Matheus Bloem (Fig. 27). There is no rubbed-in softness, as in the Pontormo drawing. Rather, the tooth of the rough paper picks up particles of chalk, which is applied in light, swift, free-moving strokes.

Francisco Goya's predilection for dark, dramatic, pressure-filled scenes receives a strong, full treatment in *Bullfight* (Fig. 28), a drawing in which the artist has used white paper to represent not only air but planes as well. For example, the seemingly empty white space directly behind the figures functions as a plane, perhaps the wall of the arena. Its boundaries are established by the lightly sketched mass at the top. In this reproduction, which reveals the texture of the paper, we can see the play of darks alternately filling in the grain of the paper and remaining on the surface.

CHARCOAL    Charcoal comes in hard and soft varieties, the softer producing the darker line. Compressed charcoal, which is much more dense and black than the traditional kind, can be used to create darks as rich as those in *The Prisoner* by Odilon Redon (Fig. 29). Redon called his velvet-textured, highly personal drawings "my blacks."

*opposite above:* 27. MATHEUS BLOEM (active 1640–1664; Dutch). *Group of Old Trees.* Chalk. Landesmuseum, Braunschweig.

*opposite below:* 28. FRANCISCO GOYA (1746–1828; Spanish). *Bullfight* (*Two Groups of Picadors Rolled Subsequently by a Single Bull,* No. 32 in the *Tauromaquia* series). 1812–15. Red chalk. Prado, Madrid.

*right:* 29. ODILON REDON (1840–1916; French). *The Prisoner.* Charcoal, $15\frac{1}{8}$ x 14″. Collection Claude Roger-Marx, Paris.

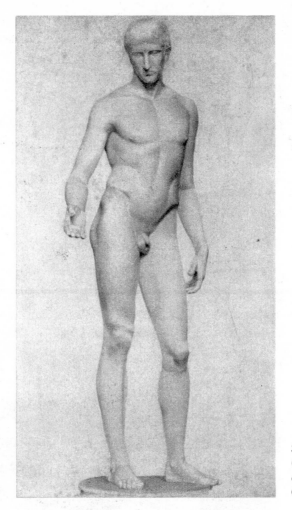

30. Anonymous. *Cast of a Greek Sculpture*. Late 19th–early 20th century. Charcoal. Collection the author.

    An anonymous student at the turn of the century produced the charcoal drawing in Figure 30 from a cast of a Greek sculpture. In this example we can observe the method of teaching that was popular at most academies of the period. With a smooth cardboard stump the student rubbed his charcoal into the paper to hide the individual strokes. The suppression of any personal handwriting was prevalent in this traditional and classicizing academic atmosphere.

    By contrast, Matisse, in *Head of a Woman* (Fig. 31) incorporates into the finished drawing the erasures created by his search for the correct location of forms on the page. The aura provided by these erasures eventually becomes part of the head and its environment.

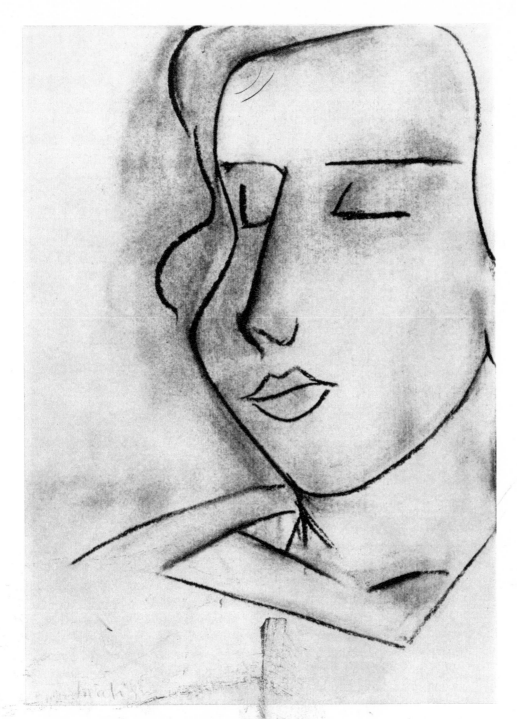

31. HENRI MATISSE (1869–1954; French). *Head of a Woman*.
Charcoal. Whereabouts unknown.

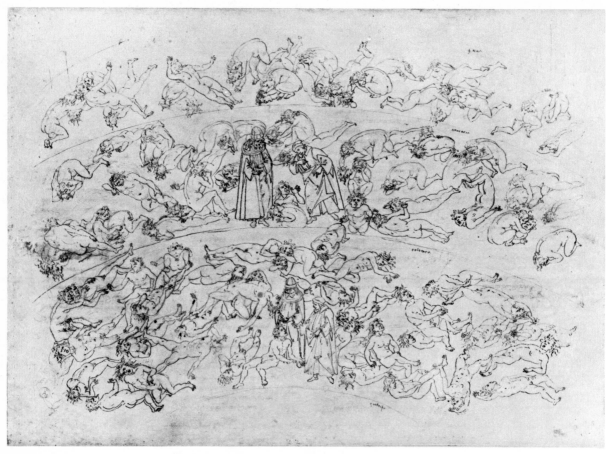

32. Sandro Botticelli (1444?–1510; Italian). *Inferno XXXIII* (illustration for Dante's *Divine Comedy*). c. 1482–92. Pen and ink, 12¾ x 18″. Kupferstichkabinett, Berlin.

## LIQUID MEDIA

PEN AND INK    Among the most flexible of drawing media is pen and ink. A wide variety of effects can be obtained, depending upon the type of pen point, the amount and kind of ink, and the pressure exerted.

In Figure 32, Sandro Botticelli's *Inferno XXXIII* (an illustration for Dante's *Divine Comedy*), an ordinary medium-weight steel pen point might have been used to achieve this fairly uniform, continuous line. The lines clearly define the shape and posture of each figure, and they also compress the whole space of the composition into a unified field. Forms do not project from, or drop behind, this uniform frontal plane.

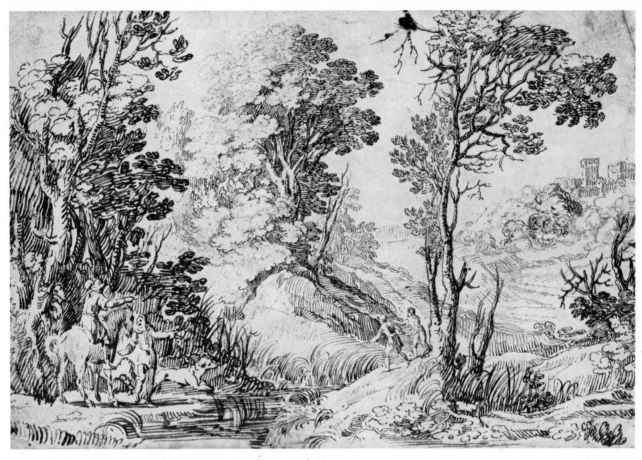

33. PAUL BRIL (1554–1626; Flemish). *Landscape with Horseman.*
Pen and ink. Landesmuseum, Braunschweig.

In Paul Bril's *Landscape with Horseman* (Fig. 33) a thicker
steel point has been used. Modern pen points come in many sizes and
shapes, and the artist should experiment with several types
to find those that suit him best. In Bril's drawing the ink has
been watered down to keep the distant planes pale in comparison to
the foreground, thereby increasing the illusion of depth and the
effect of light coming from the left. The fluidity of the ink in these
sections also heightens the airy feeling throughout the
entire space. Notice, too, that it makes the relatively heavy
strokes seem lighter.

The length of a stroke of the steel pen point is limited by the
amount of ink it can hold in one dip. Not so with a new

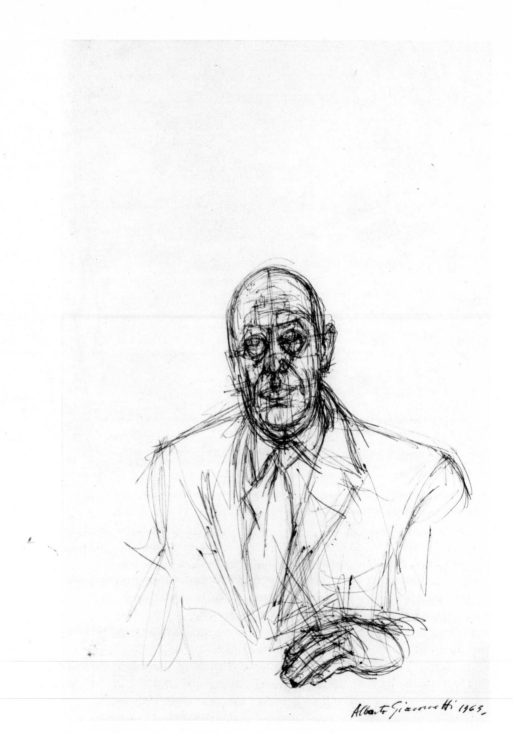

34. ALBERTO GIACOMETTI (1901–1966; Swiss). *Head of a Man*. 1963.
Ball-point pen, 19¾ x 12¾″. Courtesy Pierre Matisse Gallery, New York.

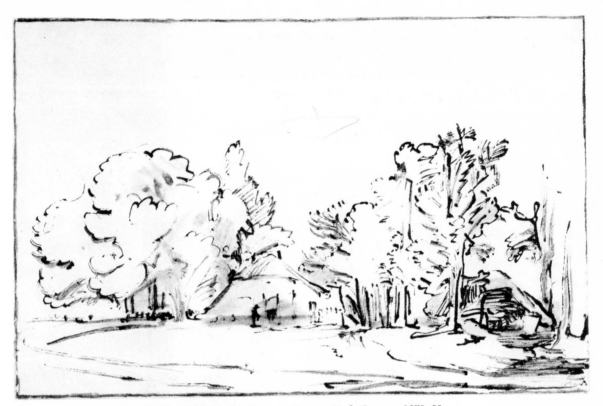

35. REMBRANDT VAN RIJN (1606–1669; Dutch). *Cottages Among High Trees.* c. 1650–60. Quill pen and ink with wash, 7⅝ x 12″. Kupferstichkabinett, Berlin.

instrument, the ball-point pen. The continuous, free-flowing line in Alberto Giacometti's *Head of a Man* (Fig. 34) carves out the geometric core of the head and its location in the compositional space. This potential for unbroken line is the great advantage of ball point. One should know, however, that the ink dyes used in ball-point pens may fade when exposed to constant light.

Each tool has its own kind of mark which the individual transforms through his sense of touch and through the peculiar cadence of his strokes. *Cottages Among High Trees* (Fig. 35), a quill pen work by Rembrandt, is a brilliant performance in the stretching of lines from thick to thin. A light wash (ink diluted with water and applied with a brush) has been added to give tone to the quill pen lines. One may prepare a quill (a turkey feather works well) by first cutting a squarish angled point, convex on one side and concave on the other. A slit down the middle of the point helps hold the ink.

Line and wash can combine in an equal partnership, as in Francesco Guardi's *Courtyard of a Palace* (Fig. 36).
A long, flexible, heart-shaped point is the modern equivalent of the pen used in this drawing. The directly applied, irregularly edged layers of wash define the space simply by keeping the yard in the sunlight. In the original drawing the preparatory layout in light chalk is visible.

*right:* 36. FRANCESCO GUARDI (1712–1793; Italian).
*Courtyard of a Palace.*
Pen and wash with traces of black crayon, 11 x 8″.
Metropolitan Museum of Art, New York (Rogers Fund, 1937).

*opposite:* Plate 1. EDGAR DEGAS (1834–1917; French).
*Danseuses Roses.* 1895.
Pastel, 33 x 22¾″. Museum of Fine Arts, Boston (Seth Kettel Sweetser Residuary Fund).
Interacting color planes in this work create polarities of warm and cool, wet and dry. The viewer's response to the drawing is quite different when it is reproduced in black and white (see Fig. 45).

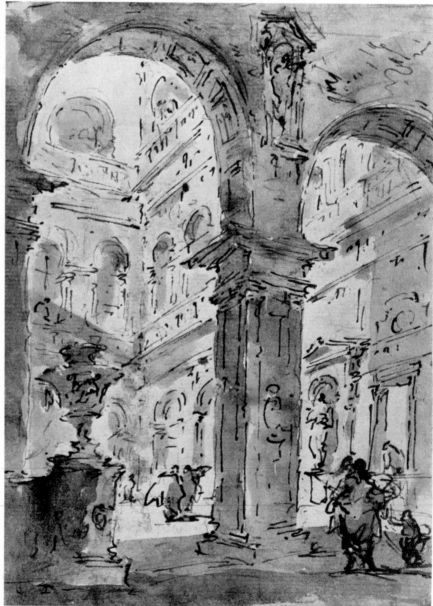

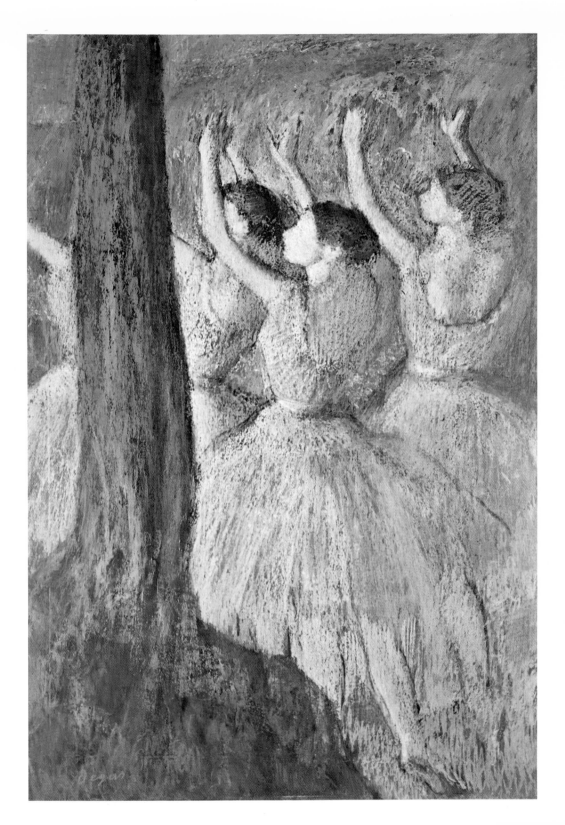

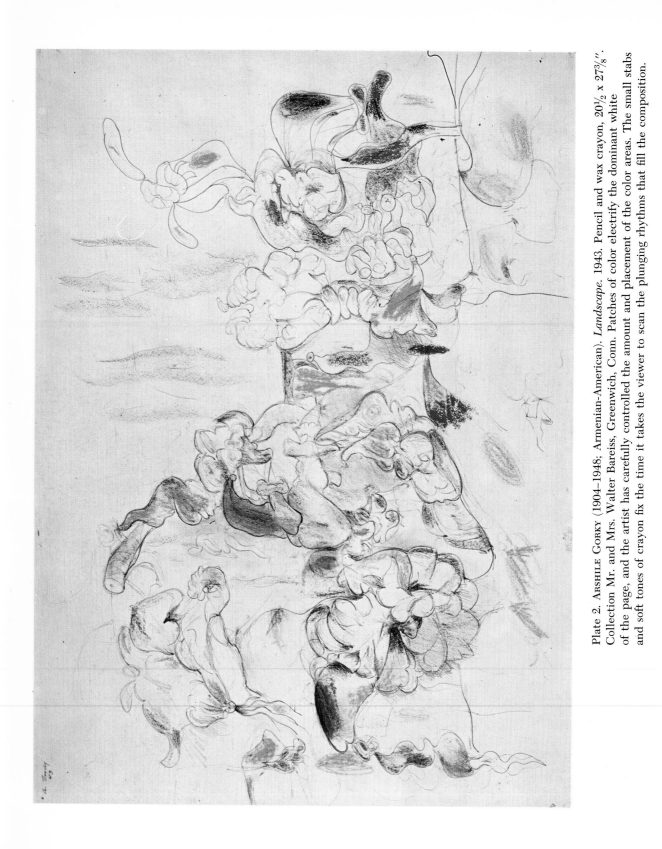

Plate 2. ARSHILE GORKY (1904–1948; Armenian-American). *Landscape.* 1943. Pencil and wax crayon, $20\frac{1}{2}$ x $27\frac{3}{8}''$. Collection Mr. and Mrs. Walter Bareiss, Greenwich, Conn. Patches of color electrify the dominant white of the page, and the artist has carefully controlled the amount and placement of the color areas. The small stabs and soft tones of crayon fix the time it takes the viewer to scan the plunging rhythms that fill the composition.

In Jacob de Gheyn's *Orpheus in the Underworld* (Fig. 37) tiny pen strokes group together to create planes in both the architecture and the columns of fanciful cloudlike forms. As in Ingres' pencil drawing (Fig. 9), line moves imperceptibly into toned plane. Yet each mark that builds the plane is visible. A crow quill point, the tiniest available, could have been used to produce this effect.

Still another type of pen is that cut from reed, which grows in many locations. The artist should cut reeds with different kinds of points to find a shape that works best for him. Van Gogh's reed-pen drawings (Figs. 18, 55) are excellent examples of the virtuosity of this tool. In the event that reed is not available, bamboo pens (which are sold at all art-supply stores) make good substitutes.

37. Jacob de Gheyn (c. 1530–1582; Dutch). *Orpheus in the Underworld.* Pen and ink. Landesmuseum, Braunschweig.

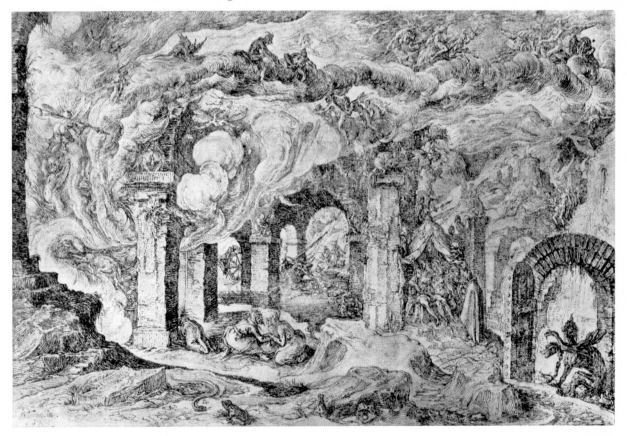

Although we normally think of drawing in terms of dark marks on white paper, Hyman Bloom's white-ink drawing *Fish Skeletons* (Fig. 38) reverses this principle. The white forms set against a dark maroon background have a tendency to move out toward the viewer. Some of the large lines have actually been made with a brush. The thin whitish film in the central portion of the drawing is an especially interesting by-product of the white-ink technique. Artists sometimes prepare an "ink" with white tempera paint and water, which makes it easy to blot out the pen strokes for correction. The residue of this blotting process produces ghostly white washes, which add to the mysterious quality of the work.

The examples of pen-and-ink techniques in this section are by no means a complete list of the possibilities in this medium.

38. HYMAN BLOOM (1913–  ; American). *Fish Skeletons*. 1956.
White ink on maroon paper, 17 x 23″. Collection Mr. and Mrs. Ralph Werman.

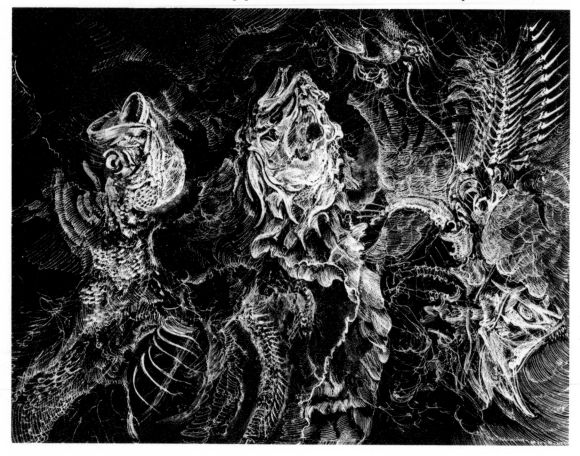

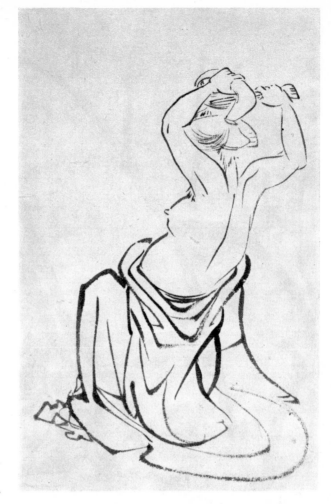

39. KATSUSHIKA HOKUSAI
(1760–1849; Japanese).
*Woman Fixing Her Hair.*
Brush and ink, 16¼ x 11⅝".
Metropolitan Museum of Art,
New York (gift in memory of
Charles Stewart Smith, 1914).

Rather, they are intended to show the potential variety of tools that
the artist has at his disposal and the different effects that
can be produced with these materials. There are no rules about
what instrument is to be used, and there is no "best" instrument.
As with line—or any other component of drawing—the artist's aim
determines the means.

BRUSH     Oriental artists write as well as draw with a brush, and
this tool is as familiar to them as the pencil is to people in the West.
The exquisite calligraphy that delights Western eyes is, for
the Oriental, simply a natural use of the instrument. Even within
this context, however, there is mastery in a drawing by
Hokusai called *Woman Fixing Her Hair* (Fig. 39). Here the
bold brush strokes describe the folding drapery and activate a spatial
sweep around it.

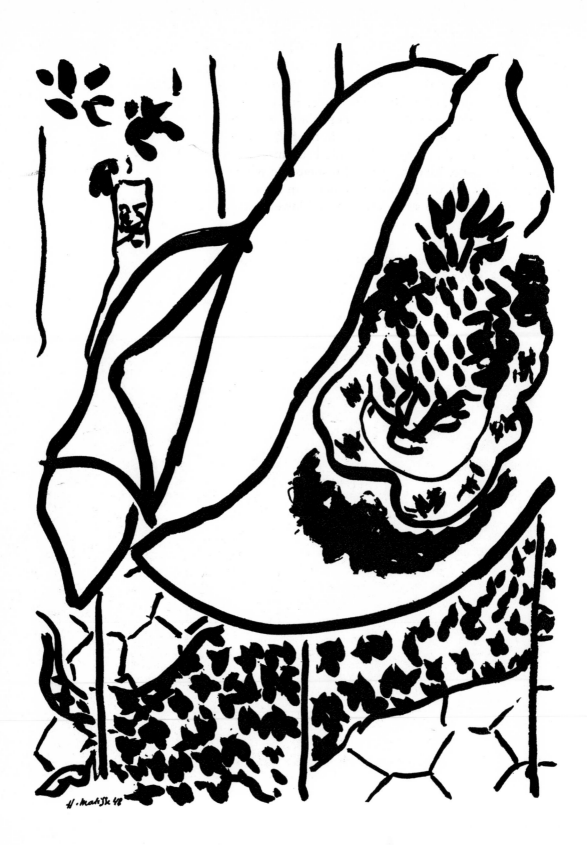

Matisse might have used a Japanese brush or a flexible
watercolor brush—either of which will produce a thick-to-thin line
—in *The Pineapple* (Fig. 40), a very large ink drawing.
The ink is unadulterated—that is, not diluted with water. With the
same kind of instrument, Paul Klee, in his *Self-portrait* (Fig. 41),
surprises us with the unique tilt of the head into the compressed
space of the page. Klee, however, broadens the technique
by diluting his ink to give watery touches in some areas
and by applying some strokes (upper and lower left) with an almost
dry brush.

*opposite:* 40. Henri Matisse (1869–1954; French). *The Pineapple.* 1948.
Brush and ink, 41¼ x 29½″. Whereabouts unknown.

*below:* 41. Paul Klee (1879–1940; Swiss-German). *Young Man at Rest (Self-portrait).*
Wash, 5½ x 7¾″. Collection Mrs. Rolf Burgi, Belp, Switzerland.

In Willem Buytewech's brush drawing *Gentleman* (Fig. 42) the posture of the figure, with its turning head, torso, arms, and legs moving in opposing directions, is beautifully contained in the fluid wash. This effect can be accomplished with a fine-pointed watercolor brush and ink thinned with water.

Goya's preparatory drawing for one of his etchings in the *Disasters of War* series (Fig. 43) suspends a dramatically poised and frightening wave of darkness that is about to engulf the figure. This virtuoso performance seems to have been accomplished with one fluid stroke of the brush.

It should be evident from these examples that the brush is capable of producing unique and wide-ranging effects, and that the

42. WILLEM BUYTEWECH THE ELDER (c. 1585–1626; Dutch). *Gentleman.* Wash. (Destroyed in World War II.) Kunsthalle, Bremen.

43. FRANCISCO GOYA (1746–1828; Spanish). *Nada, ello dirá*
(preparatory drawing for the *Disasters of War* series). Wash. Prado, Madrid.

command of its use provides the artist with yet another tool in his
search for self-expression and for the realization of his goals.

## MIXED MEDIA

Mixed media is a loose term used to embrace the infinite number
of combinations of materials and techniques that are possible
in a work of art. Any of the tools and substances described above—
plus others too numerous to list—might be combined to create
a "mixed media" drawing.

Joan Miró's *Self-Portrait* (Fig. 44) is a very large work—almost 5 feet high—that was produced by media mixed of pencil, crayon, and oil on canvas. It is a graphic linear work done essentially in lines, with slight touches of tonal color. Miró's drawing proves that there is really no size limitation for any given medium. But more important, it reveals that the boundaries between drawing and painting are not absolute.

## FROM DRAWING TO PAINTING

PASTEL AND WATERCOLOR     We have defined drawing as a graphic linear medium and referred to it as "form-making in black and white." Painting, as a separate art, is concerned with color or, to stretch the definition, color-drawing. Within this terminology, it is difficult to classify pastel. As a form of chalk, pastels may be used to create individual strokes that are both graphic and linear. Yet they surely employ color at full intensity (without a wet medium to darken or change the colors). Edgar Degas' *Danseuses Roses* (Fig. 45), with its groupings of loose strokes acting in unison, performs as a drawing—when it is reproduced in black and white. In color, however, the spatial relationships are charged with the vibration and general interaction of colors (Pl. 1, p. 41). The use of color, then, changes the whole dimension of the expression and demands separate sets of criteria (see Pl. 2, p. 42).

Watercolor shares the same conditions. Though it may employ the broadest spectrum of colors, it is linked to drawing in its general use of white as a ground for dark marks. *Tonal* watercolors—that is, those that stay in one color range—seem closer to drawing. But Goya's *Nada, ello dirá* (Fig. 43), which we labeled "wash drawing," could just as easily be called a watercolor. In the final analysis, establishing categories is the province of scientists and encyclopedists. Most artists do not concern themselves with this academic problem.

In our survey of media we have emphasized that the material, no matter how brilliantly employed, is merely a tool in the service of the artist's vision. If surface handling overpowers a work

*opposite:* 44. JOAN MIRÓ (1893–   ; Spanish-French). *Self-portrait.* 1937–38. Pencil, crayon, and oil on canvas, 57½ x 38¼″. Collection James Thrall Soby, New Canaan, Conn.

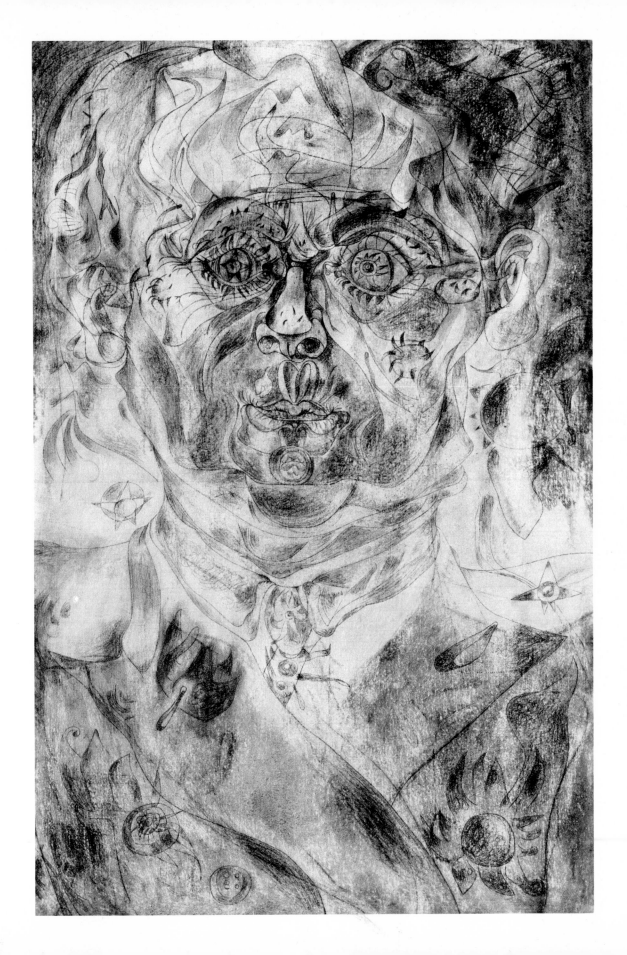

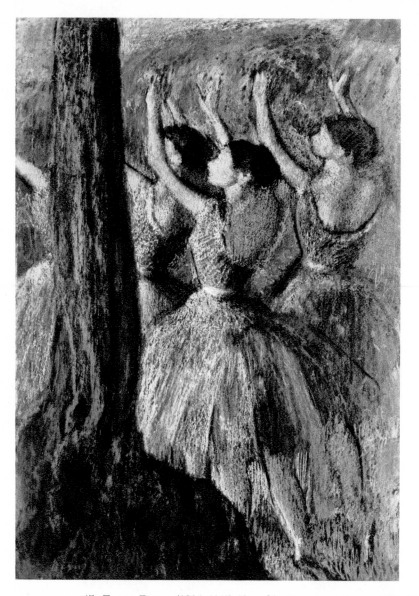

45. EDGAR DEGAS (1834–1917; French). *Danseuses Roses*. 1895. Pastel, 33 x 22¾".
Museum of Fine Arts, Boston (Seth Kettel Sweetser Residuary Fund).

and "technique" is used for its own sake, the drawing is meaningless.
It follows that if a particular drawing interests us primarily for
this "how" of technique and only secondarily for its subject,
it fails as a work of art. The beauty of drawing as an art is that all
these qualities exist simultaneously and in balance.

# 4 COMPOSITION

Drawing shares with painting an interest in common visual phenomena that we normally encounter in design courses. Perhaps the Italian word *disegno*, which refers to both design and drawing, comes closer to our meaning. These two acts—"to draw" and "to design"—are indeed interrelated. We may call composition the act of giving a unique sense of order, a life, to the forms we choose to work with. This act of composing—or locating forms in concert on a two-dimensional plane—does not mean merely enriching the chosen forms by enveloping them in a nicely designed arrangement. It is rather the transformation of a theme into a spatial structure that finally merges with the content. A good example of a compositional search is Delacroix' pen-and-wash study for the *Death of Sardanapalus* (Fig. 46), in which the artist sets up a flow of events in a special sequence on the page.

The artist should explore the perceptual phenomena that are the engineering devices of the visual arts as carefully as he does the various instruments and materials of his art. Both types of

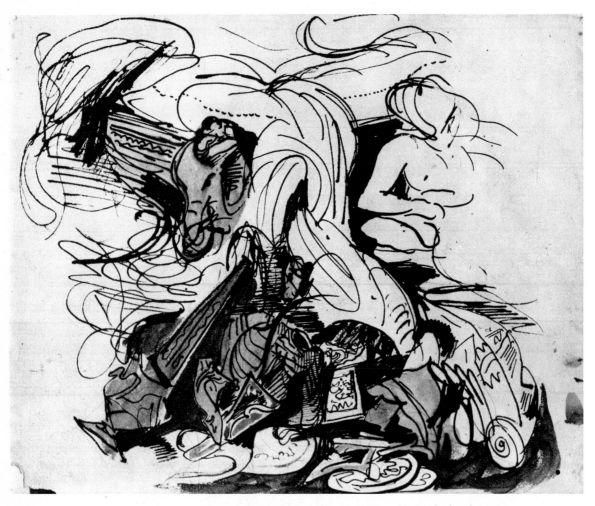

*above:* 46. EUGÈNE DELACROIX (1798–1863; French). Study for the
*Death of Sardanapalus.* Pen and ink with wash, 10 x 12⅝". Louvre, Paris.

*opposite:* 47. ALBRECHT DÜRER (1471–1528; German). *Adam and Eve.*
1504. Pen and brown ink with wash on white paper, 9⅝ x 7¹⁵⁄₁₆".
Pierpont Morgan Library, New York.

experimentation give the young artist tools in developing a personal
form vocabulary.

FIGURE-GROUND     In Albrecht Dürer's *Adam and Eve* (Fig. 47)
the white figures clearly exist in front of the dark background, which
acts simply as a back curtain. The relationship of figure to
ground is clear. However, in a series of compositions by Ralph

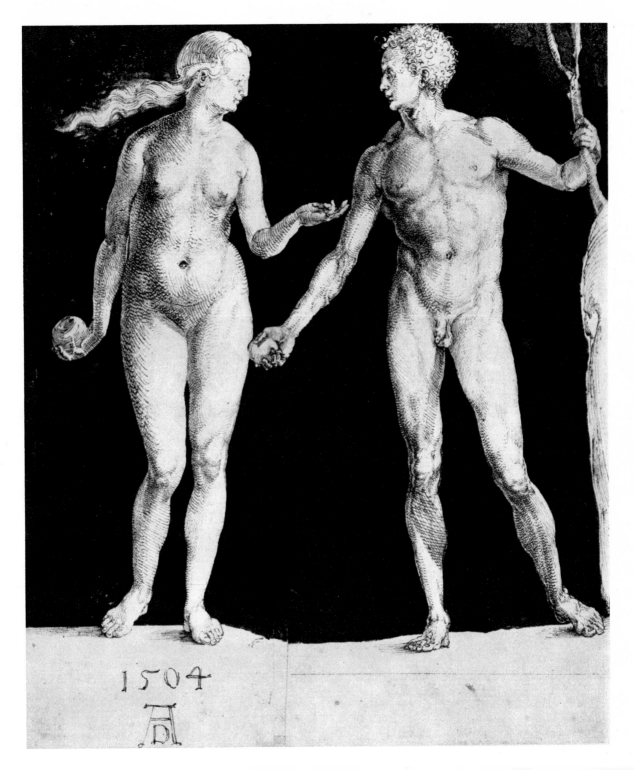

1504

a.

b.

c.

d.

Coburn (Figs. 48–51) the distinction between what is figure (foreground) and what is ground (background) fluctuates constantly. In *Variable I(a)* (Fig. 48) the black triangles at the top read as black shapes in front of a white ground; but if we scan the whole composition, we notice that the white triangles along the bottom begin to appear as frontal shapes against a dark ground. Sections in between can be read either way, depending on how we focus. In *Variable I(b)* (Fig. 49) the play between what is figure and what is ground is more ambiguous. Both examples have a relatively simple order, *Variable I(a)* reading as distinct horizontal rows of triangles and *Variable I(b)* reading as diagonal stripes. The shift between figure and ground becomes more intense in *Variables I(c)* and *I(d)* because the simple rhythmic order is destroyed. In the latter two examples the eye moves more rapidly from top to bottom over the broken pattern.

These four Variables were not created with drawing materials, but they fit the concept of drawing as form-making in black and white. Each work is composed of 64 2-inch squares of magnetized laminated plastic. The four compositions illustrated here were all made from one design, which can produce more than a million variations. What is important is the visual speed and action of the figure-ground relationships—the possibility of more than one reading from a single composition.

In Josef Albers' pen-and-ink *Structural Constellation* (Fig. 52) we can experience a similar dual reading. Albers has constructed

*opposite:* 48–51. Ralph Coburn (1923–  ; American). *Variable I* (four versions). 1968. Plexiglas, each 16″ square. Courtesy Alpha Gallery, Boston.

*right:* 52. Josef Albers (1888–  ; American). *Structural Constellation.* 1954. Pen and ink, 14½ x 11″. Collection the artist.

57

planes that reverse constantly as the viewer's eye moves over them. Pablo Picasso's *Female Nude* (Fig. 53) also produces different readings, but not in purely graphic terms. The nude is buried in the overall structure of the composition, and we search, focusing and refocusing, to define the contours of the figure.

The idea of dual reading can easily be traced back to medieval illuminated manuscripts, border designs from earlier cultures, and some Renaissance compositions. It is clear that finding two or more visual solutions to one structure is an integral part of our way of perceiving pictorial space (see Pl. 3, opposite).

53. Pablo Picasso (1881–  ; Spanish-French). *Female Nude.* 1910. Charcoal, 19½ x 12¼″. Metropolitan Museum of Art, New York (Stieglitz Collection).

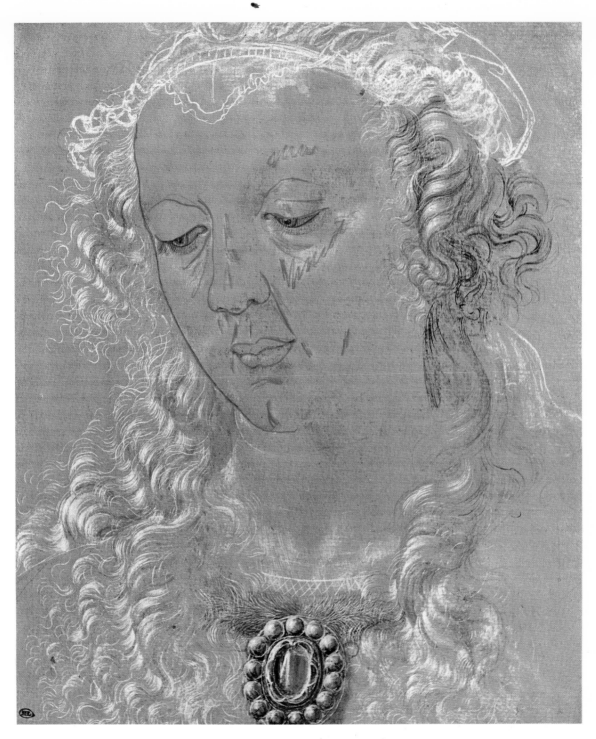

Plate 3. Andrea del Verrocchio (c. 1435–1488; Italian) or Leonardo da Vinci (1452–1519; Italian).
*Head of a Woman*. Brush and black ink heightened with white on red paper, $10\frac{1}{2}$ x $8\frac{7}{8}$″. Louvre, Paris.
The subject of this drawing is the head of a woman, but its presentation is subtle. The modeling is
purposely softened and submerged into the vivid red ground. The visual theme of the work, however, is not
the head but the delicate flow of cascading hair. The viewer may thus experience two different readings.

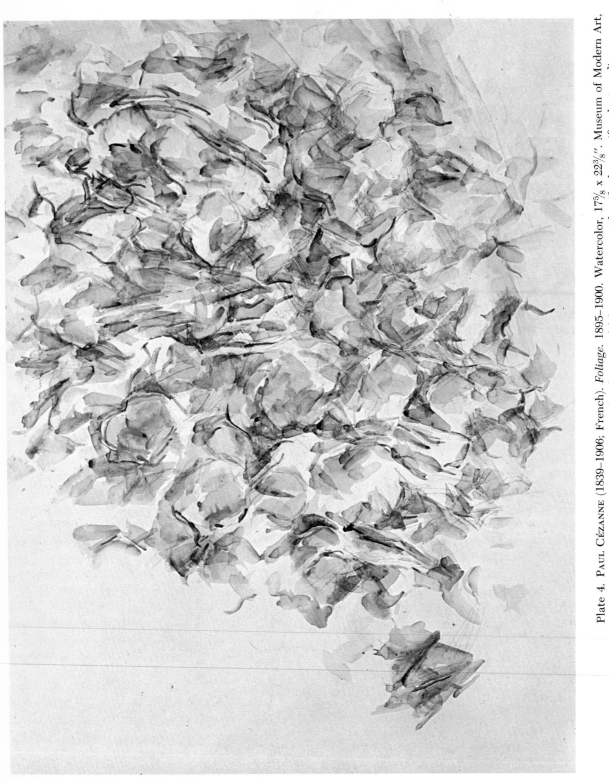

Plate 4. PAUL CÉZANNE (1839–1906; French). *Foliage.* 1895–1900. Watercolor, 17⅝ x 22⅜″. Museum of Modern Art, New York (Lillie P. Bliss Collection). In this drawing of foliage one cannot identify the specific plant or discern the edges of individual forms. The interpenetrating flow of shapes is repeated in an overall rhythmic pattern that leads the viewer's eye upward to the top right corner of the drawing, where this visual flight is terminated.

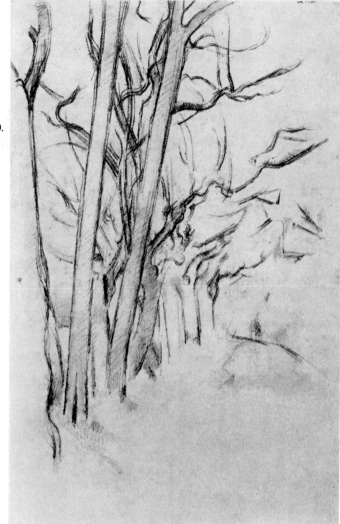

54. PAUL CÉZANNE (1839–1906;
French). *Tree and House.* c. 1890.
Graphite pencil, 18⅜ x 12″.
Whereabouts unknown.

INTERSPACE    The empty spaces between distinct forms are often
referred to as negative space, or interspace, as opposed to the positive
form-shape. Cézanne in his graphic pencil drawing, *Tree and
House* (Fig. 54), tries to shape and define the empty air
space between the trees. He considers this interspace to be full and
volumetric. The shapes of these spaces around the forms are
enclosed and released alternately by the sharp and soft edges of
the trees, so that space becomes a flowing but seemingly
invisible mass (see Pl. 4, opposite).

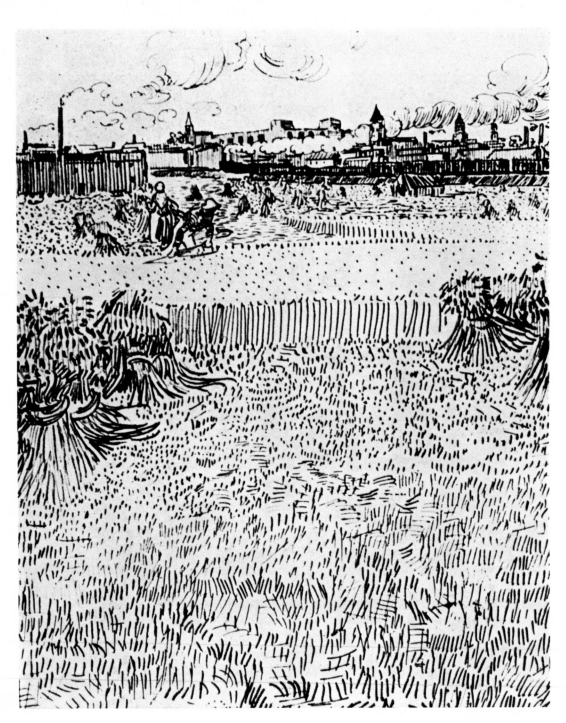

55. VINCENT VAN GOGH (1853–1890; Dutch-French). *Landscape: The Harvest.* 1888.
Reed pen and ink, 12¼ x 9½″. Collection J. Hessel, Paris.

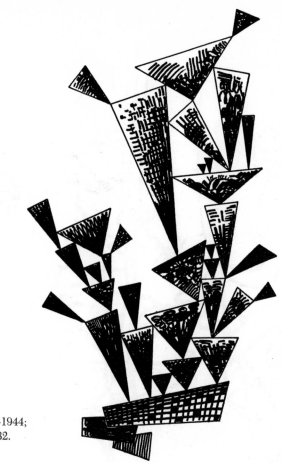

56. WASSILY KANDINSKY (1866–1944;
Russian). *Untitled Drawing*. 1932.
Pen and ink, 13¾ x 9″.
Collection Mr. and Mrs.
Josef Albers, New Haven, Conn.

Van Gogh, in his letters, wrote about the resemblance
between the movement of fields of grass and that of the ocean. In
his *Landscape: The Harvest* (Fig. 55) the pen strokes change
direction constantly—contracting and moving apart—as one follows
them up the page. They become, in effect, a kind of visual
inhaling and exhaling. It is clear that in this landscape the white
ground (interspace) between the strokes is an active participant in
the vibration.

PRESSURE     The force or lack of force that one form exerts on another
depends on the pressure at their meeting point and the angle of their
meeting. In Wassily Kandinsky's *Untitled Drawing* (Fig. 56) the three
bottom forms overlap one another to create a trio of pressure points
at their intersection. These pressure points act in unison to form
weights which seem to hold up the "tree" of triangles. Because the

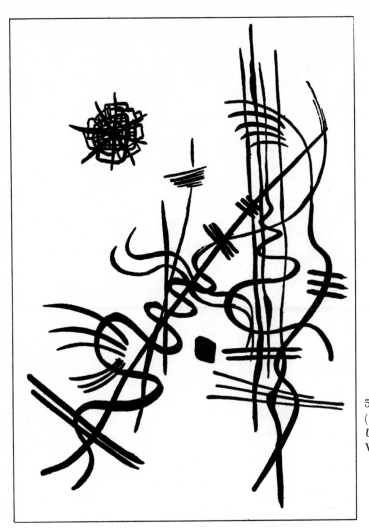

57. WASSILY KANDINSKY
(1866–1944; Russian).
*Untitled Drawing.* Brush and ink.
Whereabouts unknown.

triangles barely touch each other edge to edge, they form an almost
weightless void compared to the weight at the base. Both kinds
of pressure join in the total effect.

In another drawing by Kandinsky (Fig. 57) the lines
constantly cross, intersect, and intertwine—each line throwing
its weight on its neighbor. Two frontal shapes—the star at upper left
and the black mass in the lower center—establish equilibrium.

Two examples of another artist's work also demonstrate
degrees of pressure. In Giovanni Battista Piranesi's *Construction*
(Fig. 58) we sense the architectural members overlapping but
not exerting much pressure on each other. However, in the sketch
in Figure 59 we can feel the weight of the masses of these
bisecting angles.

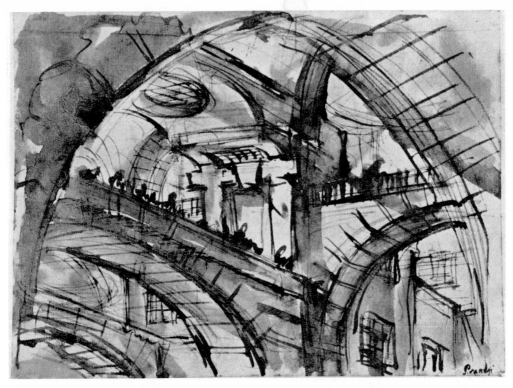

58. Giovanni Battista Piranesi (1720–1778; Italian). *Sketch of a Construction.*
Pen and wash over chalk. Kunsthalle, Hamburg.

59. Giovanni Battista Piranesi (1720–1778; Italian). *Sketch of a Construction.*
Pen and wash over chalk. Kunsthalle, Hamburg.

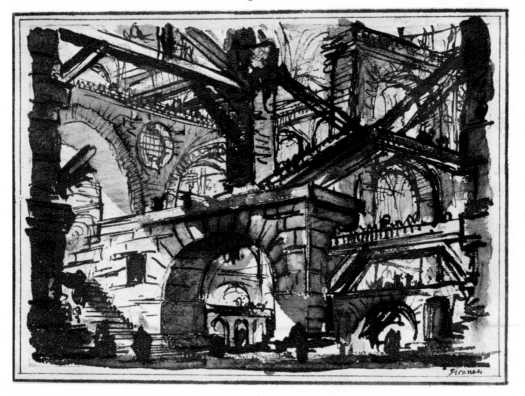

65

Bisecting forms appear also in John Marin's watercolor, *Lower Manhattan* (Fig. 60), but they do not meet within the compositional space. The point of their forceful impact, which we follow by extension, is a loud visual shock off the left corner of the page. This suggested crash, interrupted as it is, is completed by the viewer, but at the artist's direction. Marin experimented with such pressure-filled experiences many times in his career.

PERSPECTIVE     The logical system of perspective is the skeleton on which traceries of fine pen line and delicate wash are drawn by Canaletto in *View of the Canal* (Fig. 61). Canaletto's drawing is a good illustration of the academic system of perspective because, while exploiting the system, the artist does not permit it to dominate his personal expression.

In Francesco Guardi's *Gondolas and View of Venice* (Fig. 62) the system, although very much present, is even less

60. JOHN MARIN (1870–1953; American). *Lower Manhattan.* 1920. Watercolor, 21⅞ x 26¾″. Museum of Modern Art, New York (Philip L. Goodwin Collection).

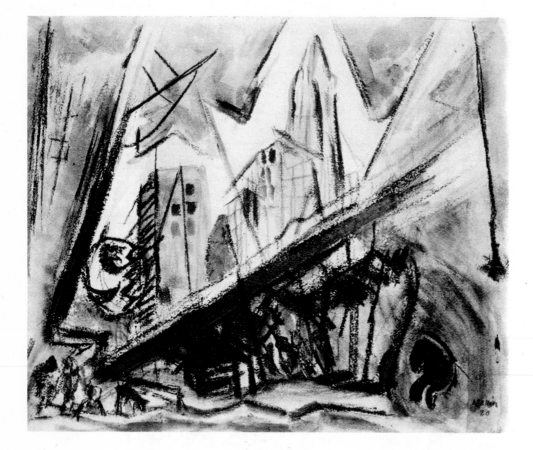

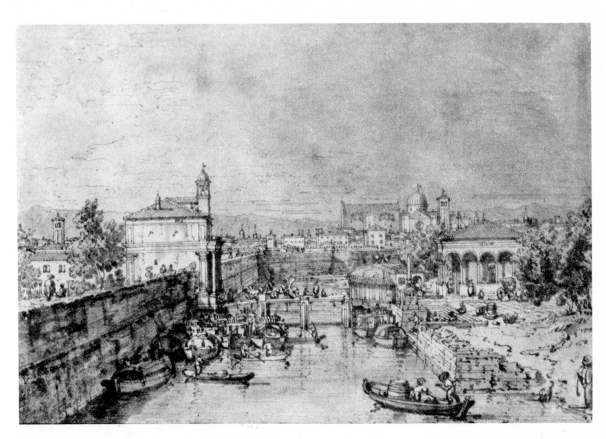

61. CANALETTO (ANTONIO CANALE, 1697–1768; Italian). *View of the Canal.*
Pen and ink with wash, 7 x 10¼″. Collection Robert Lehman, New York.

62. FRANCESCO GUARDI (1712–1793; Italian). *Gondolas and View of Venice.*
Pen and bister wash, 13¾ x 25⅝″. Collection Robert Lehman, New York.

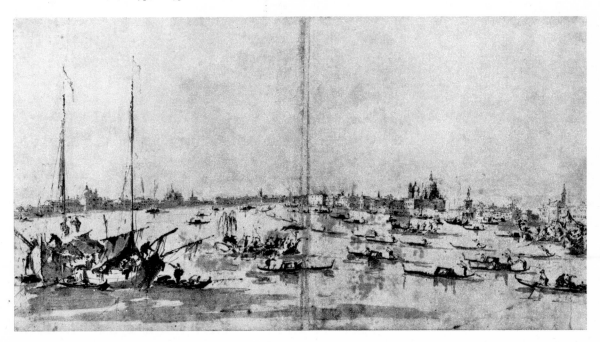

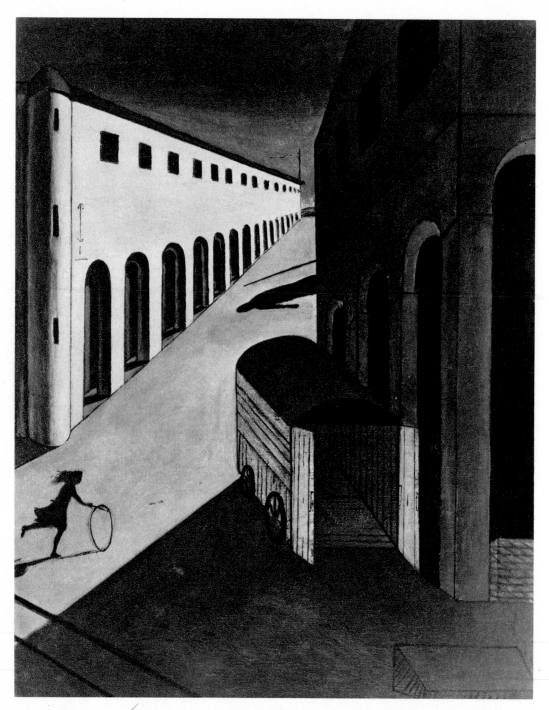

63. Giorgio de Chirico (1888–    ; Greek-Italian). *The Mystery and Melancholy of a Street*. 1914. Oil on canvas, $34\frac{3}{8}$ x $28\frac{1}{4}$″. Private collection.

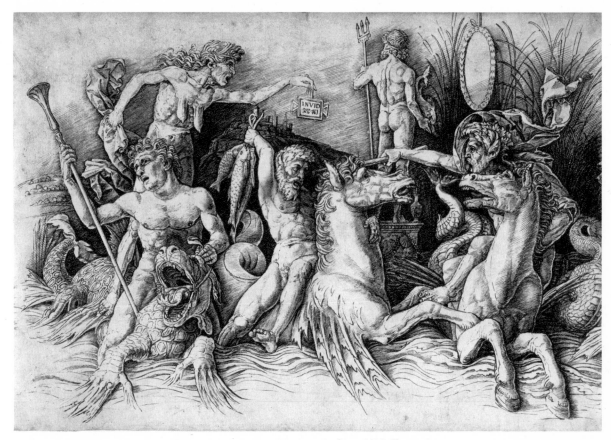

64. ANDREA MANTEGNA (1431–1506; Italian). *Battle of the Sea Gods.* c. 1490. Engraving. Museum of Fine Arts, Boston (gift of Francis Bullard in memory of Stephen Bullard).

prevailing. Perspective is created by the diminishing size of the gondolas, which establish the scale and locate forms in deep space. Guardi's perspective is carefully precise and "true," but an exaggerated perspective is employed in Giorgio de Chirico's oil painting, *The Mystery and Melancholy of a Street* (Fig. 63). The title aptly describes the brooding quality of this artful distortion.

Overlapping planes recede to a shallow background in Andrea Mantegna's *Battle of the Sea Gods* (Fig. 64). The cramped space is equivalent to a sculptured relief, and the violent action of the figures and horses makes them seem to erupt from their crowded stage.

The placement of figures in an architectural environment necessarily affects their volume as they relate to the setting.

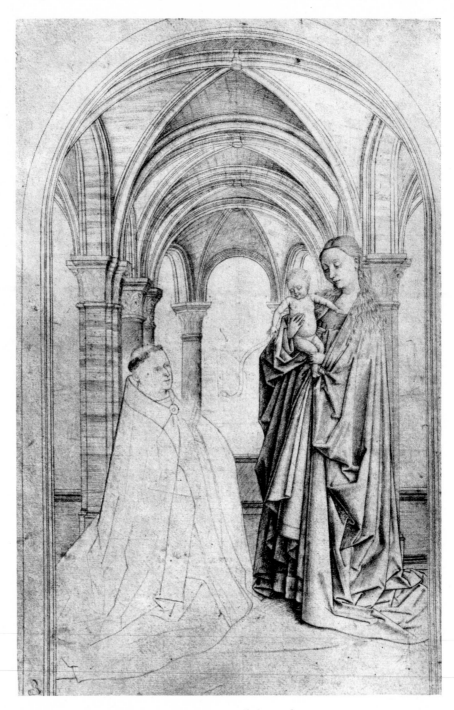

65. JAN VAN EYCK (1390–1441; Flemish). *Maelbeke Madonna.*
Silverpoint, 11½ x 7″. Albertina, Vienna.

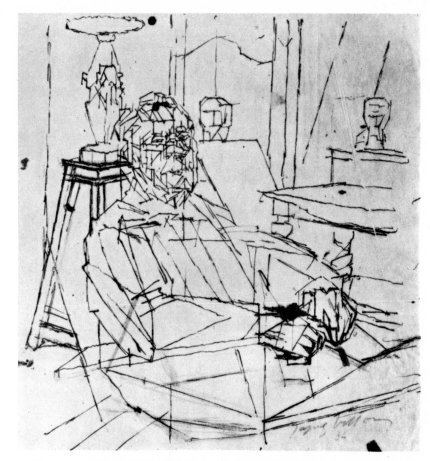

66. JACQUES VILLON (GASTON DUCHAMP-VILLON, 1875–1963; French). *Self-portrait*. 1934.
Graphite pencil with pen and ink, 9¹¹⁄₁₆ x 8⅞″. Courtesy Galerie Louis Carré, Paris.

In Jan van Eyck's *Maelbeke Madonna* (Fig. 65) a detailed rendering
of the architecture leads us to expect rounder volumes in the
presentation of the figure. Instead, the figures seem flat and two
dimensional, almost like paper cutouts set in front of deep space.

Two twentieth-century drawings will demonstrate that
pictorial space always remains subject to individual invention,
for the way in which space is organized is itself expressive. Jacques
Villon in his *Self-portrait* (Fig. 66), diagrams and dissects the
whole space of the drawing. Lines that establish planes locate
the figure and relate it to its surroundings. A strong oblique line
just below the hands sets up a system of planes that tilt back into
space, while the furniture behind the head counters this movement.

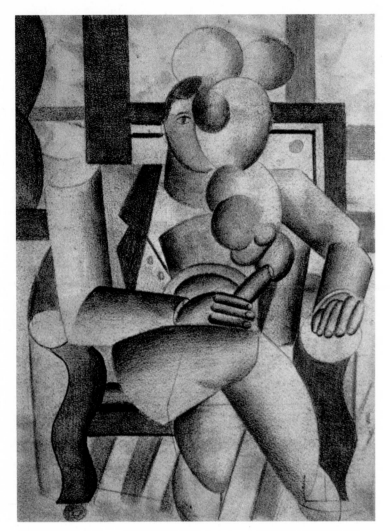

67. FERNAND LÉGER (1881–1955; French). Study for *The Smoker*. c. 1921.
Graphite pencil, 12⅛ x 9⅜″. Musée National Fernand Léger, Biot, France.

Like Mantegna, Fernand Léger in a study for *The Smoker* (Fig. 67)
establishes a narrow spatial field. There is very little space from
the circles that represent smoke to the head behind the circles, to the
strong vertical stripe behind the left shoulder, to the horizontal
stripes, to the final white wall plane. In this structure, with its
tension between circles, horizontals, and verticals, space moves back
in planes parallel to the picture plane. We may compare
this to the oblique cutting into space in Villon's drawing.

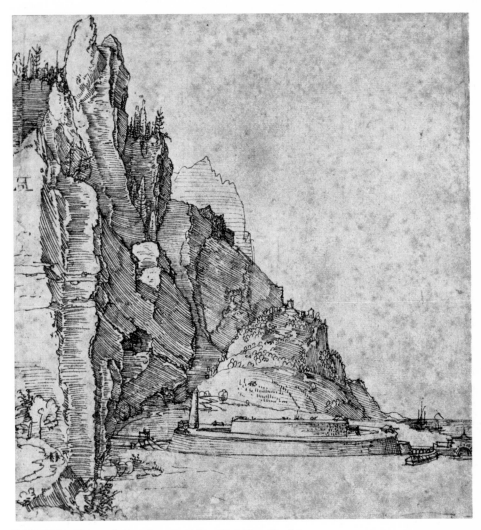

68. ALBRECHT DÜRER (1471–1528; German). *Landscape with a Fort Near the Sea.*
1526. Pen and ink. Biblioteca Ambrosiana, Milan.

SCALE    The scale of any object or structure is usually defined
in terms of some other object or structure. In *Landscape with a Fort*
(Fig. 68) Dürer gives the rock formations the scale of a mountain
by juxtaposing them against smaller forms representing boats,
houses, and trees. However, even without these details, the mass of
rock dominates the page, and thereby assumes scale. We
will explore this problem of scale in Chapter 6, when we attempt
through drawing to transform rocks into mountains.

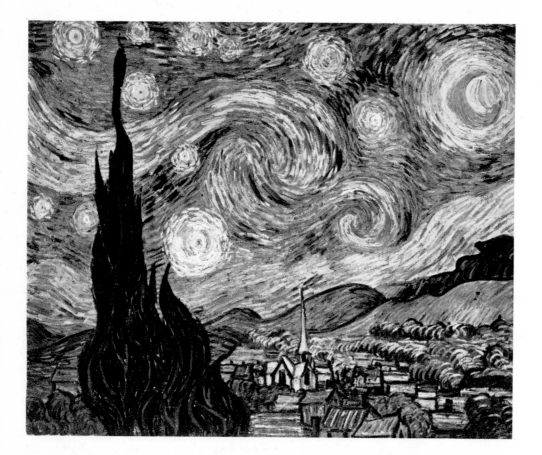

69. VINCENT VAN GOGH
(1853–1890; Dutch-French).
*Starry Night.* 1889.
Oil on canvas, 29 x 36¼".
Museum of Modern Art,
New York (acquired through
the Lillie P. Bliss Bequest).

"REAL" SPACE     The space at the bottom of Van Gogh's *Starry Night*
(Fig. 69) is clear and logical: Trees overlap the view of the town,
buildings exist in normal relationships to one another, and mountains
recede into the distance. But as we look upward to his principal
forms, the stars, the enormous scale of these celestial giants
overpowers the scene below. The negation of "real" space is a
by-product of Van Gogh's dramatic psychological vision.

In Nicolas Poussin's pen-and-wash *Death of Meleager* (Fig. 70)
vibrations of light move through the tree forms and penetrate the
clouds to form continuous vertical movement. This pattern, which
produces a true visual drama, nevertheless lessens the
"normal" planar relationships of foreground, middleground, and
background. The visual reality in this drawing is a two-dimensional
wall of light. Needless to say, our implication here is that
faithful imitation of nature, however much it may require genuine
skill, is not the only criterion for measuring artistic ability.

70. NICOLAS POUSSIN (1594–1665; French). *The Death of Meleager.*
Pen and ink with wash, 9⅞ x 7¼″. Louvre, Paris.

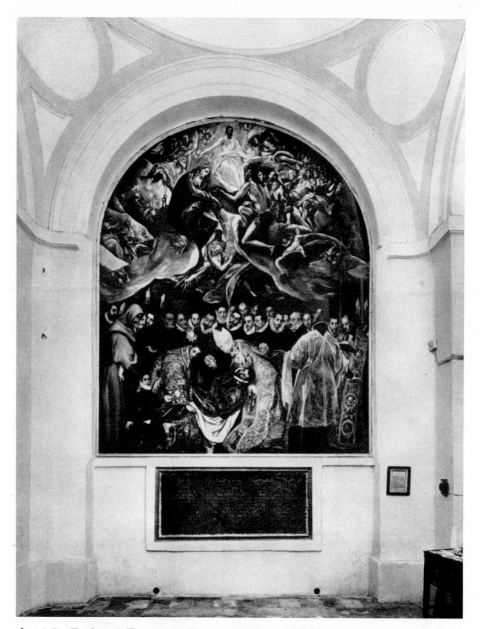

*above:* 71. EL GRECO (DOMENIKOS THEOTOCOPOULOS, 1541–1614;
Greek-Spanish). *The Burial of Count Orgaz.* 1586.
Oil on canvas, 16′ x 11′ 10″. San Tomé, Toledo.

*opposite:* 72. EL GRECO (DOMENIKOS THEOTOCOPOULOS, 1541–1614;
Greek-Spanish). *The Holy Family.* 1592. Oil on canvas, $51\frac{7}{8}$ x $39\frac{1}{2}$″.
Cleveland Museum of Art (gift of the Friends
of the Cleveland Museum of Art in Memory of J. H. Wade).

DISTORTIONS    When one views El Greco's mural-sized painting *The Burial of Count Orgaz* (Fig. 71) installed in the place for which it was designed, the effect is quite different from seeing it in reproductions. The painting was conceived to be observed from a particular viewing height, with the viewer's eye-level well down in the bottom third of the picture. As one looks up into the arched top section of the painting, the Christ figure, the angels, and the flowing drapery all form a vivid spatial thrust. But in a reproduction these forms seem distorted and awkward in relation to the rest of the painting.

The same can be said of El Greco's *Holy Family* (Fig. 72). Standing directly in front of the painting, one is forced to use peripheral vision to contain the forms that bulge and stretch out at either side. The viewer becomes physically involved with the painting. Again, the reproduction, with its distorted cheeks and heads, its pulling arms and draperies, can only hint at the effect the artist intended.

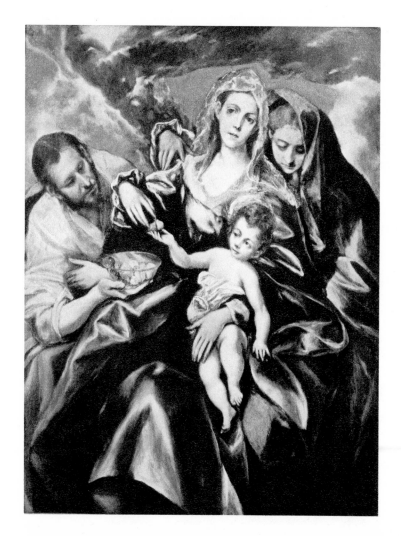

The distortions in Cézanne's *Clockmaker* (Fig. 73) are oddly similar to El Greco's, and, in some ways, they serve the same purpose. As in the two El Greco paintings illustrated, the proportions of the figure change depending on the viewer's position in relation to the canvas. However, in addition to this, Cézanne's drawing gives the effect of many different viewpoints from the *same* eye level. The pulling out of the clockmaker's left shoulder, the sloping away of the right side of the figure, and the stretching, contradictory planes of the head all combine to create the impression that the figure is seen from several angles simultaneously, even when the viewer is standing directly in front of the painting.

Throughout this introduction we have extracted and analyzed specific qualities in the drawings and paintings that are illustrated in order to better understand the form-life that makes each a work of art. In the following chapters we shall examine some of the "problems" representative of age-old concerns of serious draftsmen-artists and the responses of selected students to these problems. If, in these examples, we continually point to the underlying visual logic of the drawings, it is only to emphasize that the way in which an artist structures space is, in itself, an expressive art.

73. PAUL CÉZANNE (1839–1906; French), *The Clockmaker.* 1895–1900. Oil on canvas, 36¼ x 28¾". Solomon R. Guggenheim Museum, New York.

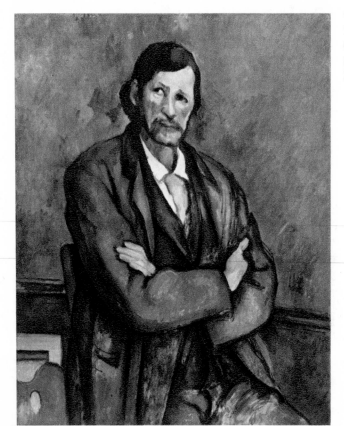

DRAWING:
THE PROCESS
OF VISUALIZATION

# LANDSCAPE

Two drawings of trees attributed to Leonardo da Vinci may be used to represent the major ideas to be explored in this chapter: the structure of a form itself and the same form as part of an environment. These viewpoints are not necessarily inimical. They can be combined at will.

The pen-and-ink drawing of a tree reproduced in Figure 74 exaggerates the point of juncture where one branch grows out of another to suggest a joining and growth similar to that in bone and muscle. The gentle, gradual swelling and stretching as one form pulls out of another is constructed almost as if it were a human figure. No clear line designates exactly where the tree emerges from the ground. Instead, we feel the roots pulling loose from the earth and spiraling upward. This sense of pulsation is fostered by clusters of rounded pen strokes at the point where the branches sprout, three-dimensionally, in space to suggest an inverted cone. The effect is like an opening umbrella (see Pl. 5, p. 93). The same modeling

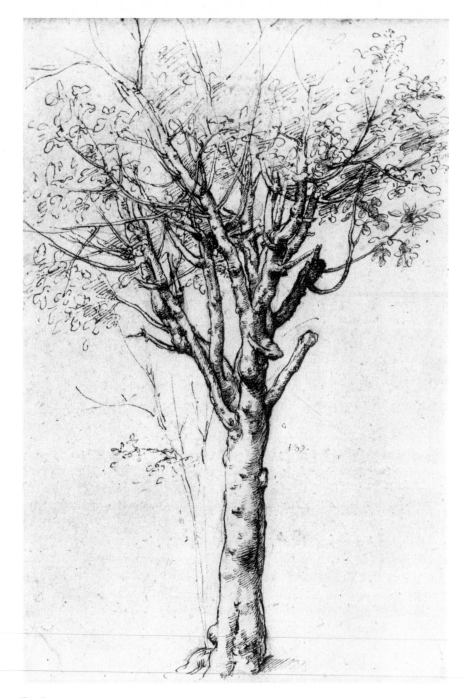

74. Leonardo da Vinci (1452–1519; Italian) or Cesare da Sesto
(1480–1521; Italian). *Tree*. Pen and ink over black chalk on blue paper,
15 x 10⅛″. Royal Collection, Windsor (copyright reserved).

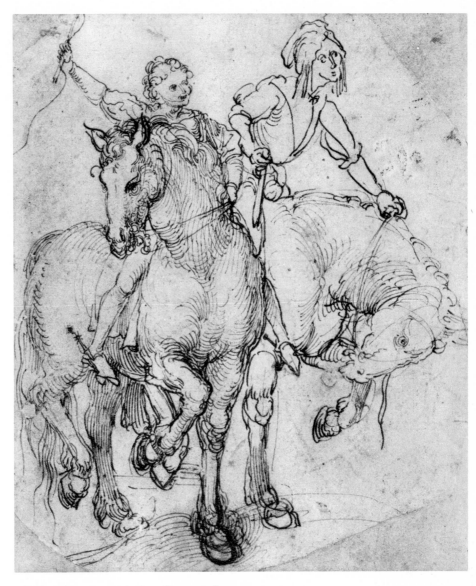

75. ALBRECHT DÜRER (1471–1528; German). *Two Young Riders.* c. 1493–94.
Pen and ink, 7 x 6½″. Staatliche Graphische Sammlung, Munich.

attitude exists in Dürer's drawing, *Two Young Riders* (Fig. 75),
at the point where the front leg of the horse pulls out of
the body. Both examples suggest that drawing is concerned with
discovering, then understanding, and finally expressing
an attitude toward form.

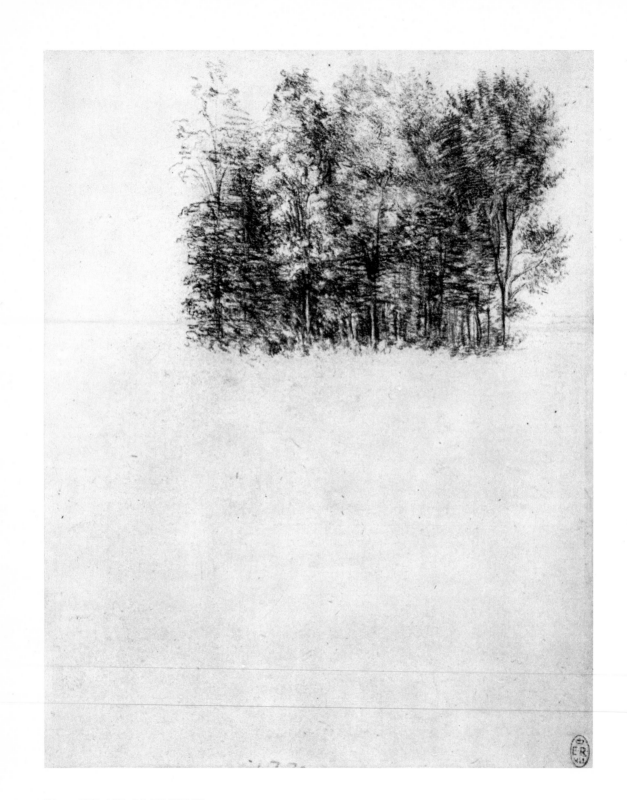

84    THE ART OF DRAWING

The second Leonardo drawing, *Copse of Birches* (Fig. 76) is not an idle, unfinished sketch. The apparent haze through which the trees are seen is intentional, as is the placement of the forms at the top of the composition. The heavy mass set high on the page produces a particular *spatial experience,* which is another role for drawing. When this work is reproduced in books, the empty space at the bottom is usually eliminated, thus robbing the drawing of its distinctive spatial effect.

Volume is also defined in Cézanne's *Sketch of a Tree* (Fig. 77), but instead of stressing a sculptural swelling as Leonardo did, Cézanne breaks up the volume of the tree by

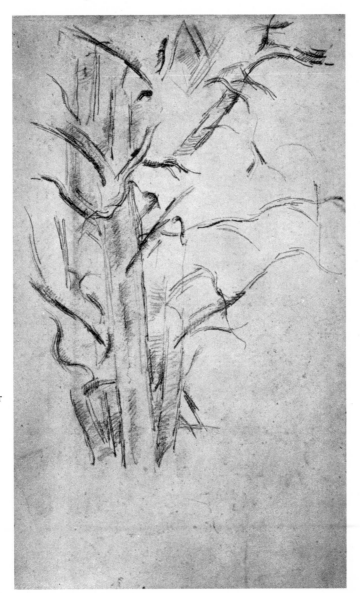

*opposite:* 76.
LEONARDO DA VINCI
(1452–1519; Italian).
*Copse of Birches.* c. 1508.
Red chalk, 7½ x 6″.
Royal Collection, Windsor
(copyright reserved).

*right:* 77. PAUL CÉZANNE
(1839–1906; French).
*Sketch of a Tree.*
Graphite pencil.
Whereabouts unknown.

85

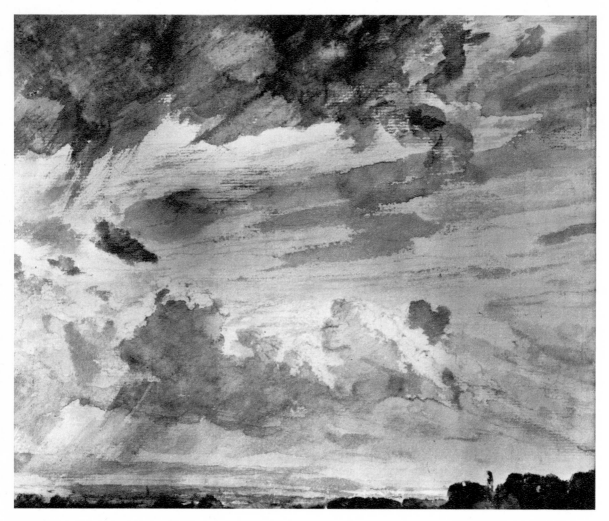

78. JOHN CONSTABLE (1776–1837; English). *Study of Clouds.* 1830.
Graphite pencil and watercolor, 7½ x 9″. Victoria and Albert Museum, London.

controlling the contours of its form, opening and closing them
at will. Because of this fragmentation, the air around and
between the volumes seems as fully modeled as the tree; that is,
the empty space becomes as substantial as the object.

In Leonardo's drawing (Fig. 76) the horizon is suggested
by the lower edge of the dark mass, and the sky is revealed
only between the top of the page and the upper branches of the
trees. By contrast, in John Constable's *Study of Clouds*
(Fig. 78) the horizon hugs the very bottom of the space.

Gravity is established at the lower right where the darkest, clearest, heaviest masses rest. The artist counters this downward pressure by anchoring a large and broken-edge cloud mass to the opposite corner. Between these two opposing masses the amorphous cloud forms, weightless by designed contrast, glide freely.

Yet a third variation in the placement of a horizon is seen in Hercules Seghers' *Landscape with Churches* (Fig. 79). Here the horizon line is a fraction above the center, and the trees, constructed in irregular layers, recede gradually to this boundary. By controlling the amount of sky that is visible, the artist constructs an open, pressureless space. But, as in the Constable, the heavier weight at the bottom establishes gravity. The location of the horizon in these three examples is not an accident. In each case the artist has made

79. HERCULES SEGHERS (c. 1589–c. 1638; Dutch). *Landscape with Churches.* Black pencil with brown wash. Kunsthalle, Hamburg.

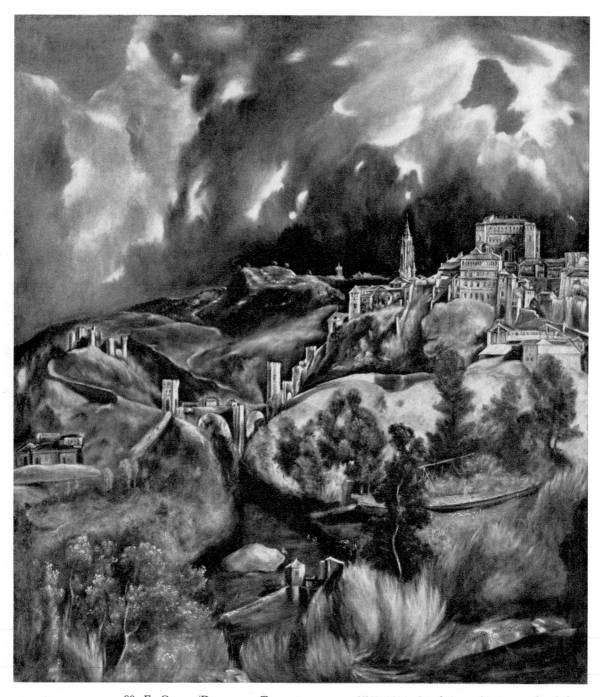

80. EL GRECO (DOMENIKOS THEOTOCOPOULOS, 1541–1614; Greek-Spanish). *View of Toledo.*
c. 1604–14. Oil on canvas, $47\frac{3}{4}$ x $42\frac{3}{4}$''. Metropolitan Museum of Art,
New York (bequest of Mrs. H. O. Havemeyer, 1929; the H. O. Havemeyer Collection).

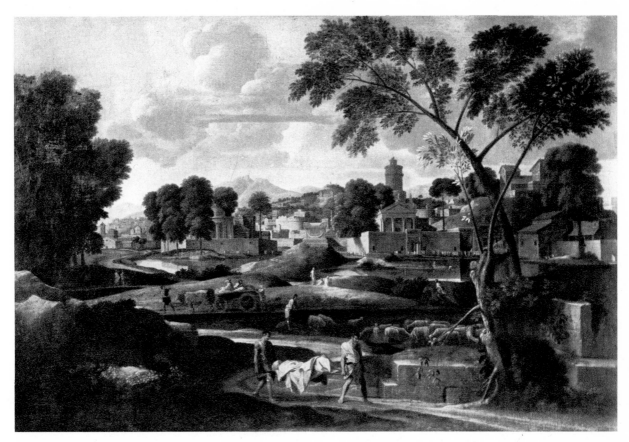

81. Nicolas Poussin (1594–1665; French). *Landscape with the Burial of Phocion.* c. 1648. Oil on canvas, 3′ 11″ x 5′ 10½″. Louvre, Paris.

a calculated decision in order to provide the viewer with a particular experience.

In El Greco's *View of Toledo* (Fig. 80), the rhythmical shapes that intertwine throughout the canvas eliminate the horizon as a prime focal point. Instead, planes move *through* the horizon to the light and dark masses in the sky. The dramatic clouds are engineered to give the illusion of moving over the spectator's head, thus engulfing him in the picture space.

Poussin's *Landscape with the Burial of Phocion* (Fig. 81) clearly presents three planes in space: foreground, middleground, and background. The artist chooses and constructs his space, moving it logically, step by step, to the horizon.

Another approach is used by Raoul Dufy in *Wheat* (Fig. 82). Dufy places large, casually spaced pen strokes in the foreground and lets the white of the page establish a frontal plane. He then gradually reduces the size of the strokes to lead the eye backward to the dominant mass of the trees, which vibrates with textural change. The sky behind serves as a backdrop, yet the whole space is quite shallow.

Receding space can also be presented by dark frontal masses, as in Seurat's conté drawing, *Place de la Concorde, Winter* (Fig. 83). The one dominant vertical is echoed in a casual rhythm throughout the work and is set in tension against the horizon line and other horizontals, thus giving order to the composition. This central vertical, then, is the focus that tightens and particularizes space.

The dark lines of the tree forms in a copy of Rembrandt's *Farm in the Forest* (Fig. 84) press heavily against the sides of

*below:* 82. RAOUL DUFY (1877–1953; French). *Wheat.* Pen and ink. Whereabouts unknown.

*opposite above:* 83. GEORGES SEURAT (1859–1891; French). *Place de la Concorde, Winter.* 1882–83. Conté crayon, $9\frac{1}{8}$ x $12\frac{1}{8}''$. Solomon R. Guggenheim Museum, New York.

*opposite below:* 84. REMBRANDT VAN RIJN (1606–1699; Dutch). *Farm in the Forest* (copy). Pen and ink. Staatliche Graphische Sammlung, Munich.

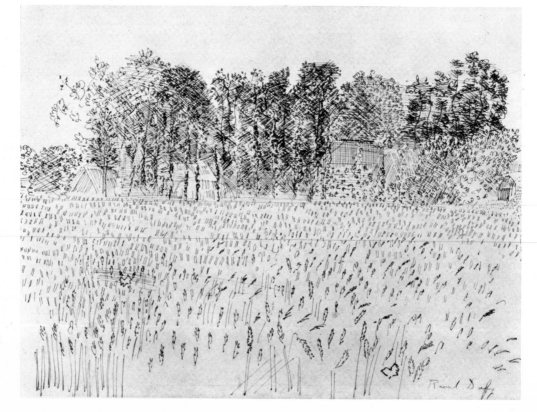

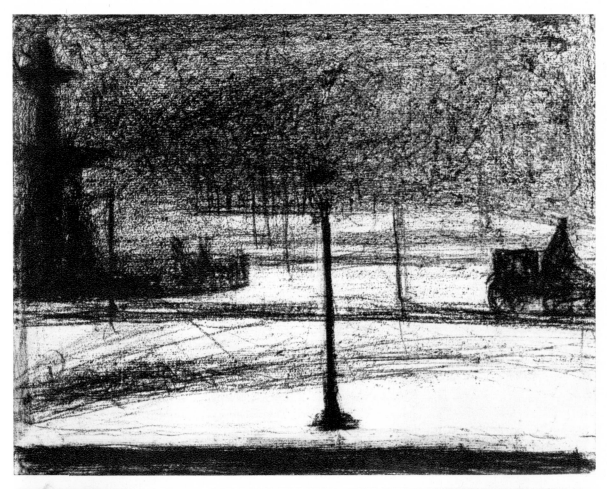

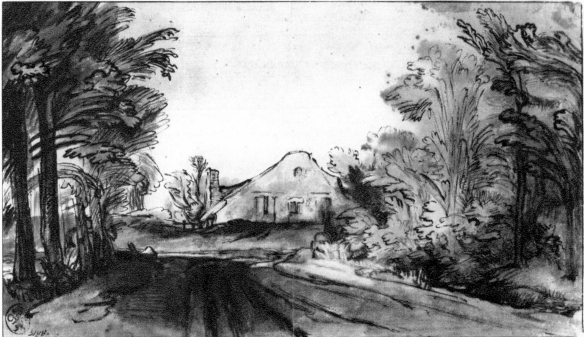

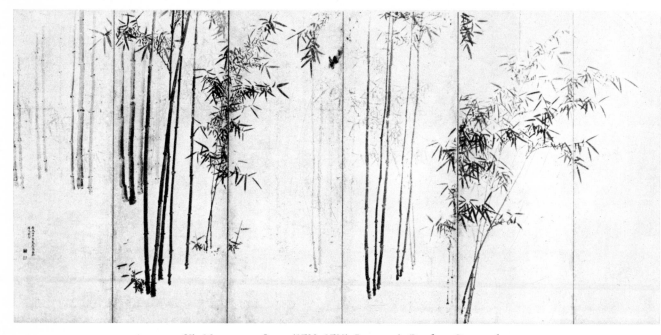

85. MARUYAMA OKYO (1733–1795; Japanese). *Bamboo*. Six-panel screen, brush and ink. Kyoto National Museum.

the page to carve out a particular space. The remaining white air spaces appear full and spreading, as though released from the constricting landscape elements (see Pl. 6, p. 94).

The space in *Bamboo* (Fig. 85), a Japanese folding screen in six panels by Maruyama Okyo, is carried smoothly from one panel to another by the white interspaces between the vertical tree forms. These intervals lead the viewer's eye across the surface of the screen in a directed time sequence from left to right. Short, casually spaced, parallel brush strokes and their interspaces (panel one) become long, assertive strokes and are used to introduce scattered leaf forms in the second panel. In panel three the leaf strokes hover near the top of the composition only, but they assert themselves on the white space and the ghostlike trunk forms below them. The long, slender verticals of the trees are echoed again in panel four, this time more delicately, and a few leaf forms are repeated at top and right. In panel five the dancing leaf strokes define a diagonal upward thrust, and the composition is brought to a close in a final spray of feathery strokes in the last panel.

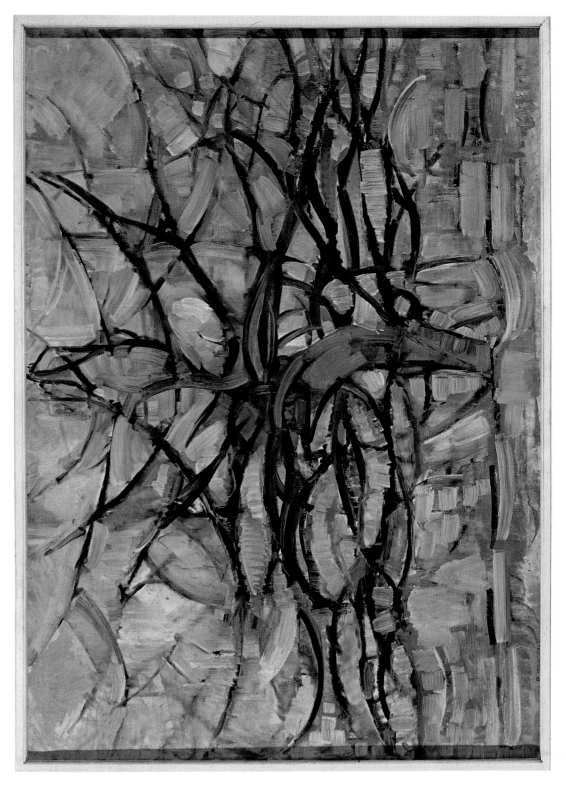

Plate 5. Piet Mondrian (1872–1944; Dutch). *The Gray Tree.* 1912. Oil on canvas, 30⅝ x 41¹⁵/₁₆″. Gemeentemuseum, The Hague (on loan from S. B. Slijper). Mondrian spins a complete circle in space around the central core of a tree trunk, and these three-dimensional planes culminate in a pointed top. The cone thus formed suggests one of the functions of a tree—to act as an umbrella.

93

Plate 6. SAMUEL PALMER (1805–1881; English). *Barn in a Valley (Sepham Farm)*. c. 1824–28. Pen and brush in India ink over pencil, heightened with white on brownish paper; 11⅛ x 17⅝″. Ashmolean Museum, Oxford. The artist composes a dialogue between the dark, heavy masses of the fields and the lyrical scrawls of the trees. The latter produce a texture that implies air or wind moving through the branches.

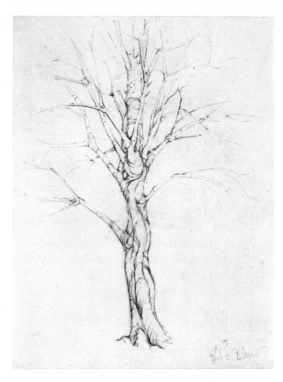

*right:* 86. KENT BLOOMER. *Sculptural Tree.* 1960.
Graphite pencil. Collection Yale University,
New Haven, Conn.

*below:* 87. Student drawing, *Trees Intertwined.*
Pen and ink. Collection Yale University,
New Haven, Conn.

## Student Response

THE INDIVIDUAL TREE FORM     The drawing in Figure 86
presents a tree stripped of its surface bark. The extremities pull
and stretch in a sculpturally conceived form-attitude. Each
section seems cut, welded, and fitted into place. The student,
who is a sculptor, translates the object with his own form
preferences.

Pulling and stretching are also evident in the pen drawing
in Figure 87. An accompanying theme is found in the

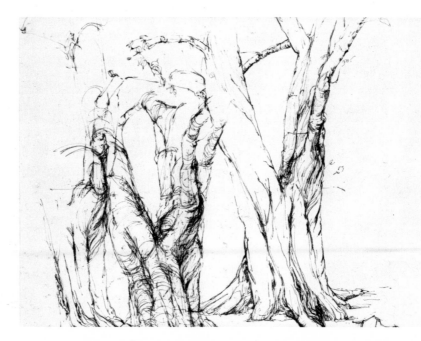

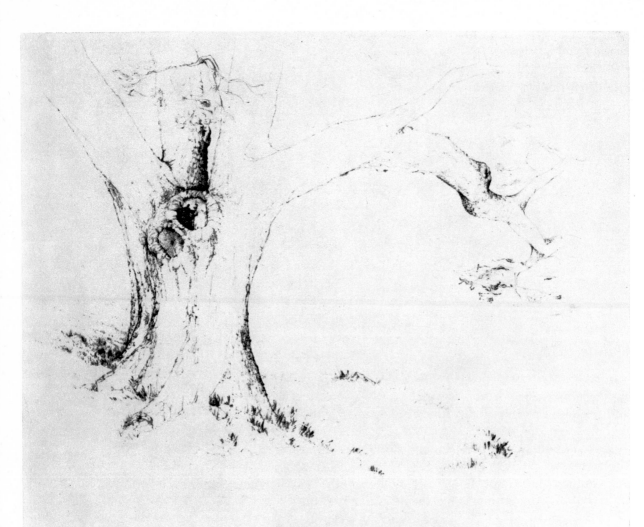

88. WILLIAM REIMANN. *Tree: Line and Volume.* 1957. Graphite pencil.
Collection Yale University, New Haven, Conn.

insistent intertwined forms that house volumetric projections.
Notice that the artist hides human figures in the trees.

The movement of bark is used to produce volume in the
pencil drawing in Figure 88. Crucial areas where forms
intersect are spotlighted, while other parts are defined with
only light contours. The emphasis on detail compels us to
accept contour line for volume within the "unmodeled" sections.
Gentle grasslike lines encircling the tree define its
immediate location.

The pencil lines in Figure 89 are sinuous and elastic. This undulating line, in turn very pale, medium-gray, and quite dark, stretches and contracts to exaggerate the impression of growth.

LANDSCAPE SPACE    Two attitudes, rhythm and volume, exist in the complex study in Figure 90. Branch forms entwine to create tension and interlocking rhythms in a space that is relatively shallow. On closer examination we discover one major articulated volume, the large tree form, which is studied as an individual structure, yet exists as part of the allover composition. This sculptured volume merges into the total rhythm of the work. The artist directs his viewer to see first the rhythms and then the sculptural volumes that compose them.

*below left:* 89. GERALD HAHN. *Undulating Tree Form.* c. 1960. Graphite pencil. Collection Yale University, New Haven, Conn.

*below right:* 90. DONALD LENT. *Trees: Tension and Rhythm.* 1960. Pen and ink. Collection Yale University, New Haven, Conn.

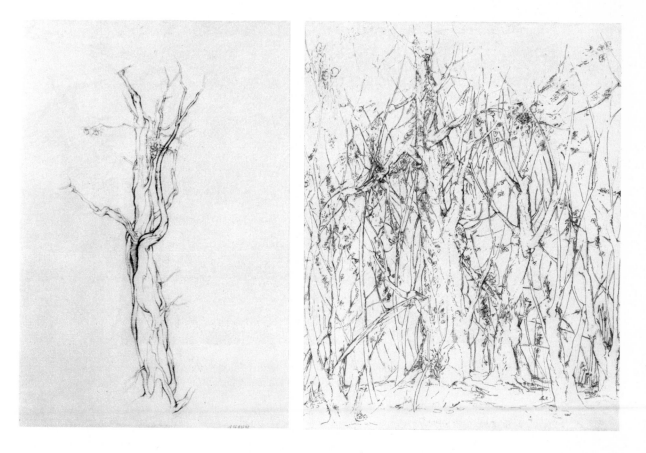

91. ROBERT BIRMELIN. *Landscape with Oblique Horizon.* 1955. Pen and ink.
Collection Yale University, New Haven, Conn.

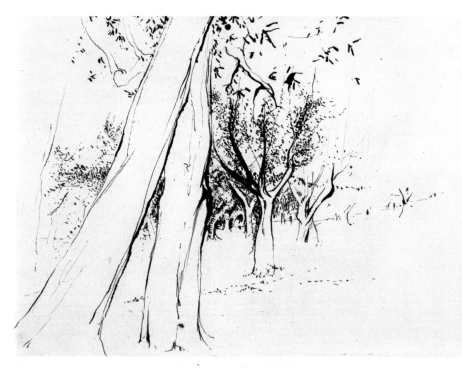

92. JOANNA BEAL. *Landscape with Diagonal Tree.* 1956.
Pen and ink. Collection Yale University, New Haven, Conn.

The drawing in Figure 91 hurtles us directly into its
space. The cut-off wall at the lower right, a sharp diagonal tipped
into space, moves swiftly to the counter-tipped horizon.
Its headlong rush is slowed only by dark, amorphous shadows.
The high angle of vision, coupled with the tilted horizon
and wall, throws us off balance, and to restore our equilibrium we
must complete the motion in our minds. By projecting us
directly into the composition, the artist makes us create a total
environment beyond the picture.

The leaning diagonal tree in Figure 92 also pushes us into
the drawing, but, by comparison, it is only a tentative
projection. The form cut off at the top inhibits our passage,
and, more important, the projection is immediately counter-
weighted by a crowding vertical mass. To reinforce this
counterweight another vertical tree form in the center of the
composition further reduces the tension of the diagonal.
The space itself presses toward the viewer, because the horizon
is visible between the two vertical trees and thus

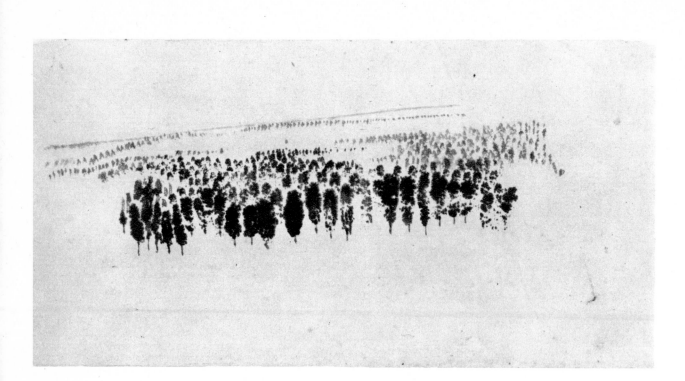

93. JOHN FRAZER.
*Panoramic Landscape.* 1959.
Wash. Collection Yale
University, New Haven, Conn.

seems closer than it should be. The total impression creates
sufficient tension to fill the large white area at the right.

Unlike the last two examples, the wash drawing in Figure 93
makes us detached observers of a calm, panoramic
scene. The brush strokes start almost halfway up the page and
move back in a relatively tensionless retreat. The large
white area at the bottom serves as a frame and also keeps the
viewer at a safe distance from the first row of black spots,
the symbols of vegetation.

The light in Figure 94 creates space much as in Seurat's
drawing (Fig. 83); that is, the shapes in the foreground
recede logically but with no tension-producing diagonals.
The simple shapes of the opposing horizontal and vertical masses
carry the weight of the composition. The lines that define
these masses are always exposed, even in the darkest areas.
They are neither blurred nor rubbed. These lined planes
produce a texture that is a by-product of constructing the
masses, not a decorative afterthought. And the vibrating lines,
in turn, become a light-giving force.

The broken light in Figure 95 derives from shapes (grayed,
soft-edged washes) which, at first sight, do not organize

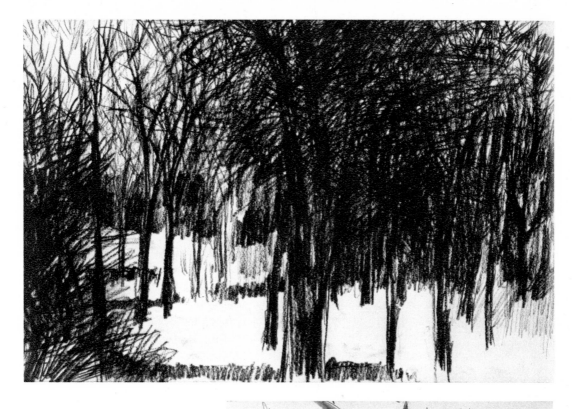

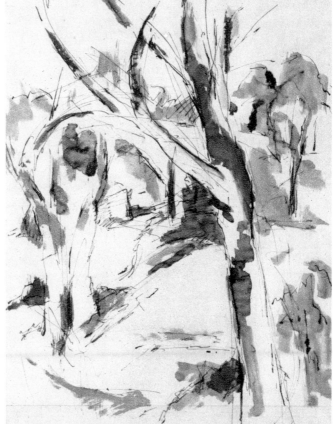

*above:* 94. PAUL COVINGTON.
*Textured Landscape.* 1961. Charcoal.
Collection Yale University,
New Haven, Conn.

*right:* 95. BARRY SCHACTMAN.
*Landscape Conceived Geometrically.*
1959. Pen and ink with wash.
Collection Yale University,
New Haven, Conn.

themselves spatially. One notices first the geometric shapes—
the dark triangles behind the tree at the extreme left and the
same shape repeated on the right. Punctuating the space,
they set up what we can term spatial stations, similar shapes
answering one another, and the eye tends to group these
corresponding shapes. Yet if we deliberately do not concentrate
on the triangles, the allover broken light appears as the main
interest. Thus, by focusing differently, the viewer may
get two readings.

In the pen-and-ink drawing in Figure 96 the white of the
paper is used to establish a long horizontal wall of light.
This is punctuated with a delicate, economical calligraphy that
does not violate the white but, rather, creates a dialogue with it.
These strokes define a slow, tensionless dancing rhythm.
The drawing was produced by a careful observation of
linear patterns directly in front of the motif and the selection
of these elements from an actual landscape. However, this does
not necessarily mean that the artist must study nature
directly to produce such a visual action. At the time this
drawing was done, the student's paintings were quite abstract,
but the kinds of rhythms and shapes he preferred in painting he
purposely sought in nature and presented in drawing.

96. Joseph Raffaele. *Landscape with Dancing Rhythm.* 1954. Pen and ink.
Collection Yale University, New Haven, Conn.

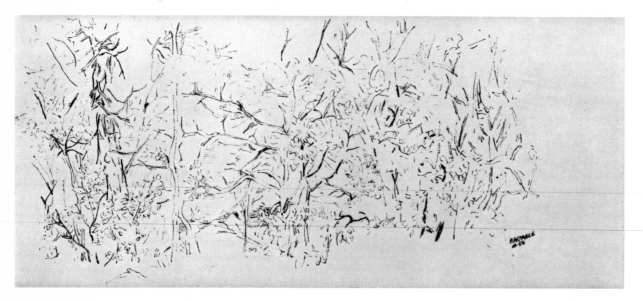

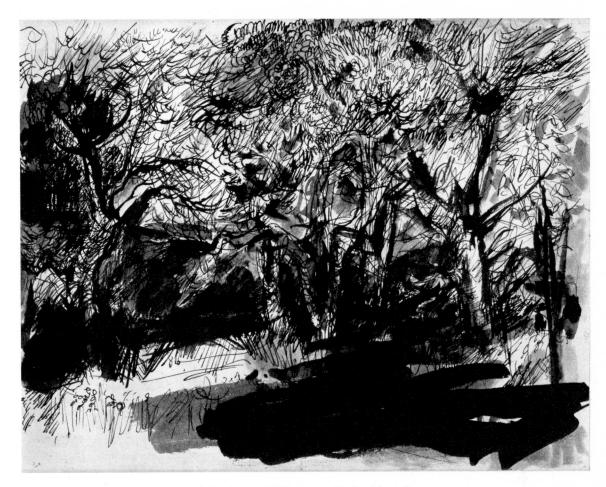

97. Michael Chelminski. *Saturated Landscape.* 1961. Pen and ink with wash. Collection Yale University, New Haven, Conn.

The air is heavy in the pen-and-wash drawing in Figure 97, and the choking darkness moves the entire picture plane forward. Only the very bold brush strokes in the foreground advance and push the trees back into the dense atmosphere.

In summary we must emphasize that each form should be studied from two points of view: the object regarded as a particular volumetric structure and the object used as a compositional tool for a particular spatial expression.

# FORMS
# FROM NATURE

For centuries artists have been bringing natural forms into the
studio for study. As we might expect, the kind of study
varies with the period and the individual artist. Renaissance
artists studied twigs and rocks to re-create trees and
mountains. Paul Klee, in a different time, used natural forms
to construct his fantasies.

The idle sketching of these natural forms for the sake
of play is not wholly worthless. But for this studio problem the
uniqueness of the form, the quality of being an *actor*
was stressed. The students were asked to assume an attitude
toward the forms and to study their character and their
volumetric structure as a basis for future interpretation.
This was to include an analysis of the use they could make of
the forms and a testing of themselves by drawing the forms
from memory. The memory drawings are nearly always the best.
Memory brings out the essential attitude; unnecessary detail
(unnecessary for the particular attitude) is simply forgotten.

98. ANTONIO PISANO PISANELLO
(1397–1455; Italian).
*Studies of Flowers.*
Pen and ink. Louvre, Paris.

More important, memory drawing helps one to realize that
drawing is more what is known than what is seen.

Natural forms were introduced to reinforce the ideas
expressed in Chapter 5: the creation of landscape space and
the articulation of individual objects in the landscape.
However, the individual forms have become more complicated,
presenting more issues and discouraging the development
of a "one style, one medium" approach.

## PLANTS

The difference between Antonio Pisano Pisanello's pen drawing
of lily bulbs and other plants (Fig. 98) and a rendering in an
encyclopedia is that the latter is concerned with the
characteristic contour-shape for the purpose of identification.
Pisanello assumes another approach: The forms seem to be bending,

moving, and blossoming sculpturally. The form at the upper left, for example, flexes like metallic drapery. The flower form at the center of the page suggests the presence of a bud moving up through the central cylindrical volume, spreading the protecting leaves apart. In short, each form on the page has an exaggerated characteristic. And yet it is not only the projected volumetric character of each form that may be essential to the artist. The composing of the page itself can be the crucial task. Both attitudes may be stressed together or separately in varying degrees, since it is possible for the artist to diagram the structure alone as a rehearsal for translation into another medium. Or, as has been previously stated, the drawing can be a complete work in itself (see Pls. 7–8, pp. 111–112).

## Student Response

Figure 99 is a memory drawing completed in less than two hours. The attitude is evident. The broken-line contours of the form are obviously exaggerated: they droop, float, hang, twist, turn, and seem to die in slow-motion in the center of the page. The continuous white border holds them in the space and at the same time serves as a barrier between the viewer and the scene.

The contours in Figure 100 (also a memory drawing) are predominantly open. The modeling was achieved by thinking of

*opposite:* 99. Sandra Whipple. *Drooping Flower Forms.* 1961.
Pen and ink. Collection Yale University, New Haven, Conn.

*above:* 100. Mark Strand. *Cylindrical Growth.* 1958.
Pen and ink. Collection Yale University, New Haven, Conn.

101. Mark Strand.
*Texture and Volume.* 1958.
Pen and ink.
Collection Yale University,
New Haven, Conn.

the forms as growing from the inside. Although the whole
form seems to be constructed within a gently pointed, diagonal
cylinder, the broken light hides this construction and suggests,
instead, lazily spiraling forms. This broken light and the
dark patterns are organized to move around the volume.
We should note, too, that the light source is invented, not
imitated.

Figure 101 (a memory drawing) is not merely a texture
study. The texture is used in the service of both light and
volume. It is part of the modeling, not a decorative effect.
The very tiny pen strokes at the outer edges of each ball form
vibrate and act upon the space around them, suggesting energy
moving outward. Note, too, the larger white units in the
centers, which gradually get smaller. Here again, the leftover
white paper acts as a unit within the modeling, not as mere
passive space surrounding a form.

The same medium—pen and ink—was used in Figure 102
as in the previous two drawings, yet the instrumentation is
quite different. The hand seems to have moved simultaneously
through the modeled forms and the surrounding space. There
is a reciprocal action: both the forms and the space around
them seem to be moving together at the same tempo.

By contrast, the rhythmical motion in Figure 103
is limited; the air space is still and heavy. The focus in this

102. JOEL SZASZ. *Flowers:
Space and Interspace.* 1957.
Pen and ink.
Collection Yale University,
New Haven, Conn.

103. HAROLD FORD.
*Flowers Suspended in Still Air.*
1958. Pen and ink.
Collection Yale University,
New Haven, Conn.

104. Student drawing, *Patterns of Growth*. Pen and ink.
Collection Yale University, New Haven, Conn.

work is on the turning edges of the forms, and these edges are
studied and stressed. The other forms start to bend and
disappear, gradually meeting and dissolving into the heavy air
around them. The concept of modeling the whole page is similar
to a sculptured relief.

The intersections that are studied in the drawing
in Figure 104 attempt to articulate the way in which one form
grows out of another. The irregular sequence of these
articulations in space, coupled with the peculiar posture of
the lower form, gives life to the idea. But the instrumentation
here also contributes to the effect: The swiftly drawn pen
lines darken sharply at the intersections for further dramatization.

Plate 7. EMIL NOLDE (1867–1956; German). *Red Poppies*. c. 1931. Watercolor, 13 x 18″. Collection Mr. and Mrs. Hans Popper, San Francisco. Brilliant wet light captures the postures of the flowers as they move in slow motion through the compressed space of the composition. The drawing is a complete work of art in itself.

Plate 8. LEONARDO DA VINCI (1452–1519; Italian). *Lily.* c. 1479. Pen and ink and sepia wash, heightened with white over black chalk; 12⅜ x 7″. Royal Collection, Windsor (copyright reserved). Each section of the plant is clearly diagramed and articulated, and the viewer's focus is distributed fairly equally throughout the composition. It is likely that this drawing was intended for translation into another medium, for the surface has been punctured with tiny needle holes along the edges of the form. This was a common practice for transferring a design, usually to a wood panel.

105. Vaino Kola. *Interacting Flower Forms.* 1962. Pen and ink.
Collection Yale University, New Haven, Conn.

In the pen-and-ink drawing in Figure 105 the individual
form gives way to a study of the interaction of a group of
forms. The placement of the darkest mass establishes both
gravity and the plane that is farthest back in space. (If we were
to block out the dark, the page would seem to slide.)
The pattern of light in the jars suggests solidity, and this is
accomplished without enclosing the forms in firm contours.
In order to achieve the diffuse light that pervades the drawing,
it is essential that the lines be left open. If the jars
had been firmly outlined, the vibrating, irregular forms of the
plants would have taken on a different pattern of light
and shadow.

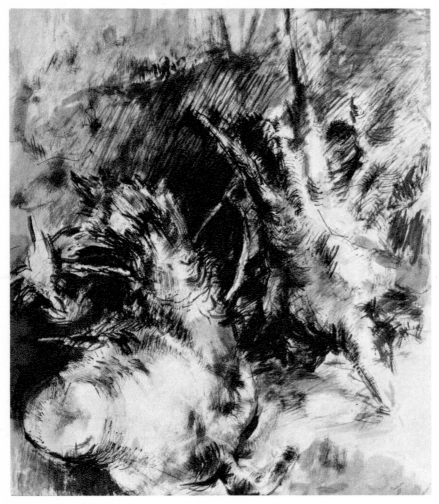

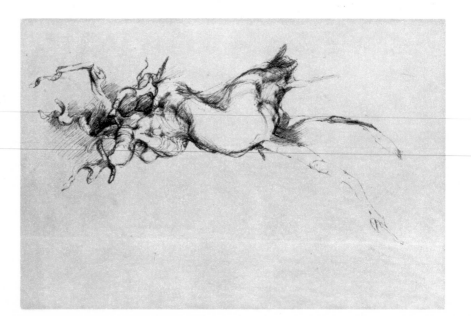

left: 106. MICHAEL ECONOMOS.
*Gesticulating Roots.* 1960.
Pen and ink with wash.
Collection Yale University,
New Haven, Conn.

below: 107. Student drawing,
*Organic Root Forms.*
Pen and ink.
Collection Yale University,
New Haven, Conn.

# ROOTS

By examining root forms at close range we are permitted many kinds of investigation. For some the roots suggest distorted animallike configurations; others are interested in the velocity at which the forms unexpectedly travel; still others examine the sculptured weights, thrusts, and counter-thrusts into space. Yet no matter which attitude or combination of attitudes is stressed, one consideration should be borne in mind: All the extremities that were twisted into strange patterns underground derive from a central core, the trunk. This idea has a parallel in figure drawing, in which arms and legs move from the cylinder of the body (see Figs. 74–75).

## Student Response

The first four drawings in this section suggest animal imagery. In Figure 106 the roots are presented in a dramatically staged composition. The actors—the large trunk and root forms—gesticulate in the center of the stage. The lighting and the ambiguous background add to the effect.

In Figure 107 the root branches resemble claws, and the bulging mass suggests organic matter that seems capable of crawling, yet the whole shape swells and moves through the space as an entity. The placement of the form at the top of the page precludes immediate contact with the viewer and leaves room on the stage for potential movement. Again in Figure 108

108. FREDERIC FELTON.
*Writhing Branches.* 1959.
Pen and ink.
Collection Yale University,
New Haven, Conn.

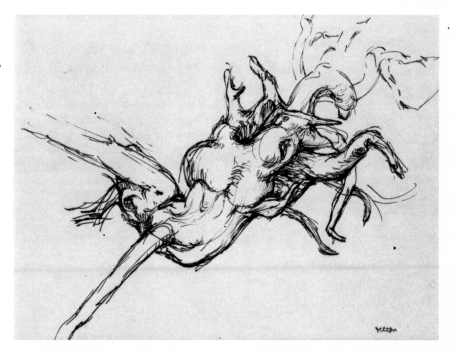

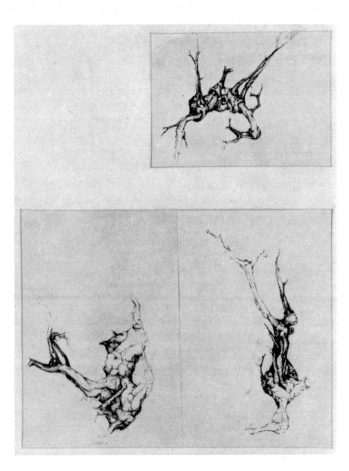

109. ASHER DERMAN.
*Three Studies of Roots.*
1957. Pen and ink.
Collection Yale University,
New Haven, Conn.

the branches are organic, animallike forms, this time writhing
and twisting diagonally across the page.

Figure 109 is a group of three separate studies, and each
gives a detailed look at minute swellings of form. This close
examination does not prevent the eye from following the
transitions from one part to another, nor does it prevent us from
reading the overall character of the individual form.

Each form in the wash drawing in Figure 110 applies
weight and pressure on its neighbor in a reciprocal action.
The complicated structure is interpreted as a heavy sculpture.

The brush drawing in Figure 111 focuses on speed. Specific
details are articulated by the fast line that contains the
modeled sections within its flow. Long, looping brush strokes
play upon the carefully chosen details. The most detailed
areas are the intersections where forms meet in tension.

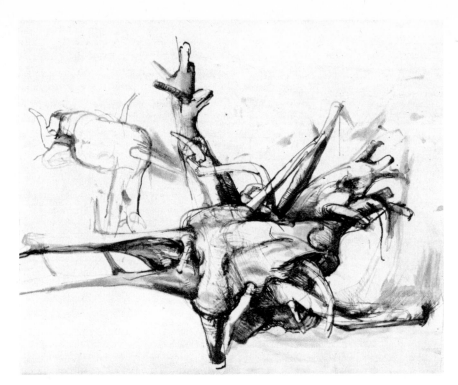

110. MICHAEL MAZUR. *Reciprocal Pressures*. 1960. Wash.
Collection Yale University, New Haven, Conn.

111. JOHN COHEN. *Roots in Tension*. 1954. Brush and ink.
Collection Yale University, New Haven, Conn.

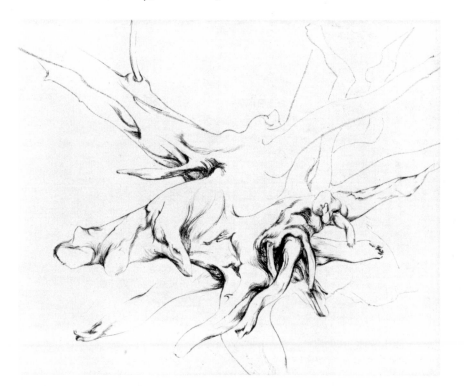

*left:* 112. LOUIS KLEIN.
*Postures of Roots.* 1959.
Pen and ink.
Collection Yale University,
New Haven, Conn.

*below:* 113. PIETER BRUEGEL
THE ELDER (1525/30–1569; Flemish).
*Landscape with Rocky Mountains.*
Pen and brown ink, $6\frac{7}{8}$ x $11\frac{7}{8}''$.
Kupferstichkabinett, Dresden.

*opposite:* 114.
PIETER BRUEGEL THE ELDER
(1525/30–1569; Flemish).
*Alpine Landscape.*
Pen and ink. Louvre, Paris.

The pen-and-ink drawing in Figure 112 uses techniques
similar to those in Pisanello's work (Fig. 98) to express the
actions of roots by accenting their postures. It is a study
of poses—the dancing movement of a whole form—and the artist
repeats the action across the page to underscore the theme.

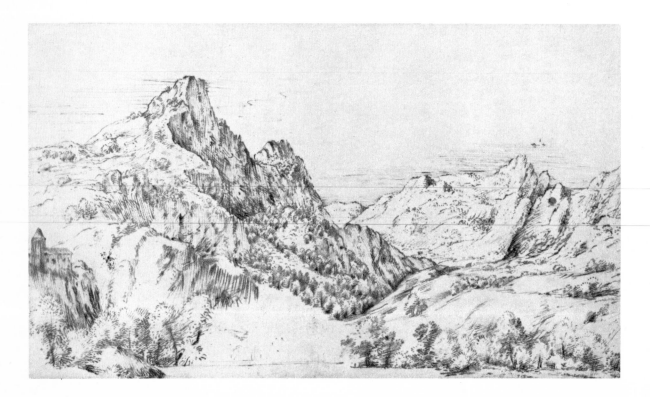

# ROCKS AS MOUNTAINS

In this problem rocks were arranged on a table by the students to simulate mountain ranges. The study was related directly to the landscape space ideas that the students were working on independently at the same time. The concept to be examined is scale and the problem of constructing large masses within that scale. A man must be considered as an ant in this context. If one merely imitates rock texture, the translation of scale is lost. The models—the rocks—are meant to suggest infinitely greater mass.

In Pieter Bruegel's *Landscape with Rocky Mountains* (Fig. 113) the firmly anchored masses are simplified, yet one can envision climbing a rough trail from base to summit. Some students prefer to construct a definite path, while others present the rock forms in a more generalized landscape environment. Bruegel selects a higher vantage point in *Alpine Landscape* (Fig. 114), where the constantly changing tilt of the various slopes creates a feeling of dizziness.

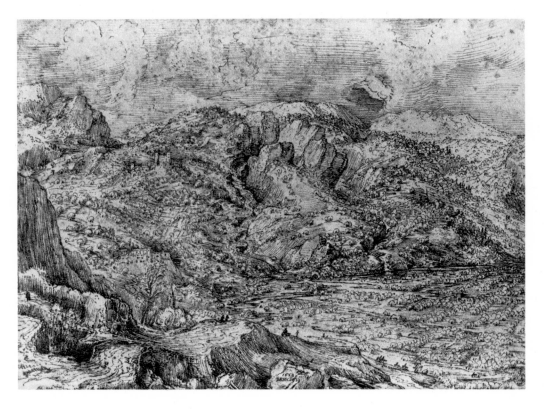

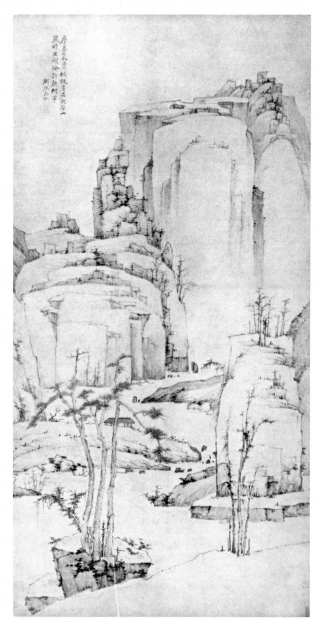

*left:* 115. HUNG-JEN (1610–1663; Chinese).
*The Coming of Autumn.* Hanging scroll,
ink on paper; 48⅛ x 24¾".
Honolulu Academy of Arts
(Wilhelmina Tenney
Memorial Collection, 1955).

*opposite:* 116. JACOPO BELLINI
(c. 1400–1470; Italian). *Baptism of Christ.*
Pen and ink. Louvre, Paris.

The proportions of the masses, plus subtle accents where
forms overlap, give *The Coming of Autumn* by Hung-Jen (Fig. 115)
a feeling of tremendous scale. The winding S-shaped trail
along the bottom weaves a path that ultimately unites the road
and mountain into a consistent rhythm. The three vertical

trees at lower left are repeated many times as a counterpoint to the rounded, solid mountains, and the tiny house directly behind the trees adds to the illusion of depth and scale.

In Jacopo Bellini's *Baptism of Christ* (Fig. 116) the sharp, angular mountains seem as architecturally designed as the

broken column in the foreground and the castle at the top.
As in the Chinese drawing, a sweeping curve leads us into space
and winds to the summit. The whole creates a stage for the
magnificent drama that unfolds in the center of the composition.
The chorus of angels directly behind Christ is delicately
and deliberately woven into the rock forms.

## Student Response

The viewer's vantage point in Figure 117 is from a high peak
overlooking another mountain form. We are invited to inspect
the large masses, the possible paths for climbing, and
hidden details. Like the crevices and points on the mountain,

117. HARRY KESHIAN. *Mountains in the Distance.* 1955. Pen and ink.
Collection Yale University, New Haven, Conn.

the tree on the central form contains a variety of rocklike details. These details are not strictly ornamental; they do not divorce themselves from the overall mass. The structure to the right, bare by comparison, still reveals all its steps and turns. The whole drawing is composed of gently tilting masses.

Unlike Figure 117, the drawing in Figure 118 (a memory drawing) invites the viewer's eye to rest on the heavy weights of the central plane. Having been forced to look at this dark, weighted mass, we discover within it a rhythmic, linear theme that moves through to the forms behind. The artist's skill in making us follow this path gives a particular sequence to the drawing.

118. Jeanette Lam. *Weighted Mountain Forms.* 1955. Pen and ink. Collection Yale University, New Haven, Conn.

119. Student drawing,
*Rocky Crags*. Pen and ink.
Collection Yale University,
New Haven, Conn.

By contrast, the broken light in Figure 119 prevents us from focusing on one particular weight or detail. The light, constantly moving up and down, gives a sensation of climbing, although we seem to be at a safe distance from the rocky crags.

In the memory drawing in Figure 120 the shapes are mountainlike, yet they appear to be more elastic, more organic than those of the previous drawings. We seem to be very close to the forms, yet the undercut portion at the center pushes sharply into the page. We have, therefore, more than one reading. We might choose to take the trip underneath and then return to the main form, pressed against a sky mass that seems to be advancing. This drawing, with its fantastically conceived shapes, provides the viewer with many visual actions and counteractions.

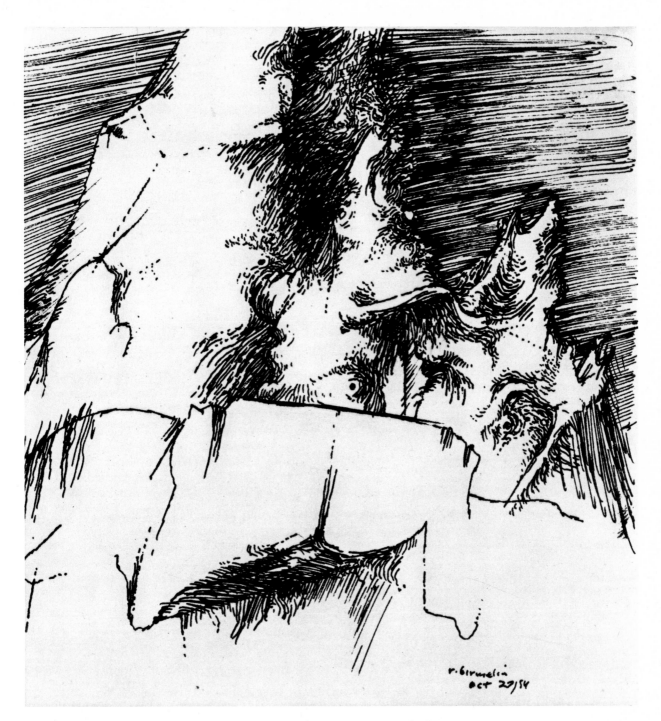

120. ROBERT BIRMELIN. *Fantastic Mountain Landscape*. 1954. Pen and ink.
Collection Yale University, New Haven, Conn.

# 7
# INTERIORS
# AND
# MAN-MADE OBJECTS

## INTERIORS

The artist's reaction to man-made environments—the settings
in which we spend much of our lives—has been a popular subject
for centuries. The character of a particular place obliges
the artist to perceive definite relationships of scale and light,
which in some ways parallel landscape space. For example,
it is a common error to identify individual objects at the
expense of a total spatial organization. But architectural interiors
and the man-made objects that fill them are obviously
constructed in different ways. The objects tend to be
sharp-edged and geometric, and the direction of light falling
on the objects may not be clear.

    The work of beginners underlines these problems. Student
artists have a tendency to make every object in an environment
the subject of a separate portrait, instead of constructing the
whole space and forcing the objects to articulate it.

    Van Gogh's reed-pen drawing *Café in Arles* (Fig. 121),
although set outdoors, is composed of furniture in a roomlike

121. VINCENT VAN GOGH (1853–1890; Dutch-French). *Café in Arles.*
Reed pen and ink. Collection Mr. and Mrs. Emery Reves.

space. The sky is merely a backdrop. It is important for our purposes to note that each line describing an object is part of an all-absorbing rhythm, which carries and intensifies the whole space. No one element dominates the scene, nor is anything neglected. The rhythmic lines that weave the space simultaneously describe its components.

Red chalk (which was employed initially as a layout) combines with a sepia wash to give Piranesi's *Architectural Fantasy* (Fig. 122) a golden glow. The light thus produced softens all the edges and unifies the whole composition. When reproduced in black and white this softening effect is seen as a much harsher series of staccato rhythms, and this distorts the artist's intention. The darkest tones are used only in the lower portion of the drawing—the angular stairs at the left and the various figure groups. These darks give a weight to the floor plane and gradually blend into the lighter, airier washes at the top. The viewer is directed to see first the round form in the lower right, because it stands out more sharply against its background. This form sets up the comparative scale in the overall composition by establishing its relationship to the human figures.

122. Giovanni Battista Piranesi (1720–1778; Italian). *Architectural Fantasy*. Pen and ink with wash over red chalk. Ashmolean Museum, Oxford.

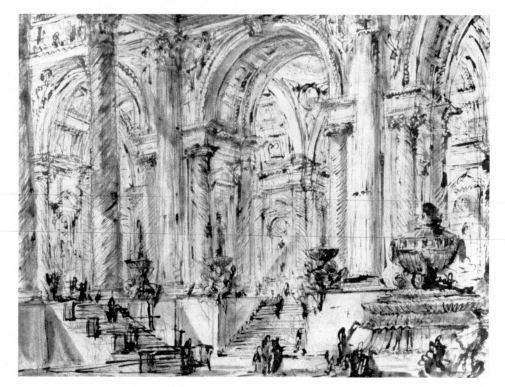

## Student Response

The students began this assignment by drawing their own rooms
after working in class on very complicated, room-filling
still lifes in which the objects were placed haphazardly in
all parts of the studio. They were asked not to limit
themselves to one or two objects in a given spatial position,
but to choose objects from the whole room and to invent
relationships for them. The choice of media and tools is
important, since each student must search for the medium and
the tool to express his individual attitude.

The drawing in Figure 123 resembles a Dutch interior in its
setting and balance. The viewer is a detached spectator,
removed from the light that defines the space and its contents.
The vague figure and objects in the strong light are
deliberately kept at a distance. Objects balanced on either
side of the door are kept in darkness, and they seem to remove
us even farther from the light, for we cannot recognize them
although they are relatively close. Forms are suggested,
never described, so that we cannot easily become involved

123. VAINO KOLA. *Lighted Interior.*
1960. Pen and ink with wash.
Collection Yale University,
New Haven, Conn.

124. WILLIAM CUDAHY. *Ambiguous Space.* 1960. Conté crayon
and white chalk. Collection Yale University, New Haven, Conn.

with particulars. Our interest is in the arrangement of the
light and dark forms in a unified spatial field.

Figure 124 gives quite the opposite effect. We are thrust
directly into a space that is not fully explained, and,
thus, we are forced to complete the environment on our own
and to imagine the source of light. The artist gives
us several clues to the nature of our surroundings.
We know, for example, that we are directly behind a studio
easel, which, although dramatically cut off at the top,
clearly reveals its structure. (The holes at the bottom of
the easel, which permit the artist to move it up and down,
are easily distinguishable.) A low table or stool at left
center is also clear. But the remaining studio furniture—
and the artist, whose elbow appears in the strongest light at
left—is only hinted at. We are, therefore, engulfed
in a dramatically lit space with ambiguous contents. We must

125. STEPHANIE KIEFFER. *Suggested Environment.* 1957. Pen and ink.
Collection Yale University, New Haven, Conn.

construct a whole environment from a few clearly defined forms
and the sketchy details that surround them.

The scale and weight of the largest objects in Figure 125
are given the scantiest description possible. They are
suggested by light pen strokes, yet they create the illusion
of planes in space and have just enough weight to counterbalance
the detailed descriptions of many small objects in the studio.
Because the balance and scale have been carefully thought out,
the details—all on the left side of the page—serve as a
counterpoint to the bare description at the right. These details
satisfy a need in the viewer to understand and identify with
the environment. The two sides of the page counter one another,
yet they are in perfect harmony. By keeping the detailed
descriptions within a constructed area, the artist makes
them articulate space rather than permitting them to become
mere comments on the surface.

In Figure 126 the exaggerated diagonal thrust of the
ceiling plane, supported by heavy parallel lines describing pipes,
forces us into the low-ceilinged room. Most of the objects
in this interior are seen only in profile, and the
pattern of darks between these profiles is concentrated
in the back-center. Here the dark areas act not only to create
"noise" in this silent room, but also to set up movements
and countermovements. Also, and equally important, they define
the plane that is farthest back in space. The naked light
bulb is set apart from the other elements in the room.
It makes us want to lower our heads, again emphasizing the low
ceiling. The light bulb adds a contrapuntal note to the
rest of the composition and, to some extent, a humorous touch.

## MAN-MADE OBJECTS: SHOES AND GLOVES

The drawing of common objects requires more than journalistic
thinking; mere description of a shoe does not probe the layers
of individual perception.

In its simplest identity the shoe is a unique form mirroring
its wearer. But as a subject for artistic exploration its uses
are much broader. Both Van Gogh and Marsden Hartley saw
the shoe as a symbol of poverty and work (Figs. 127–28).

*opposite:* 126. HAROLD FORD.
*Interior: Diagonal Thrust.*
1958. Pen and ink.
Collection Yale University,
New Haven, Conn.

*above:* 127.
VINCENT VAN GOGH
(1853–1890; Dutch-French).
*Boots with Laces.* 1886.
Oil on canvas, $14\frac{7}{8}$ x 18″.
Vincent van Gogh Foundation,
Amsterdam.

*right:* 128. MARSDEN HARTLEY
(1887–1943; American). *Boots.*
1941. Oil on gesso
on composition board,
$28\frac{1}{8}$ x $22\frac{1}{4}$″. Museum of
Modern Art, New York.

129. Eugene Baguskus. *Football Shoe.* 1962. Graphite pencil.
Collection Yale University, New Haven, Conn.

Even when shoes are presented as portraits of their owners,
we must also pay attention to the structure of the shoe itself
which, after all, is designed to fit a foot with individual
toes. In addition, the distinctive shapes and structure of the
shoe may be exaggerated to stress its character or that
of its owner. As is true with any object, these attitudes
do not come from merely looking at the shoe. What we know,
what we think and feel colors our reactions. The artist's
experience is more important than an effort to faithfully
describe an object. The object—in this case the shoe—
should be translated and composed in visual terms, but never
in caricature.

## Student Response

For this problem the students first attempted individual portraits of shoes; later, the shoes were set about in groups on the floor, and works emphasizing the composition of the whole picture space were undertaken. The latter became, as it were, shoe landscapes because of the placement of shoes on the floor below eye level. The space is equivalent to a panoramic vista.

The football shoe in Figure 129 becomes a very aggressive form, filling the whole page. The instrumentation—brusque, almost crude, with many erased lines—heightens the forcefulness and underlines the artist's expression. This meeting of handwriting and scale produces a compelling portrait. Note that the toes of the football player are strongly suggested.

A quite different attitude is evident in Figure 130. The shoe is isolated in the center of a page like a specimen

130. ARNOLD BITTLEMAN. *Slouching Shoe.* 1955. Graphite pencil.
Collection Yale University, New Haven, Conn.

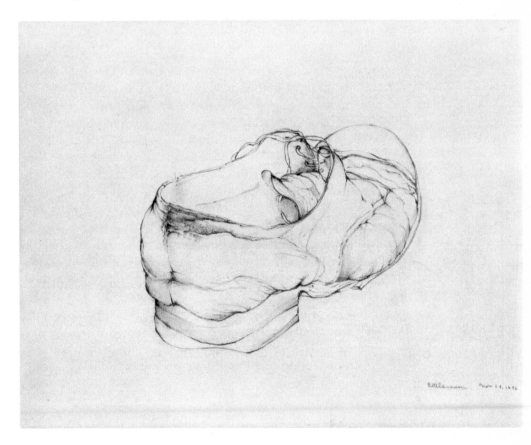

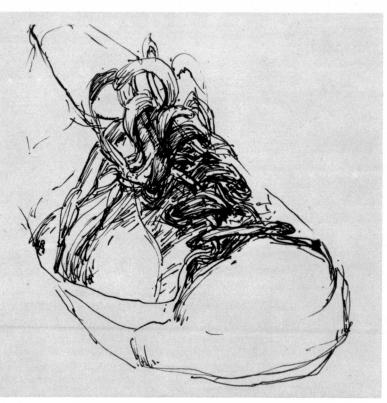

131. Student drawing, *Bulging Sneaker*. Pen and ink.
Collection Yale University, New Haven, Conn.

under a microscope, and layers of construction and destruction
acting on one another are clinically examined. The tongue,
the eyelets, the counter, and the stitching are carefully detailed.
These details are subservient to the slouching posture of the
entire shoe, which absorbs them into its overall quality.

Both Figures 131 and 132 are good examples of the
expressive use of media and the way in which a distinctive
handwriting intensifies a particular attitude.

In Figure 131 the broad, rough scratching with a blunt pen
point focuses on the shoelaces of the sneaker. The pen
strokes thus underline the character of the model. The wide
sneaker bulges toward the viewer and, with the insistent
textured strokes, places the viewer face to face with the actor.
The restricted space adds to its dimension.

Figure 132 is, by contrast, a cool whisper in keeping
with the frail elegance of the model, which is placed at an aloof
distance. The nature of the instrument (pencil) and the
instrumentation (pale, delicate modeling) build a portrait of
individual character.

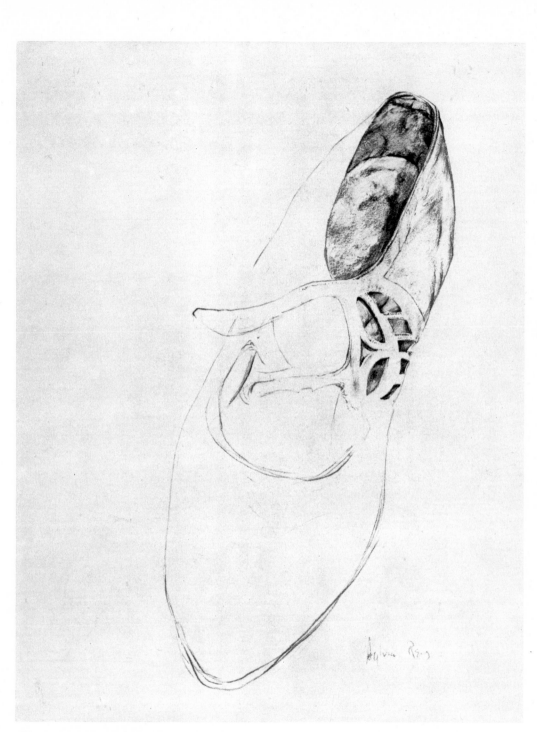

132. SYLVIA REID. *Delicate Shoe.* 1954. Graphite pencil.
Collection Yale University, New Haven, Conn.

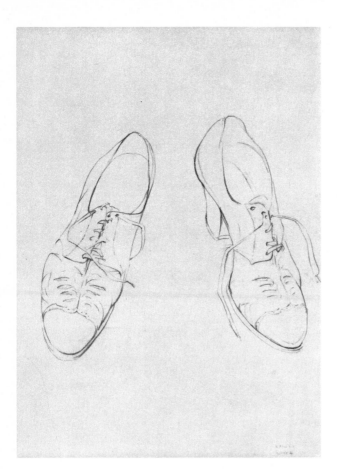

left: 133. WILLIAM LEETE.
*Shoes: Expression of Character.* 1953.
Graphite pencil. Collection Yale
University, New Haven, Conn.

below: 134. JOHN COHEN. *Shoe Quartet.*
1954. Charcoal pencil. Collection
Yale University, New Haven, Conn.

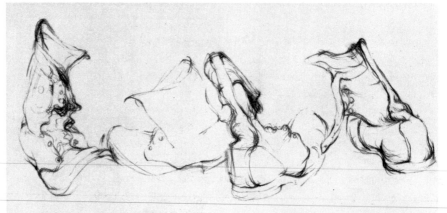

138

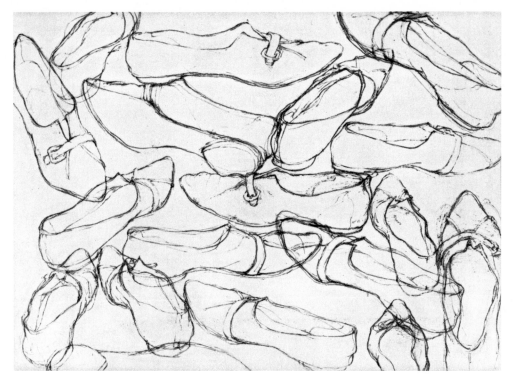

135. Sandra Whipple. *Overlapping Shoe Forms*. 1961. Bamboo pen.
Collection Yale University, New Haven, Conn.

The pair of shoes in Figure 133 creates a distinct portrait.
The shoes have been stretched to exaggerate their
character. Details are not clinical, as in Figure 130. More
important here is the posture of both shoes acting together in
concert to make the image. Each shoe has an individual
expression, but their gesture together is the essence of the
portrait.

A single shoe has been moved and placed in characteristic
poses to form a rhythmic quartet in Figure 134. The peculiar
gestures of the army boot provided the impetus for the study,
but the overriding theme is in the gestures or postures
that act together. It is the total composition that makes the
portrait what it is. There is reciprocal action: the shoes
dance together, and these dancing rhythms reorganize the content
and transform it.

One shoe is the initial subject for Figure 135 as well. The
artist used her own shoe and examined its shape from

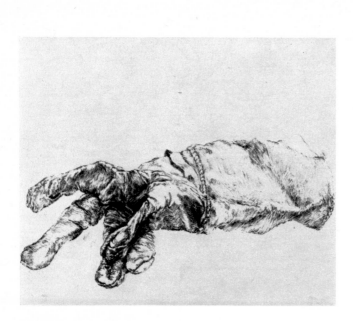

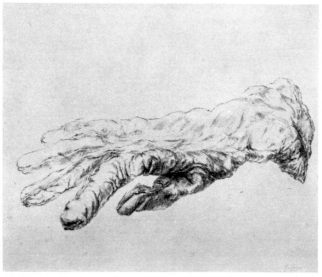

*above:* 136. CHARLES EMERSON. *Menacing Glove Form.* 1962. Pen and ink. Collection Yale University, New Haven, Conn.

*left:* 137. CHARLES EMERSON. *Glove in Repose.* 1962. Pen and ink. Collection Yale University, New Haven, Conn.

every possible angle. However, description is only the beginning. The artist rendered the shoe transparent and placed one shape over another in an allover floating arrangement. After viewing the pattern we may inspect each individual shape, and these well-observed studies are interesting in themselves. But they must give way finally to the total impact of the drawing, the expression of overlapping planes that make up the whole composition.

In two studies of gloves (Figs. 136–37) the instrumentation carries the mood. Textured lines model the leather drapery, and these surface marks become welded to the expressive gesture of the forms. In Figure 136 the emphasis is on the juncture of finger and thumb. The gestures of fingers, which appear to be frozen in the glove, are violent compared to the pose in Figure 137, in which all the fingers are gently at rest. In the latter case the modeling is appropriately delicate to enhance the intended mood.

The four studies in Figure 138 are designed to be read in sequence. The articulation of the joints is the main theme, while the texture of the gloves takes a secondary role. The

138. Walter T. Cummings. *Gloves: Articulation of Joints.* 1961. Pen and ink. Collection Yale University, New Haven, Conn.

fingers move, gesture, and pose in an unrestricted space.
These four compositions act together much as did the forms in
Figures 134 and 135.

The composition of the whole page is again the overriding
consideration in Figures 139 and 140. The shoes are examined
not as individual figures but as compositional elements.
In Figure 139 the forms act together organically: they crowd,
move, and rush through the composition. The broad use of the
charcoal gives weight to the forms and slows down their
movement, while the empty spaces exert pressure on the
blocklike units and help to define the allover space. In
Figure 140 the artist exaggerates the angle of vision. The
viewer is high above the floor, and the quick, linear charcoal
strokes give us an almost impressionistic view of the shoe
landscape.

*opposite:* 139. Student drawing, *Organic Shoe Forms.* Charcoal.
Collection Yale University, New Haven, Conn.

*below:* 140. MICHAEL MAZUR. *Shoe Landscape.* 1960. Charcoal.
Collection Yale University, New Haven, Conn.

The final drawings in this section emphasize line.
Figures 141 and 142 are brush drawings; Figures 143 and 144 are
pen drawings. Each work exhibits an individual handwriting.
It is true that each medium tends toward certain characteristics,
but the individual's natural touch modifies the effect of the
tool and the material.

In Figure 141 a fine line describes each shoe, yet the
group portrait is dominant. In Figure 142 heavier brush
strokes identify clearly only the front row of shoes, yet the
markings of the brush line, from thick to thin, define

144

overlapping shapes that convey the essence of the shoe form without resorting to obvious description.

Two different kinds of pen were used for the drawings in Figures 143 and 144. In Figure 143 the pen glides smoothly over the page without interruption, while in Figure 144 the blunt endings of the strokes produce another kind of light.

145. Unknown German Master. *Christ in the Temple.* c. 1460–80. Pen and ink.
Staatliche Kunstsammlungen, Weimar.

# MAN-MADE OBJECTS: THE PAPER BAG

The subjects presented for study become increasingly complicated. In this problem the varied structure of the forms precludes a single technical approach for, with each new form, the student must search for a new means of instrumentation and, perhaps, a different drawing instrument.

Paper bags are among the most difficult objects to articulate because of their complicated tracery of folds. Simply to transcribe the folds as they appear produces either bland illustration or confusing focal points. The hierarchy of folds, major and minor, must be perceived and articulated clearly in relation to the overall structure of the bag and its function—to contain.

This problem suggests a study of texture and surface, as well as concepts of drapery study. The quality of paper and the way its wrinkles tend to spread and move over the whole surface are important to the structure and must be carefully interpreted in these terms. Abrupt dangling tool marks might express the surface texture of the bag, but they tend to divorce themselves from the architectural configuration of the folds. In short, drawing a paper bag involves perception in the service of concepts; what is known about the objects controls what is seen.

The problems involved in articulating the folds of a paper bag are similar to those encountered in drapery studies. Often the whole character of a drawing will depend upon the way drapery is handled. In *Christ in the Temple* (Fig. 145) by an unknown German master each figure's expression is dependent upon the amount of tension in the arrangement of his garments, the way in which they are draped. In fact, each figure in the composition is essentially represented, except for the heads, in terms of drapery. In the two figures closest to the foreground the angular folds in the cloth join the figures together so that they appear as one form. The two figures at upper left are similarly joined, this time in circular movements. This union of forms heightens the singularity of the Christ figure, but even here the artist is tempted to knit the skirt of Christ to the hood of the figure below. A system of interlocking forms changes the pace and the emphasis, as focus shifts from one form to another and keeps the viewer's eye moving at the artist's direction.

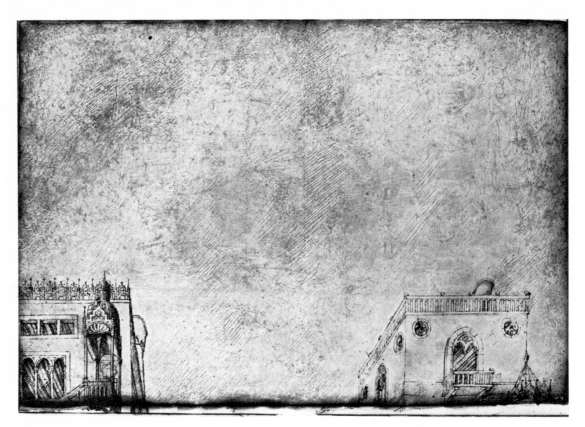

146. Jacopo Bellini (c. 1400–1470; Italian). *Two Buildings.*
Pen and ink. Louvre, Paris.

Another concept that can be generalized from these studies
of paper bags is the construction of landscape space.
The articulation of forms in open space is alluded to when one
views the bag forms on a floor plane. This problem obviously
relates to architectural studies as well.

In Bellini's *Two Buildings* (Figure 146) we are permitted to
view only the top part of the buildings that hug the bottom
of the page. These two forms, however, impregnate the empty
space above them and give us the illusion of air.

### Student Response

As with the shoes, we began by studying individual bags and
then moved to group studies. Memory drawings were attempted
in this exercise as well. In the group studies students were

advised not to limit themselves to an established arrangement.
Instead they were asked to invent their own arrangements,
picking individual forms from different positions and constructing
the total composition according to their needs.

In Figure 147, a charcoal pencil drawing, the bag is posed
in center stage and is rendered in terms of light and dark
values. When viewed from a distance the strokes of charcoal
seem to blend to produce a slick surface, but at close range each thin

147. EDWARD KOZLOWSKI.
*Charcoal Study.* 1954.
Charcoal pencil.
Collection Yale University,
New Haven, Conn.

stroke is evident. This surface treatment, which is difficult
to reproduce, gives a light glow to the original. The soft and hard
edges have an added life. This drawing, which seems
almost mechanical, is deliberately representational. However,
it can be criticized from another viewpoint: it leaves nothing
to the imagination of the viewer. It reminds one of the work
of portrait painters who carefully delineate every eyelash, only
to lose our interest. A more subtle approach is taken by such
masters as Rembrandt, who suggest without clearly describing,
thus demanding participation from the viewer.

The author of the pencil drawing in Figure 148 took
apart a paper bag and flattened it into one sheet to study its
structure. The information he acquired is obvious in this
clearly focused study of the bottom and side of a bag.
He selects this attitude and houses it in the emphasis on sharply
turning planes. This preconceived attitude expresses, too,
his own visual reactions to the form.

Similarly, in Figure 149 one corner of the mouth of the
bag is in sharp focus. The detailed modeling in this area

148. Roy Superior.
*Structure of a Paper Bag.*
1961. Graphite pencil.
Collection Yale University,
New Haven, Conn.

149. SYLVIA REID. *The Opening of a Bag.* 1954. Graphite pencil.
Collection Yale University, New Haven, Conn.

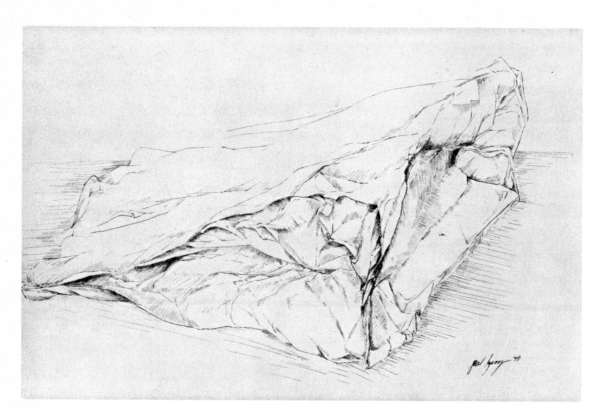

150. JOEL SZASZ. *Flowing Surface*. 1958. Pen and ink.
Collection Yale University, New Haven, Conn.

gradually slips from tone to line. The subject of the drawing,
then, is not the bag itself, but the *opening* of the bag.
The remainder of the form acts solely as a support and is of
secondary interest.

The delicate pen lines in Figure 150 encompass the entire
form of the bag. Here the interest is in the flow of the
surface, yet the underlying structural character of the container
is defined within the free-flowing lines. The corner, which
is held in focus, preserves the identity of the object.

The bag in Figure 151 is transformed into a sharply
punctuated baroque valley of folds. The drama that is suggested
by a particular paper bag becomes the subject of the study.
The shape of the bag itself, lost in the heightened expression,
is of lesser importance.

The first of the group studies is a pencil drawing (Fig. 152)
that achieves an architectural presence and scale. The

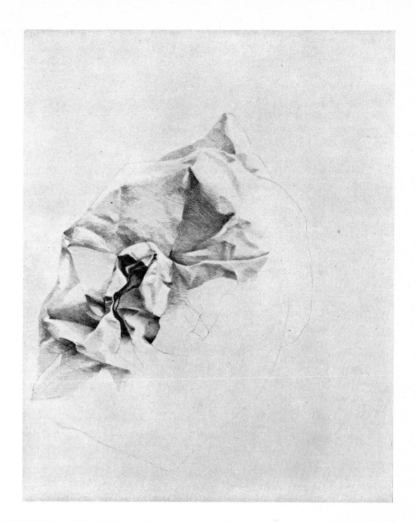

*right:* 151. JOHN E. DEVINE.
*Valley of Folds.* 1966.
Graphite pencil.
Collection Yale University,
New Haven, Conn.

*below:* 152. VAINO KOLA.
*Paper Bags: Architectural Form.*
1960. Graphite pencil.
Collection Yale University,
New Haven, Conn.

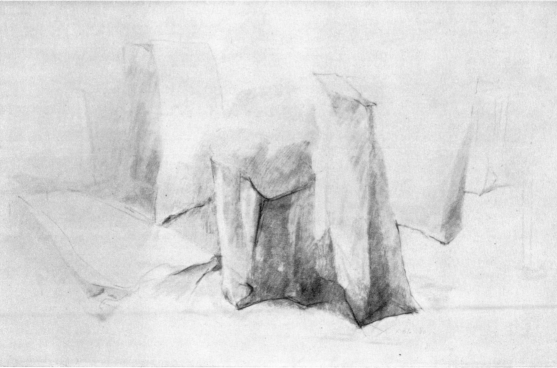

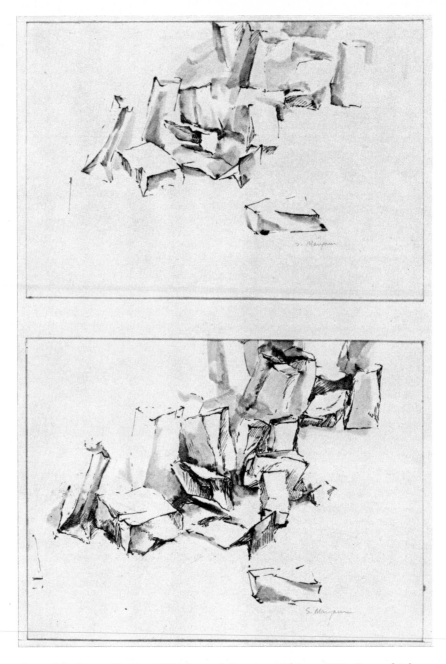

*above:* 153. Susan Mangam. *Weights and Counterweights.* c. 1959. Pen and ink with wash. Collection Yale University, New Haven, Conn.

*opposite:* 154. Donald Lent. *Bags as Mountains.* 1960. Graphite pencil with wash. Collection Yale University, New Haven, Conn.

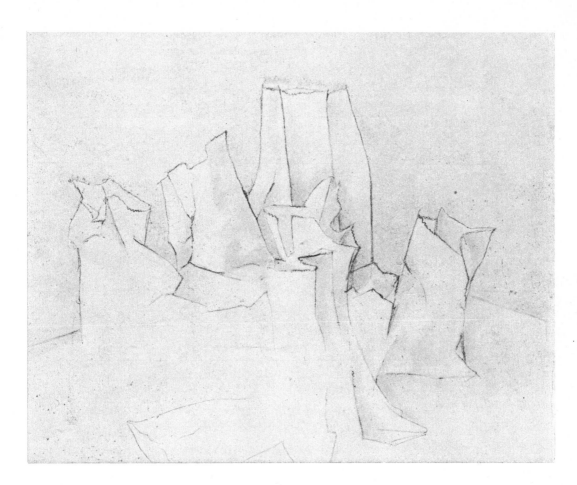

pattern and flow of the gently modeled and simplified block
shapes gives a monumental quality to the paper bag.

The two drawings in Figure 153 use the blocklike shapes of
bags only as the suggestion for a composition. The actual
subject of the drawings is the flow of weights and counterweights,
tipping and moving diagonally up the page. These masses
tumble and finally collapse against the back plane, and
this crowding in the background establishes gravity. A second
look shows the forms moving in reverse toward the viewer. We have
both readings, depending on where we choose to focus.

Figure 154 is a small pencil and wash drawing. The bags
are grouped and placed against a backdrop that suggests sky.
They are posed as mountains, and the whole spatial arrangement
intensifies the idea of a landscape. This small drawing
with its large-scaled forms thus suggests a limitless space.

155. JEANETTE LAM. *Atmospheric Haze.* 1955. Pen and ink.
Collection Yale University, New Haven, Conn.

156. GERALD CINNAMON. *Interacting Bag Forms.* 1957. Pen and ink.
Collection Yale University, New Haven, Conn.

In Figure 155 we see the forms through an atmosphere
created by a pattern of cross-hatched pen strokes. The subject
of the drawing is this textured light. The forms emerging
from the pattern are focused in the center, and the light seems
to melt them as it spreads down the page.

Figures 156 and 157 present the bags in a panoramic
space similar to that of the shoes in Figures 139 and 140.
In Figure 156 the even-weighted pen line meanders through the
compositional space without any particular emphasis. The
line is committed to expressing the interaction of forms in a
group. Individual shapes can be seen standing, leaning on
their neighbors, or lying down, but this focus on singular form

157. W. R. FARRELL. *Bags in Panoramic Space.* c. 1958. Pen and ink.
Collection Yale University, New Haven, Conn.

quickly dissolves into a reading of the whole arrangement
(see also Fig. 141).

Although the spatial arrangement in Figure 157 is similar,
each form is clearly overlapping its neighbor. The ink lines
punctuate the points at which each form touches another. This
emphasis is clear, but it should be noted that the forms
themselves preserve the light weight of the paper bags.

# SKULLS

Having examined man's environment, indoors and out, and having studied man-made and natural forms, we next undertake a study of human and animal structure. It is a good practice to start two projects simultaneously—a study of animal skulls in the studio and experimentation with self-portraits at home. Comparative anatomy is not the goal, but certain basic structural similarities are apparent. The study of skulls is at first approached on a purely diagrammatic, informational basis. What we feel and observe must take account of this structural awareness as the key to interpretation.

## ANIMAL SKULLS

The obliquely structured angle of the eye socket in animal skulls in obvious, but much more subtle, in human skulls. Figure 158 is a diagram of a typical animal skull seen from the

158. Diagram of animal skull, as seen from the top.

159

top. The structure housing the eyes moves back at an angle from the center so that the eye has a greater field of vision. What we know about this structure in animals is not easy to observe in a foreshortened drawing. Our personal reactions to the skull form, in terms of drawing, must presuppose this structural knowledge if we want the drawing to be more than an idle sketch. It is conceivable, of course, that the shapes themselves, as perceived by the eye, might inspire a meaningful composition. But, for the most part, awareness of the volumetric structure is the key to using the shapes organically and with authority.

Skulls obviously suggest a death image. When children draw skulls, they invariably produce Halloween symbols with black eyes and nose and outlined teeth. In a studio class of mature students the skulls are objects of horror for some and beautiful sculptured forms for others, according to the individual's frame of reference. One's own reactions to the forms may crystallize or change completely after studying the basic structure, which is stressed purposely at the expense of other values. Several weeks of merely diagraming the skull may elapse before the student is ready to react to the form or to its symbolic content in a personal way.

In this diagraming stage the studio contains the following skulls: horse, cow, dog, pig, goat, deer, rhinoceros, and hippopotamus. During this period proportional characteristics of individual skulls tend to be neglected. The fascination of fitting together parts volumetrically distracts the student's attention from the individual shape of the form to be studied. The choice of media is stressed only after the diagraming stage is completed. As with any other study, one's attitude dictates this choice.

## Student Response

Some students took a clinical attitude, experimenting with individual connections, overlapping planes, and details. Others developed expressionistic studies, and still others examined simple volumetric relationships. The drawings reproduced do not include the two weeks of diagraming. This stage was considered to be purely informational. The change back to the values of drawing with attention to spatial considerations and instrumentation required some readjustment.

In Figure 159, a brush-and-ink drawing of a goat skull, curving, interlocking brush strokes pick up speed and spin away into the empty spaces, so that the whole composition is in motion. The forms are carried to the edge of the page and attempt to move out of the restricted stage. The quick movements of the brushstrokes suggest the expression of the jaw, but the speed of the instrumentation permits us only a fleeting impression.

Although Figure 160 presents almost the same view of the goat's skull and employs the same medium, the emphasis is

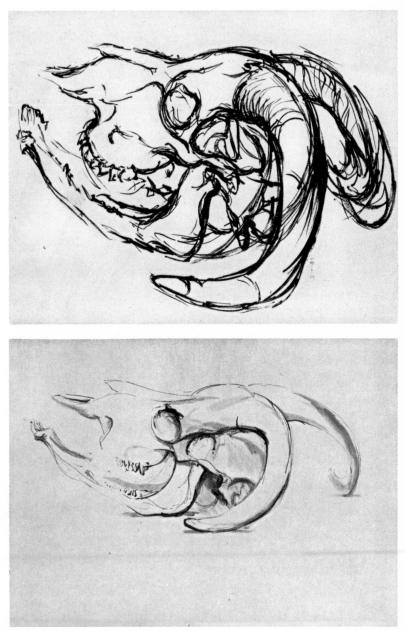

*above:* 159. JACQUELINE ECKLUND. *Goat Skull.* 1954. Brush and ink. Collection Yale University, New Haven, Conn.

*right:* 160. JOHN COHEN. *Pressure Points of a Skull.* 1954. Wash. Collection Yale University, New Haven, Conn.

quite different. The form rests in a more comfortable open space, and the edges of the page are at a safe distance. The laughing expression of the jaw is underplayed. Here the emphasis is on intersecting pressure points, especially below

161. MICHAEL ECONOMOS. *Menacing Skull.* 1959. Wash
with black-and-white chalk. Collection Yale University, New Haven, Conn.

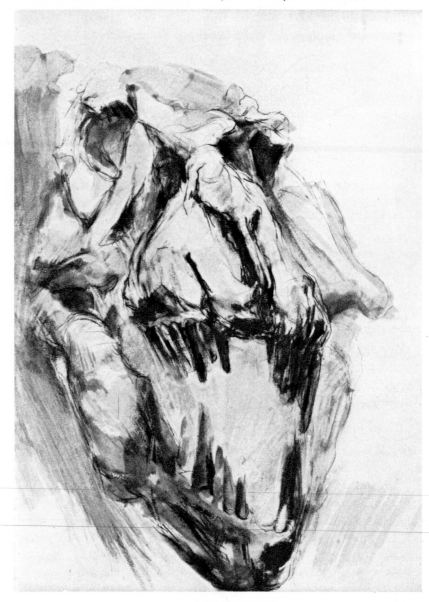

162. HERMAN SNOOK. *Deer Skull*. 1955. Brush and ink. Collection Yale University, New Haven, Conn.

the eye. We can work our way back through these intersecting forms that stress changing weights and pressures.

The protruding open mouth of the skull in Figure 161 is projected at an angle toward the viewer. The emphasis is on menacing teeth. We do not have a sense of gravity, but rather the whole form seems to be suspended in air. The expression of the stretching jaws is alive and threatening.

The next two illustrations are clinical studies. Figure 162 is a series of fine-line drawings of the eye structure

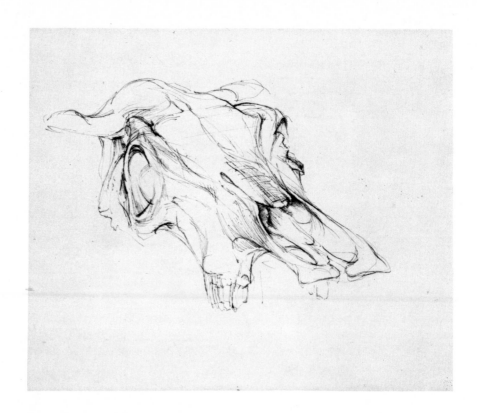

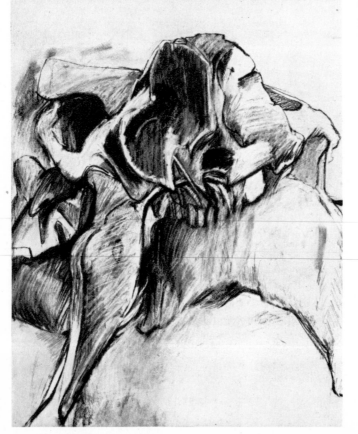

*above:* 163. STEPHEN ROSENTHAL.
*Eye Structure of the Skull.* 1957.
Pen and ink. Collection Yale
University, New Haven, Conn.

*left:* 164. FRED MARCELLINO.
*Hippopotamus Skull.* 1962.
Pencil and black and white chalk.
Collection Yale University,
New Haven, Conn.

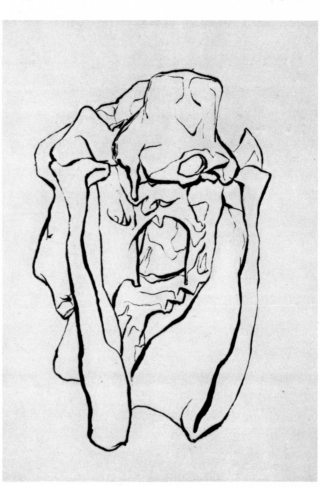

165. SYBIL WILSON. *Skull of a Horse.*
1958. Brush and ink. Collection
Yale University, New Haven, Conn.

of a deer skull. The eye socket is seen both as part of the skull
and as an individual form, and its projected position as a
container is emphasized. The beauty of this form is isolated
from the context of the whole skull.

The eye structure is featured also in Figure 163. The
curving bones surrounding the eye stretch the socket into an
exaggerated spatial position, thus providing a unique emphasis.

The back view of a hippopotamus skull is the subject
of the chalk drawing in Figure 164. The initial emphasis is on
the massive weight of the whole form. Overlapping shapes
are seen as elegantly fitted sculptural units. By contrast, the rear
view of a horse's skull (Fig. 165) is focused not on the
hulking weight or gravity of the form, but on an undulating

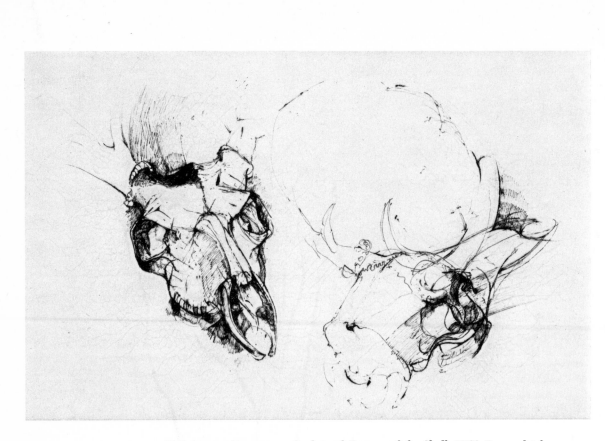

166. ARNOLD BITTLEMAN. *Sculptural Essence of the Skull.* 1955. Pen and ink.
Collection Yale University, New Haven, Conn.

linear movement created by the continuous brush strokes
that depict interlocking parts. The line itself is emphasized as it
moves through space and flattens the whole form.

In Figure 166 the skull (at left) is reduced to its sculptural
essence. The forms of the lower jaw and the forehead are
not mere descriptions but are transformed into simplified masses.
The stress points where one form joins another are in
focus and, particularly where the nose meets the eye, are tightly
forced. This attitude gives a tautness to the whole form.

## THE HUMAN SKULL

During the period of animal skull study, as was mentioned, the
class began self-portraits on their own time. The project
was started prior to the introduction of human skulls into the

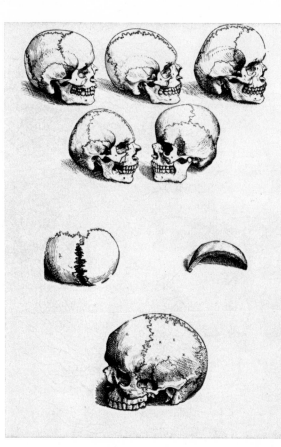

167. ANDREAS VESALIUS (1514–1564; Belgian). *Skulls*. Woodcut.

studio. This was done in order to test before-and-after concepts and to prove that what is known determines what is seen. The first portraits, made before study of the human skull, invariably stressed the individual features—mouth, nose, eyes, and ears—at the expense of the skull underneath. The students did not at first realize that the skull's structure is essential to the portrait's likeness.

In the early portraits the relationship of upper skull to lower mask is usually distorted, and the fullness of the back of the skull is often reduced, thus giving an apelike appearance to the drawings. With the introduction of the skull in class, together with the study of live models, the relationships become clearer. In a woodcut by Andreas Vesalius (Fig. 167) the skull at upper left represents the "natural" head; the others are variations on the model. Dürer also presents variations on the shape of the head in a brutal

168. ALBRECHT DÜRER (1471–1528; German). *Four Heads.* 1513/15. Pen and ink, 8¼ x 7⅞". Nelson Gallery-Atkins Museum, Kansas City, Mo. (Nelson Fund).

caricature (Fig. 168). He concentrates on the mask—that is, the features and their exaggerated relationships.

The structure of the skull is celebrated in Giacometti's *Self-portrait* (Fig. 169), and this structure forms the basis of the expression. In this work the features are only suggested. The skull is arched, and the plane from the back of the jaw to the chin is thrust into space diagonally. The

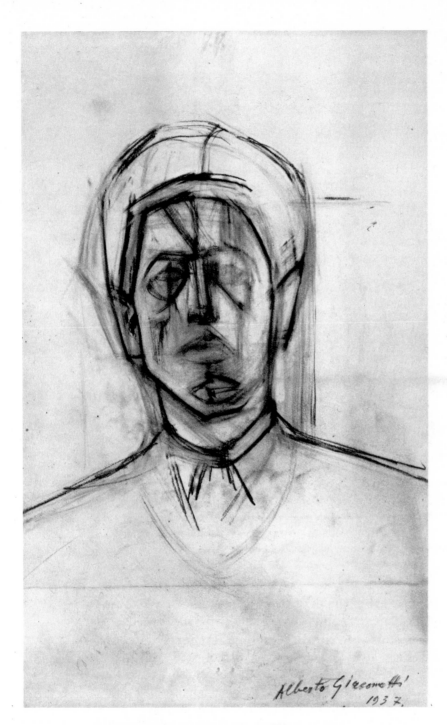

169. ALBERTO GIACOMETTI (1901–1966; Swiss). *Self-portrait*. 1937.
Graphite pencil, 19¼ x 12¼″. Courtesy Pierre Matisse Gallery, New York.

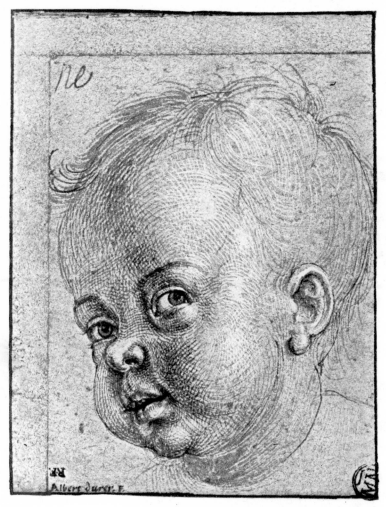

170. ALBRECHT DÜRER (1471–1528; German). *Head of a Child*. Pen and ink heightened with white ink. Louvre, Paris.

lower portion of the drawing is empty, and this void creates a frontal plane that pushes the whole structure back into space.

Features are clearly delineated in Dürer's three heads of a child (Figs. 170–72), yet the structure of each skull is obvious. In Figure 170 the eye sockets are isolated as though a spotlight were focused upon them. In Figures 171 and 172 the eye sockets are also clear; Figure 172 has white, radiating lines to indicate each corner plane and its connection with its neighboring planes.

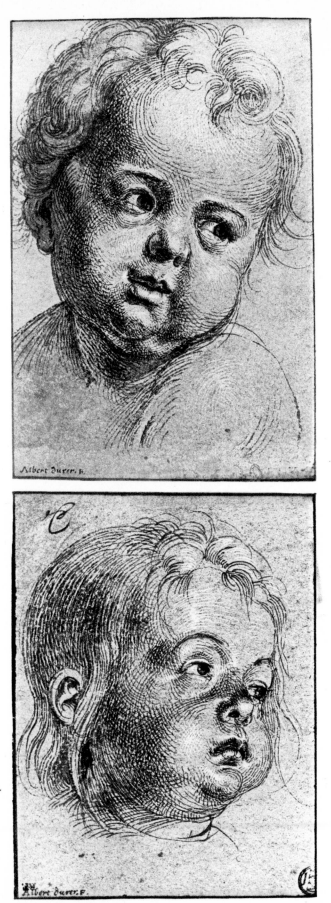

171. ALBRECHT DÜRER (1471–1528; German). *Head of a Child*. Pen and ink heightened with white ink. Louvre, Paris.

172. ALBRECHT DÜRER (1471–1528; German). *Head of a Child*. Pen and ink heightened with white ink. Louvre, Paris.

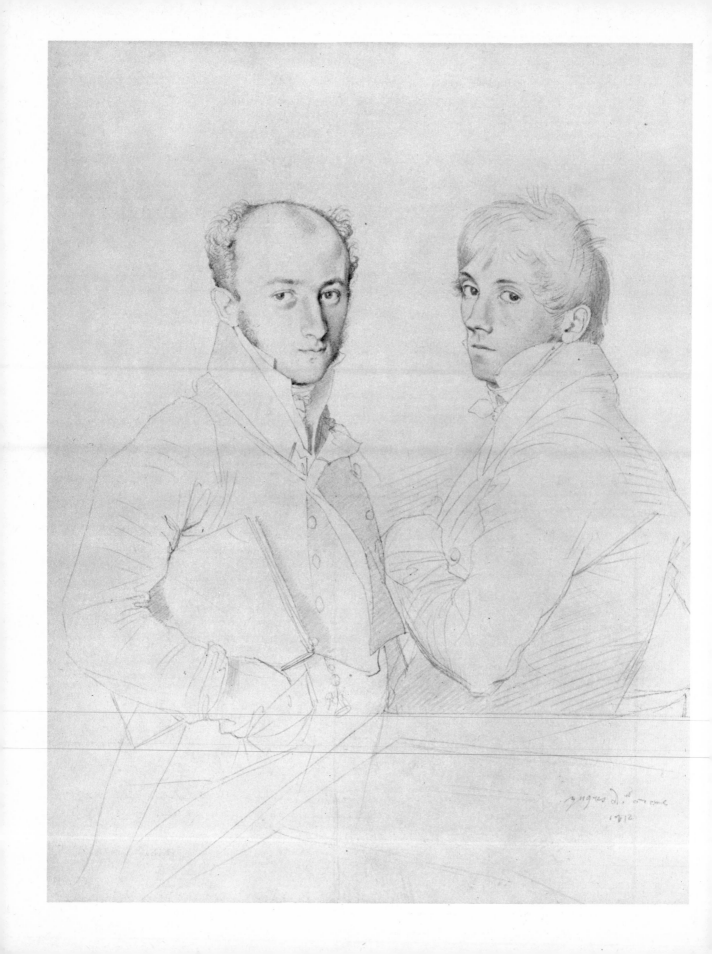

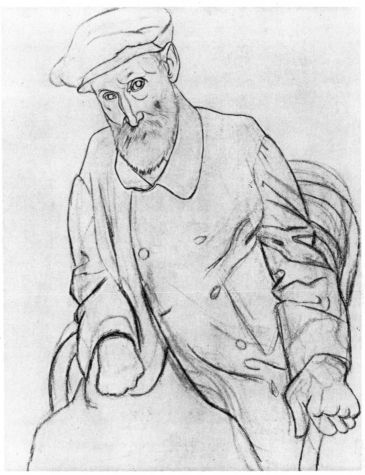

opposite: 173.
JEAN-AUGUSTE-DOMINIQUE INGRES
(1780–1867; French).
*Portrait of Leclèrc and Provost.*
1812. Graphite pencil, 12³⁄₈ x 9⁵⁄₈″.
Smith College Museum of Art,
Northampton, Mass.

right: 174. PABLO PICASSO.
(1881–   ; Spanish-French).
*Portrait of Renoir*
(after a photograph). 1919.
Graphite pencil and charcoal,
23³⁄₄ x 20¹⁄₈″. Collection the artist.

Underlying structures are subtly hidden in Ingres' *Portrait
of Leclèrc and Provost* (Fig. 173). Nevertheless, the
simplified head mass becomes a uniquely characteristic shape.
The position of the eyes is exaggerated so that they seem
to move around the head. The contours of the cheekbones
and the arch of the eyes on the figure at left subtly move
into space. Both figures recede into the page because of
the placement of the table in the foreground. Ingres directs
the viewer's eye with light and dark masses: we see first
the dark head and then its echo. The soft contour of the coat
at far right underplays the impact of its strange shape.

Picasso's *Portrait of Renoir* (Fig. 174) follows the
example set by Ingres. The head is emphasized, but the rest

of the figure, although soft-edged, is not merely roughed in. The symbol for the arthritic hand at the right is clearly invented. The head—with eyes of two different sizes and shapes which are the focus of the drawing—is constructed in artificial spatial perspective. A strong line representing the eyebrow (at left) moves down to the base of the nose. This line flattens the sculptured effect by calling attention to itself, but, more important, it echoes the leaning stance of the whole figure.

### Student Response

While Vesalius' skulls (Fig. 167) illustrate the basic shapes of human skulls, our study in class emphasized the volumetric projection of masses. The students drew skulls and immediately

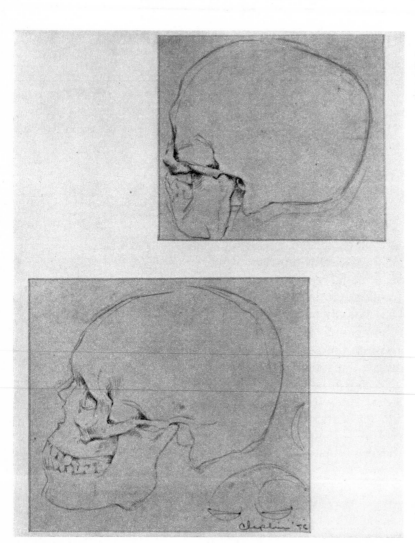

175. GEORGE CHAPLIN. *Study of Skulls.* 1957. Conté crayon. Collection Yale University, New Haven, Conn.

invented features to fit into and over them. Reversing this procedure, they drew from the model and projected the skull underneath.

The two drawings in Figure 175 illustrate this study. The cheekbone and eye structures jut out from the form. The skull is seen not only as an inanimate object with a particular shape, but also as a three-dimensional structure with projecting planes.

Figure 176 is a page of studies in ink made directly from a model. A kind of X-ray vision is the frequent product of this type of study. In the large head the artist attempts to locate particular features in the skull simultaneously, so that we do not feel a sense of overlapping. In other studies on the page the skull and individual parts are examined separately.

176. MICHAEL MAZUR.
*Parts of the Skull.* 1960.
Graphite pencil.
Collection Yale University,
New Haven, Conn.

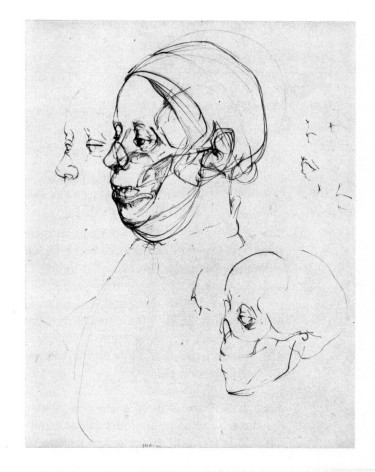

177. ERNEST BOYER. *Self-portrait.* 1956. Graphite pencil.
Collection Yale University, New Haven, Conn.

In Figure 177, a self-portrait in pencil, the modeling is
quite soft-edged. This softness heightens the intensity of
individual features. The eyes and mouth curve rhythmically
over the underplayed structure beneath.

Figure 178 is also a self-portrait, and in this case the shape
of the head is gently attenuated. From the lips down the
form cuts back into an extremely foreshortened jawline.
The collar of the shirt pulls forward to enhance the effect of
the foreshortened chin.

A third self-portrait (Fig. 179) emphasizes the surface
movement of the skin. We sense muscles rippling underneath
the tightly stretched contours of the mouth. This pulling of
the skin is a counterpoint to the boniness of the nose.

178. JOHN FRAZER. *Self-portrait.*
1959. Pen and ink. Collection
Yale University, New Haven, Conn.

179. STEPHEN BARBASH.
*Self-portrait.* 1960.
Graphite pencil. Collection
Yale University, New Haven, Conn.

177

180. PAUL COVINGTON. *Self-portrait*. 1961. Wash and chalk.
Collection Yale University, New Haven, Conn.

181. ROBERT BIRMELIN. *Self-portrait.* 1955. Graphite pencil.
Collection Yale University, New Haven, Conn.

Figure 180 focuses on the planar structure of the head
in directed light. The light is sharp as it hits the major
planes at the right, but it is clearly stated as well in the soft
darkness of the nearest plane. We sense space in front of
the form, freely moving around the head and finally
anchored in the soft, dark stripe at the extreme right of the
composition.

In a final self-portrait (Fig. 181) the undulating line
playfully carries space around the form and seems to hide the
carefully observed details. This line derives from both
description and invention.

182. Peter Milton. *Study from a Model.* 1960. Graphite pencil.
Collection Yale University, New Haven, Conn.

Figure 182 was drawn from a model in class. The angle of
the glasses is thrust against the protruding lower jaw and
countered by a flowing ear form. The pencil strokes that define
these opposing masses are used in a liquid manner that is
beautiful in itself.

The students worked from a clothed model for several weeks
and attempted a number of experiments. They tried to draw
the whole figure in a room without putting features on the head
in order to stress the feeling of a particular space, rather
than the structure of a form. This permits a concentration
on the unique shapes of the whole figure in a given room.
In a similar experiment the students drew only the space of the
room around the figure. These exercises are designed to
develop an awareness of spatial composition in conjunction with
individual structures.

# ANIMALS

In this exercise mounted animal skeletons were used to further
the examination of bone structure as a prelude to figure study.
The class worked for several hours in a museum of natural history,
and this automatically restricted the size of the drawings
and the choice of media. However, it also made possible a
spontaneity of drawing performance.

     The project emphasized locomotion and articulation, the
character of individual species, and economy of means.
Locomotion and articulation were stressed to give the feeling that
the parts of the total structure fit together and form
an interdependent mechanism that can move in a certain manner.
Character was defined as the peculiar proportions and posture
of the whole animal. It was pointed out that the goal of economy
is *essence*, rather than simplicity of presentation.

     Economy is evident in Rembrandt's quill-pen drawing, *Camels*
(Fig. 183), where the structure of the head, which is
almost a caricature, is reduced to its essence. The underlying

planes of the skull, projected in two views, are masked by the artist's search for particular facial expressions. This is accomplished in a direct, rather offhand and whimsical manner.

Articulation is illustrated in Pisanello's *Mule* (Fig. 184), where the tight, short strokes of the pen serve two purposes. They are used to show textured hair on the animal's hide— the way it moves and grows on the surface; and, more important, in describing the rippling coat they reveal the animal's bone and muscle structure. The skin is pulled so tight that it becomes transparent. We are made to see the inner structure and the outer covering simultaneously.

A sense of locomotion is brilliantly portrayed in a notebook sketch by Toulouse-Lautrec (Fig. 185). The individual

shapes of each part of the horse—head, neck, torso, and widespread legs—are interlocked to give us an instantaneous transcription of a unique posture.

The character of Cranach's *Wild Boar* (Fig. 186) is expressed in the menacing silhouette of a dark shape against a white background, coupled with the triumphant pose and open jaws. This creature may be seen as an invention of horror or of humor (or a combination of the two), depending on one's interpretation. The dashing white lines of the fur suggest speed, but the dominant shape of the animal suspends this action.

The Persian drawing in Figure 187 seems, at first glance, to be similar to Pisanello's rendering of a mule's skin (Fig. 184), but in the latter the surface suggests foreshortening, gravity, bone, and muscle. The Persian drawing, on the other hand, presents the skin as a beautifully designed arabesque of drapery. This does not imply praise or criticism of either drawing. It merely points out that each culture sets up its own values and its own frame of reference.

Rembrandt's *Elephant* (Fig. 188), with its comical, awkward hulk, might be mistaken for a portrait of a man in

186. LUCAS CRANACH THE ELDER (1472–1553; German). *Wild Boar Facing Left*. Pen and ink with watercolor, 6¾ x 10″. Kupferstichkabinett, Dresden.

184

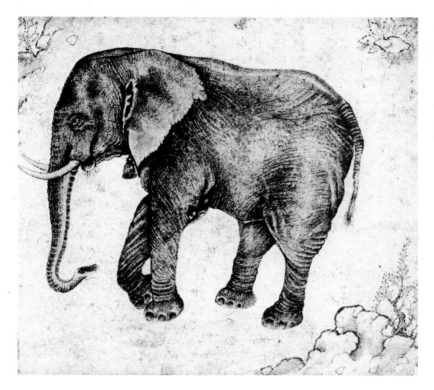

*left:* 187. *Elephant.*
Persian drawing.
Late 15th–early 16th century.
Museum of Fine Arts, Boston.

*below:* 188. REMBRANDT VAN RIJN
(1606–1699; Dutch).
*Elephant.* Black chalk.
British Museum, London.

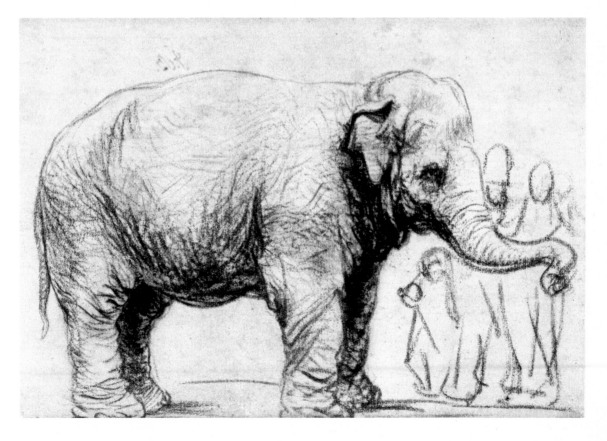

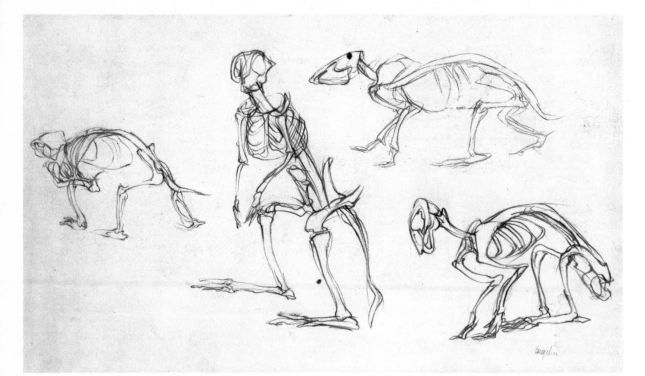

189. Patricia Coughlin. *Study of Animals.* 1960. Graphite pencil.
Collection Yale University, New Haven, Conn.

an elephant suit. The tensions and articulation of the skin
are generalized to preserve the characterization, which is the
point of the drawing. This attitude toward the elephant
is in keeping with Rembrandt's total vision as an artist. Each
work of art is produced by a form attitude, which in turn is
produced by a larger artistic culture.

### Student Response

Although articulation, locomotion, character, and economy of
means are the broadly defined goals, it is the individual
student's responsibility to pinpoint his own interest, for the
ultimate end, as we have constantly reiterated, is the
development of a personal attitude.

In the pencil drawing in Figure 189 the organization of
the whole page is considered, as is each animal's characteristic
posture and articulation. The animals move as a group, and

190. WILLIAM REIMANN. *Elephants*. 1957. Conté crayon.
Collection Yale University, New Haven, Conn.

our focus is directed from one to the other, yet as we pause to
examine each one, we sense its individual locomotive mechanism.

The conté drawing in Figure 190 was done at a zoo, and
it owes an obvious debt to Rembrandt's elephant studies.
A student's response to the work of the masters is at least
as important as working from nature, for masterworks permit us
to see nature in a new way. In the large figure at left the
weight, gravity, and stance of the elephant is expressed in the
tension between the accented half circle, representing the
body, and the contoured volume of the front leg. This junction
is the focus of the work.

191. ELIZABETH MATZ. *Skeleton of an Animal.* 1959. Conté crayon.
Collection Yale University, New Haven, Conn.

An angle of vision that places all four extremities in a
tilted projection gives added life to the drawing in Figure 191.
Without this volumetric exaggeration the detailed information
and the carefully articulated joints are merely descriptive.

The hippopotamus in Figure 192 stands, in a fixed, dumb
trance, directly in the center of the drawing. The animal
is quickly sketched with an X-ray vision, but, nevertheless,
the shapes of the head, body, and feet are clearly presented
and readable.

In Figure 193 the skeleton of a dinosaur inspired an
interest in the rhythmic intervals of the spinal column. The line,
which in turn darkens and disappears with the alternating

*left:* 192. STEPHANIE KIEFFER.
*Hippopotamus.* 1957.
Pen and ink.
Collection Yale University,
New Haven, Conn.

*below:* 193. SUSAN DRAPER.
*Skeleton of a Dinosaur.*
1956. Felt-tipped pen.
Collection Yale University,
New Haven, Conn.

pressures of the pen, carries us along as it moves between bone
shapes and interspace. This instrumentation, with its
undulating movement, directs us on our visual journey and
becomes, in a sense, more important than the subject.

To create the image in Figure 194 one lobster was moved
around constantly on a table, then drawn and redrawn on the
same page to produce a community of overlapping and crawling
forms. This group action thus becomes the main interest of
the drawing. Yet again the configuration of the individual joints,
which must be examined closely to be seen, is clearly
articulated. This awareness of structure is important not only

196. ELTON ROBINSON. *Rhinoceros Head.*
1956. Charcoal pencil. Collection
Yale University, New Haven, Conn.

for its own sake but because it aids in freeing the artist to make
his own interpretation.

Figure 195 consists of three studies of one shellfish, drawn
on separate pages and matted together. Each study
focuses on a separate aspect of the form, unlike a scientific
illustration which would concentrate on a clear and equal
description of all parts from one point of view. Here the forms
are composed and stressed by choice, and they therefore
take on a visual life.

The portrait head of a rhinoceros takes up most of the
space in Figure 196. The forms of the lower jaw, with its
protuberant nostrils and teeth, are darkened and pulled forward
in an exaggerated perspective. The instrumentation distorts
and stretches these threatening forms in an elastic tension. In
this respect it is similar to that in some of the studies of
roots in Chapter 6. These tensely drawn forms italicize the
author's attitude; they are not simply a technical device.

# 10

# INTRODUCTION TO THE FIGURE

Although many of the celebrated painters and sculptors of the recent past and the present deal with the figure, it is no longer the focal subject of art. The academies of the past, reflecting the official artistic cultures of their time, considered the figure to be the center of interest. Each academy represented a different ideal and featured its own style of presentation.

With the proliferation of art reproductions—one of the results of the technological revolution—we have access to many cultural heritages, and we can study and make use of their special form vocabularies. We have learned, in short, to regard nature, including man, in a new light. Furthermore, we have learned to see our own Western tradition in terms of fresh concepts.

Western figure drawing centers on gravity—volumes and weights adjusting themselves to a solid floor plane seen in perspective. Within this framework, individual masters have re-created the human figure in a variety of ways, each according to his own vision (see Pls. 9–10, pp. 193–194). It is through study of these interpretations that we

Plate 9. Antonio Pisano Pisanello (1397–1455; Italian). *Four Female Nudes.* c. 1423–27.
Brown ink on parchment, 8⅝ x 6½″. Museum Boymans–van Beuningen, Rotterdam. A group of
notebook sketches has been composed into a beautifully balanced composition. The two studies
at lower left repeat the investigation seen in Figure 184, this time in terms of the human body.
As in the drawing of the mule, the skin has been rendered transparent, so that the artist
may test his knowledge of what it conceals. The figure at far right displays a different attitude:
it concentrates on the rounded, sculptural masses of the form.

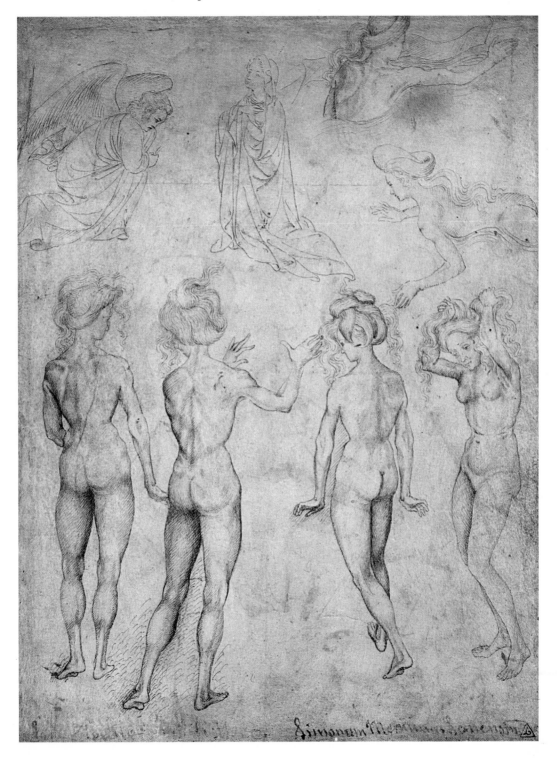

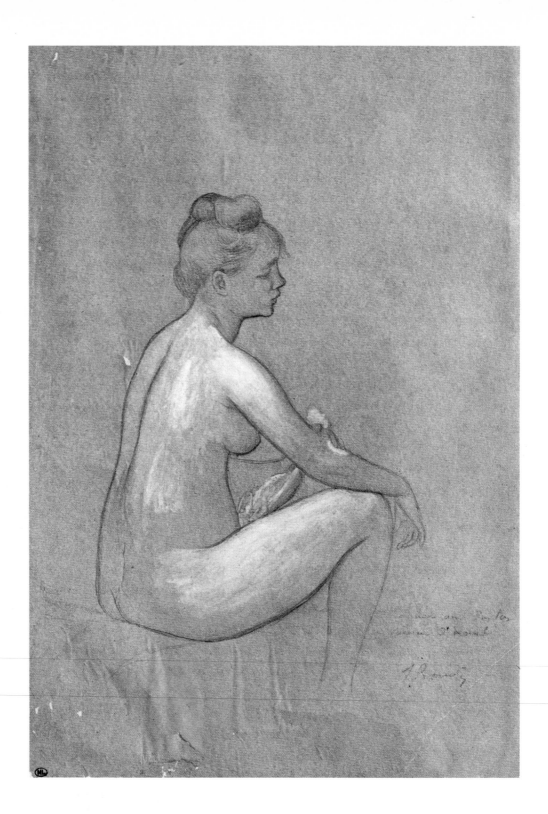

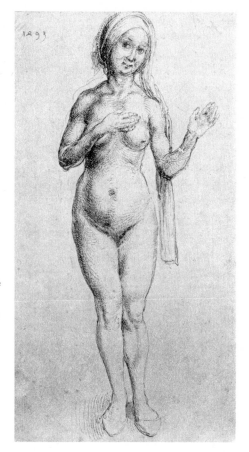

begin to formulate our own preferences and attitudes in seeing and,
ultimately, in drawing.

Dürer's *Nude Woman* (Fig. 197) presents the figure from
a rather unusual point of view: the navel is set at eye
level. All the forms below the navel are seen in a foreshortened
downward perspective, and these foreshortened volumes
are reduced to their simplest forms. The stomach protrudes like a
sphere, while the cylindrical forms of the legs move down
and back from the frontal plane of the page. The musculature of the
legs is reduced to a minimum in order to further accent
the downward thrust. Sharp, contoured edges define the junctures of
thigh and knee, and the entire weight of the figure is thrown on
these tension-filled joints. All the forms above the navel
are seen from a low vantage point. The head in particular looks
down at us, reinforcing the logic of the fixed eye level. Volumes

are strongly modeled at the point where one form intersects another, and the line continually changes from contour to modeling and back again.

The foreshortening is severe in Degas' *Dancer* (Fig. 198), for the artist pushes the head far behind the fan. This becomes obvious when one covers the fan. The dancer's head is then seen as sharply back from the right arm. Below the fan the arms establish the middle space of the page. The feet, which are the most clearly

198. Edgar Degas (1834–1917; French). *Dancer*. Chalk. Museum Boymans–van Beuningen, Rotterdam.

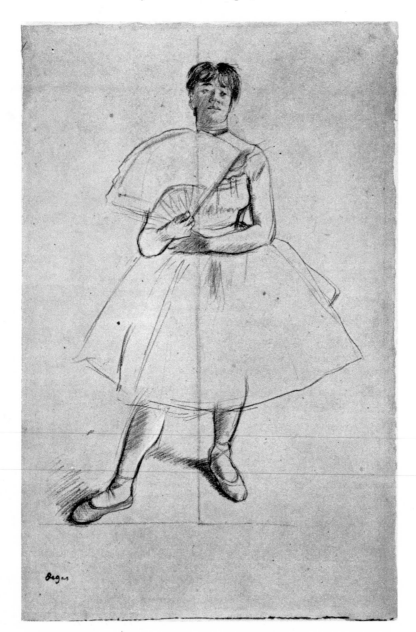

outlined forms, define the frontal plane, while at the same
time they set up a strong gravitational pull. The sense
of foreshortening is intensified by a reverse reading—from feet to
arms to head—which further illustrates how far back in space
the head is placed.

Dufy's pen drawing, *Back View of a Nude* (Fig. 199), is a
virtuoso performance in the use of line, which is employed here to
contain dramatic shifts of weight. The posture of the figure is more

199. RAOUL DUFY (1877–1953; French). *Back View of a Nude.* Pen and ink.
Courtesy Galerie Louis Carré, Paris.

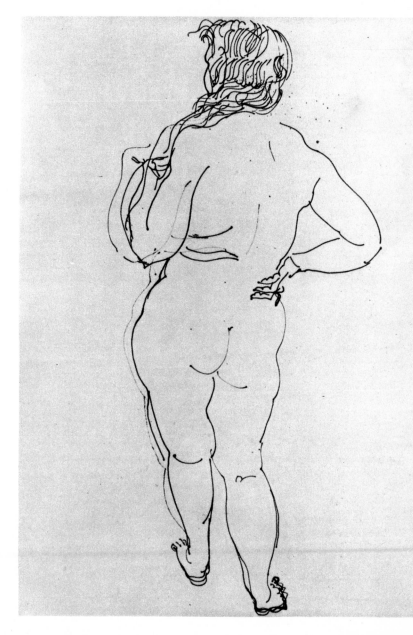

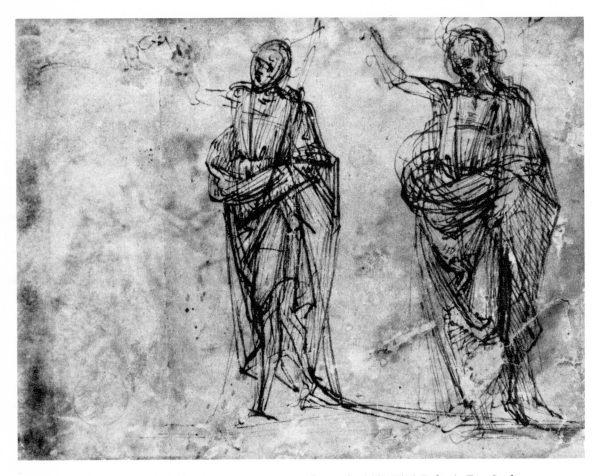

200. Fra Bartolommeo della Porta (c. 1474–1517; Italian). *Two Studies of John the Baptist.* Pen and ink. Kunsthalle, Hamburg.

exaggerated than in Dürer's nude. Dufy convinces us that line can express weight without modeling, or, more precisely, that line may be another method of modeling. He makes rapid corrections in contour in this swiftly executed but convincing study.

Fra Bartolommeo's *Two Studies of John the Baptist* (Fig. 200) is, like the previous illustration, basically a line drawing. In this work, however, the line is not continuous but dissolves in mid-air to become a faint thread or a point in the suggested interaction of figure and space. The lines representing drapery encircle the forms and, at the same time, imply space around the figures. Especially noteworthy are the postures of the two figures. In the

study at the right the swing from hip to floor suggests weight, even as the line all but disappears.

In Ingres' *Seated Female Nude* (Fig. 201) the volume of the model's back is suggested by a soft, contoured pencil line. The back, full and gently arching, is countered by the thrust of the protuberant stomach. Subtle shading emphasizes the curve of the abdomen, thus providing a shift of weight from the line of the back. Other dark areas separate the arms from the torso; the shading against the back arm defines the contour, hidden by the arms, that joins the line of the abdomen. The pressure caused by the weight of the whole figure is centered in the buttocks, which rest on a surface that is implied but not actually visible, and a delicate line across the legs further describes this unseen resting place.

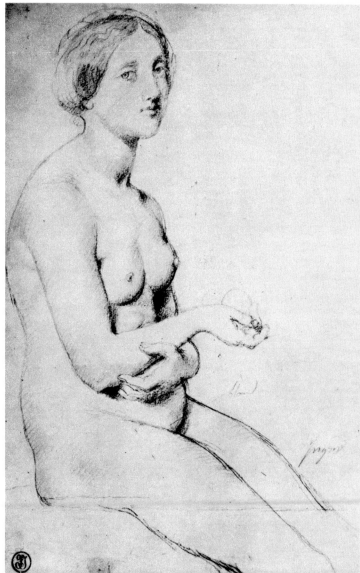

201. JEAN-AUGUSTE-DOMINIQUE INGRES (1780–1867; French). *Seated Female Nude.* c. 1841–67. Graphite pencil, $12\frac{7}{16}$ x 8″. Baltimore Museum of Art (Cone Collection).

In Baccio Bandinelli's *Two Male Nudes* (Fig. 202) we are concerned, as in all the drawings here, with the exaggerated posture of the figure. This drawing, however, does not stress simplified sculptural volume. Instead, the emphasis is on a surface arabesque of muscles as they intertwine and overlap. These surface rhythms, balanced and counterbalanced, take on a life of their own beyond muscular description (see Pl. 11, p. 211).

Surface treatment is of particular importance in Degas' *Study for a Nude* (Fig. 203). Although the musculature is softly visible, the primary interest is the supple, sensuous skin as it stretches over the inner framework of the body.

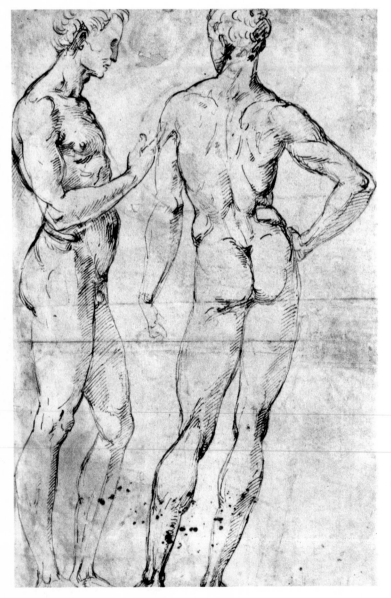

*left:* 202. BACCIO BANDINELLI
(1493–1560; Italian).
*Two Male Nudes.* c. 1560.
Pen and ink. Albertina, Vienna.

*opposite:* 203. EDGAR DEGAS
(1834–1917; French).
*Study for a Nude.* Pencil.
Louvre, Paris.

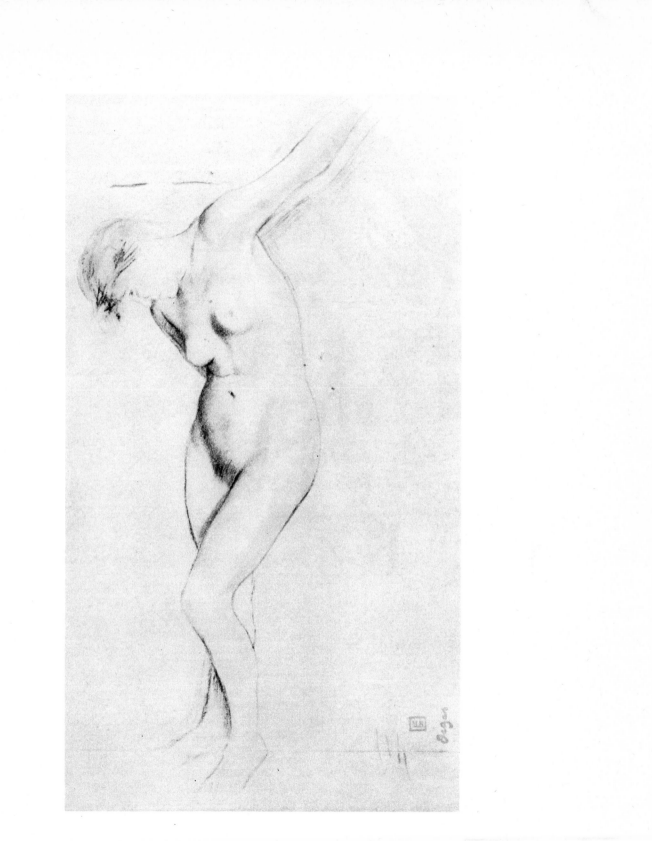

204. IVAN LE LORRAINE ALBRIGHT (1897–   ; American). *Three Love Birds*. 1931.
Charcoal on canvas, 7′ x 3′8″. Collection the artist.

A distinct contrast is seen in the attitude toward body surface
in the following two examples. In Ivan Albright's *Three Love Birds*
(Fig. 204) the subject, decidedly, is flesh. As in the previous
illustration, the skeletal frame is barely suggested, but the "supple,
sensuous skin" of Degas' nude has vanished. Instead, Albright
wraps his figure in three-dimensional knots of rippling,
ropelike forms, accented with ornamental flesh patterns. This

205. Georges Rouault (1871–1958; French). *Filles.* c. 1906.
Watercolor. Courtesy Galerie Bernheim-Jeune, Paris.

treatment is invented to underline the artist's portrayal of flesh
as a symbol of decay.

In Georges Rouault's *Filles* (Fig. 205) flesh takes the form of
simplified sculptural masses that shift dramatically as the
eye moves from hip to torso to breast to shoulder. The dominant
impression in this drawing is, of course, the strong message implicit
in the subject, and this message is dramatized by the artist's

structuring of the forms and of the whole composition. The figures dominate the space, they are compressed and stand in a frontal plane with light savagely raked across them. All of these devices intensify the form and give visual life to the message.

Villon's nude (Fig. 206) reminds one of a sculptor's armature with bundles of wire mapping out the tensions between masses. Each mass seems to stretch independently, yet all move in opposing shifts of weight.

The total environment is the subject of Giacometti's *Nude in a Room* (Fig. 207). The space of the room is investigated both around and through the figure. We are led into the room by lines along the bottom, and these lines turn sharply to make a ruglike floor plane below the feet, which acts as a pedestal for the figure. The room is dissected by transparent objects and interspaces, and the figure, the clearest object in the composition, interacts with the objects and the space. All elements are woven together and are rotating constantly, yet their relationships are maintained by the seemingly casual sketched lines.

206. JACQUES VILLON (GASTON DUCHAMP-VILLON, 1875–1963; French). *Standing Nude with Arms in the Air.* 1909. Drypoint, 21⅝ x 16¹¹⁄₁₆″. Museum of Fine Arts, Boston (Lee M. Friedman Fund).

207. ALBERTO GIACOMETTI (1901–1966; Swiss). *Nude in a Room.*
Pencil. Courtesy Galerie Maeght, Paris.

*Student Response*

It was stressed in Chapter 8 that basic structural facts must be taken for granted during the period when personal attitudes toward form are developing. In the academies of the past this anatomical awareness was taught through drawings of sculptural casts and the study of charts and diagrams, but in recent years both practices have increasingly been seen as of limited value.

This exercise was begun with studies from the human skeleton, both alone and in combination with a model. The skeleton was arranged in simple sitting and reclining poses, while the

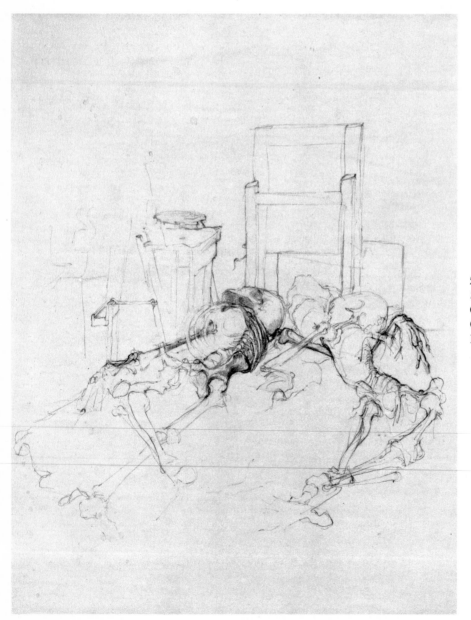

208. RICHARD KINSCHERF.
*Study of Skeletons.* 1967.
Graphite pencil.
Collection Yale University,
New Haven, Conn.

209. Ethel Siegel. *Study of Legs*. 1959. Graphite pencil.
Collection Yale University, New Haven, Conn.

model assumed the same poses, and the students were asked to draw
the two simultaneously. Some drew them side by side, as in Figure
208; others combined their perception of both in one figure.
The choice was left to the individual student. The goal here was not
simply a diagram showing the outer skin with the skeleton neatly
placed inside. Instead, students were asked to assume the
responsibility for studying the articulations they personally did not
understand. Two ideas were stressed: the foreshortened
simplification of volumes and the fixed-eye-level viewpoint as in
Dürer's nude (Fig. 197). This requires that all diagraming and note-
taking be performed within a three-dimensional approach; all bone
and muscular connections must be conceived in terms of volumes
moving in space.

Figure 209, a pencil study of legs, illustrates this personal
note-taking. The cross section of volumes is represented by bands of

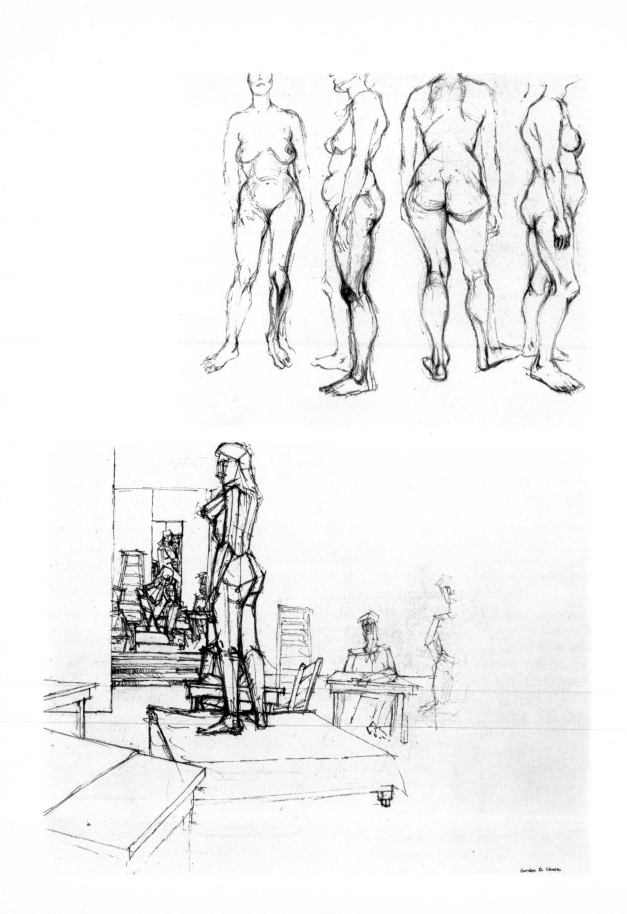

Gordon D. Chase

light lines, like strings around the forms. Thus, the student can trace one shape changing into another in terms of the whole volume, not merely the surface contour.

In the study of the model several exercises were undertaken. The same pose was seen from four angles, the model making a quarter turn on the pedestal after each twenty-minute pose. All four poses were to be composed on one sheet (Fig. 210). Another problem required that the students study the model without drawing for as long as they wished and then leave the room to do the actual drawing from memory. In still another exercise the model was asked to walk around the room and stop suddenly to pose for ten minutes. Here, too, all the poses were to be done on the same sheet of paper, with emphasis on the composition of the total page. Finally, the students drew the whole room with the figure considered as only one object in the space (Fig. 211).

In Figure 212 the transition from one connective joint to another is presented as a series of gliding masses that strongly suggest

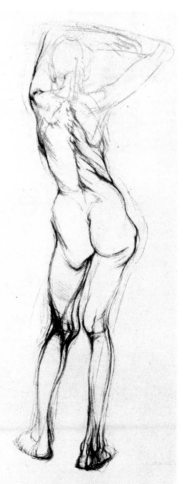

*opposite above:* 210. JOSEPH SLATE.
*Four Views of a Nude.* 1960. Pen and ink.
Collection Yale University,
New Haven, Conn.

*opposite below:* 211. GORDON CHASE.
*Nude in an Environment.* 1967.
Bamboo pen and ink. Collection
Yale University, New Haven, Conn.

*right:* 212. WILLIAM CUDAHY.
*Masses and Joints.* 1960. Pen and ink.
Collection Yale University,
New Haven, Conn.

locomotion. The student examines connections between masses with a focus on the joints. Flesh is seen tightly pulled over the bones and muscles, yet both of these structural elements are visible. The outer contours appear and disappear in the tracery of fine lines.

In Figure 213 the contours of the form are a by-product of its masses; that is, the edges of the masses create the contours. The edges themselves are blurred, but the masses, conceived from the center toward the outer contour, distribute their weights in space.

213. PAUL MOSCATT. *Masses and Contours.* 1960. Wash and white pastel. Collection Yale University, New Haven, Conn.

Plate 11. School of MICHELANGELO BUONARROTI
(1475–1564; Italian). *Male Nude.* Brown ink
on tan paper, 12⅝ x 5″. Louvre, Paris.
The theme of this drawing is sculpture. One
senses the chipping, scraping, and
polishing of a marble form carved out of a
block of stone. The drawn figure, in keeping
with the theme, emits a shimmering light.

Plate 12. Jacopo Pontormo (1494–1556; Italian). *The Three Graces.* c. 1535–36. Red chalk, 11½ x 8¼″. Uffizi, Florence. In this drawing Pontormo, influenced by Dürer, takes a satirical view of a classical theme, which, in traditional art, implied a symmetrical harmony of smoothly poised forms. Where the pose was graceful, Pontormo made his version awkward; where articulation of limbs was even and predictable, he rendered the joints heavy; where rhythms were smooth, he disrupted the surface. Proportion, harmony, and symmetry are, in this case, dictated by a personal vision, and not by conventions.

214. Robert Birmelin. *Overlapping Forms*. 1955. Graphite pencil.
Collection Yale University, New Haven, Conn.

   A motion-picture effect is created by the drawing in Figure 214,
in which the hand on the hip is repeatedly drawn across the page,
sometimes clearly stated, sometimes as a ghost. The artist
had a double interest—the composition of the whole drawing and the
study of individual parts—and these two ideas combine to produce
shapes that echo across the page.

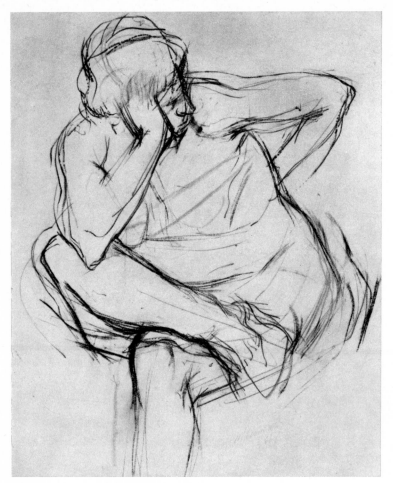

*left:* 215. MICHAEL ECONOMOS.
*Seated Nude.* 1959. Conté crayon.
Collection Yale University,
New Haven, Conn.

*below:* 216. ANNA HELD AUDETTE.
*Light on Form.* 1964.
Pencil, chalk, and wash.
Collection Yale University,
New Haven, Conn.

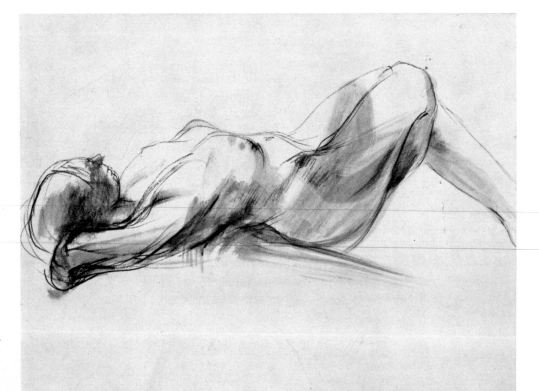

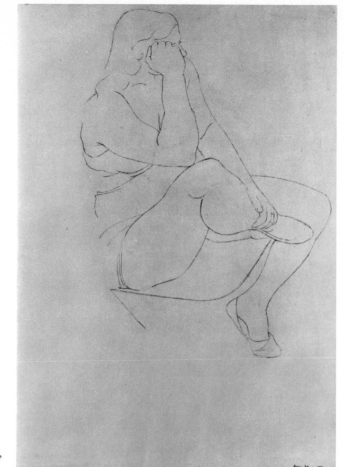

217. ARNE LEWIS.
*Weight and Contour.*
1953. Graphite pencil.
Collection Yale University,
New Haven, Conn.

The emphasis in Figure 215 is on the angularity of the pose.
Intersecting and opposing planes are presented in a directed
sequence: We see first that the movement of planes where the knees
cross is pushed forward, representing the most frontal plane; the
hand, head, and right shoulder come to our attention next,
in one unit, as they push back into space; the left hip is pulled
farther to the right in an attempt to locate it in space.
This set of spatial tensions, which we are made to see in a particular
order, is not intended to be a faithful description of details, but
rather it is the visual theme of the drawing.

Wash and pencil merge and separate in Figure 216 to
produce the feeling of a sudden light on the form. This fluid handling
seems an appropriate accompaniment to the sharply bending,
curvilinear forms of the figure. Shapes merge into one another in a
smooth, unbroken line from head to arm to trunk to legs.

In Figure 217 the concept of weight through contour
is explored. The weight of the line is sensitive to its function as an

edge of foreshortened, bulging volumes. This very pale drawing is obviously meant to be seen at close range, whereas bold, dark drawings are conceived of and should be viewed from a distance (although artists often choose to examine them at close range to study their instrumentation). Each drawing sets up its own viewing distance, as directed by the artist's conscious intention.

One's initial response to the drawings in this chapter might be: "These do not look like real people." This may be true, but it is important to remember that figure drawing concerns itself with the search for visual structures, real or invented. When the search is successful we may see bodies in real life in a new way. In drawing, as in art generally, great inventions make us look at nature with fresh insight (see Pl. 12, p. 212).

# 11
# INDIVIDUAL PROJECTS

Each of the preceding chapters in this section explored a specific, dictated problem in terms of the studio class. We discussed the experience of master artists and presented the student response. This type of directed learning experience is valid and necessary for the beginning artist, but there is a point beyond which it produces diminishing returns. In large studio classes the potential for dialogue between teacher and student is reduced, as is the opportunity for group interaction—the individual criticism and group discussion that can create a true environment for learning. The purpose of this chapter, then, will be to record the experiences of four students in advanced individual projects, outside the formal classroom setting.

For each of these projects the student chose a particular theme that he was to explore in depth for a full year or for one semester. The course was structured as a tutorial seminar: Each student met with the instructor alone once a week, and members of the group criticized each other's work several times

during the year. All the students were college undergraduates majoring in studio art. Esthetics and technical problems were not discussed beforehand, but were dealt with as they arose during the development of each project.

Such a course permits a very close association between teacher and student. In this presentation of the projects the attempt will be made to illustrate the dialogue the seminar created and to explain the way in which free but serious interaction can affect the development of an idea.

218. Mark Fennessey. *Insects I.* 1965–66. Pen and ink. Collection Yale University, New Haven, Conn.

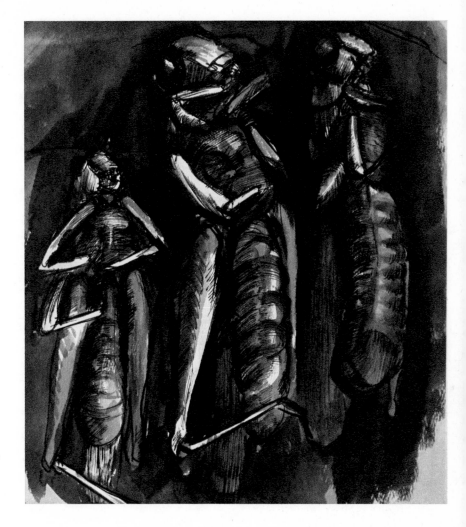

219. MARK FENNESSEY. *Insects II.*
1965–66. Pen and ink with wash.
Collection Yale University,
New Haven, Conn.

## PROJECT I—INSECTS

In this project, which lasted for a full year, the student produced
nearly a hundred drawings. Those that have been chosen
for reproduction represent pivotal points or changes in direction
in the student's progress.

The study began with casual anatomical note-taking through a
microscope. In a sense it was an almost playful investigation.
The artist produced many small group drawings, such as the one
illustrated in Figure 218.

Next, the student used the information obtained through the
microscope to create a series of works in pen and wash (Fig. 219).

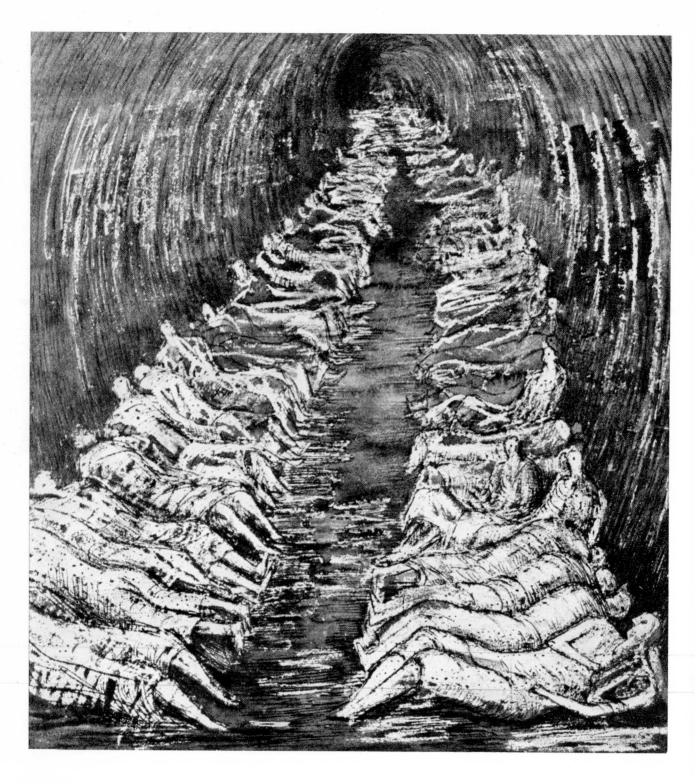

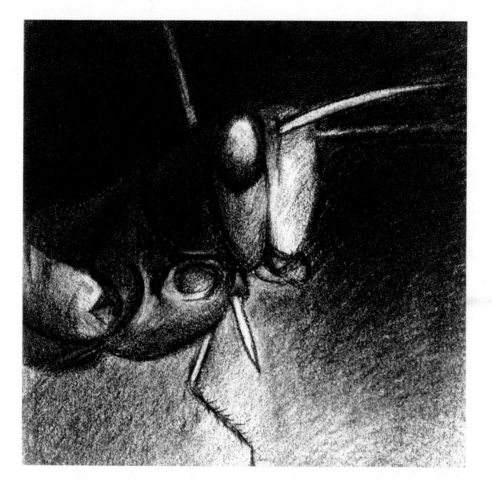

The insect forms became anthropomorphic, yet they appeared
as mounted specimens in a glass case, seen from the top, against a
shallow, dark backdrop. In many ways the forms in this
drawing resemble Henry Moore's cocoon-wrapped figures in *Tube
Shelter Perspective* (Fig. 220).

Still working from the initial notes, the student produced some
single figures in charcoal, which explored the psychological
possibilities. The insects, severely cropped at the edges of the page,
dominate the space to produce a nightmare image (Fig. 221).

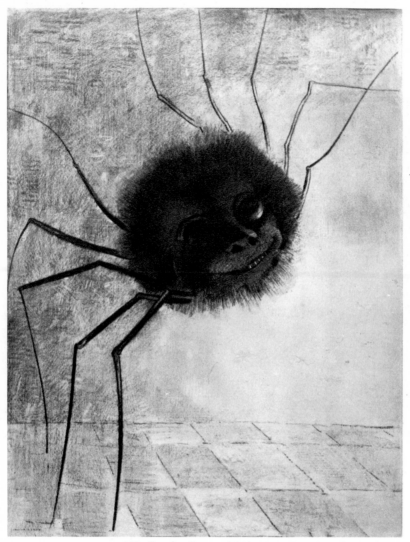

222. ODILON REDON (1840–1916; French). *The Spider*. Charcoal. Louvre, Paris.

Both the artist and I felt that the psychological emphasis, induced initially by study of Redon's graphic work (Fig. 222), was a little forced.

The student returned to note-taking under the microscope to make himself still more familiar with the insects' forms. At this point he decided to change his instrument to brush, which he employed almost exclusively during the remainder of the project. Individual insect figures looming as large as 30

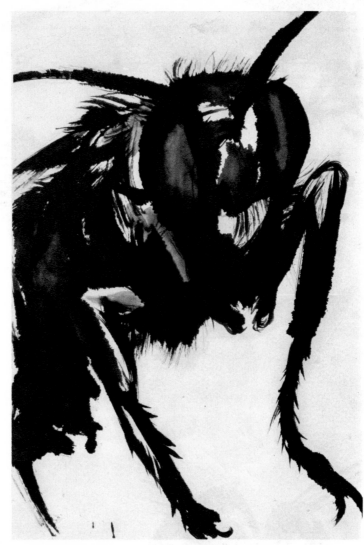

223. MARK FENNESSEY. *Insects IV.* 1965–66. Wash.
Collection Yale University, New Haven, Conn.

inches were set against the glare of absorbent white paper in direct
brush strokes (Fig. 223). My criticism of this group of works
was that the placement of the figures was a bit self-conscious,
drawing attention primarily to the forms themselves at the expense of
the composition. I suggested reducing the scale of the drawings
so that the swift brushwork would be less forced and more directly
related to the interaction of forms on the page.

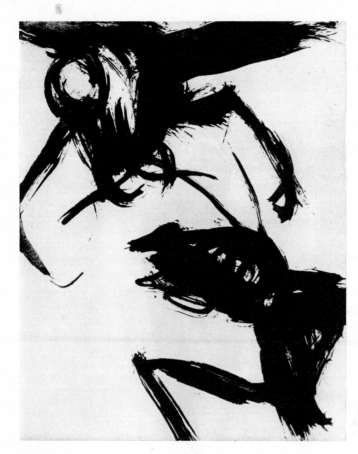

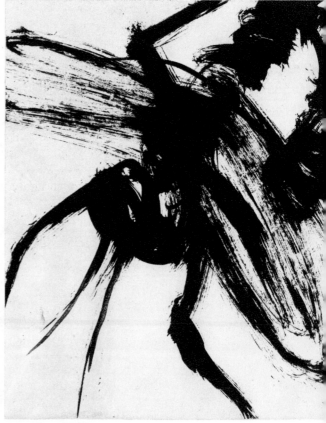

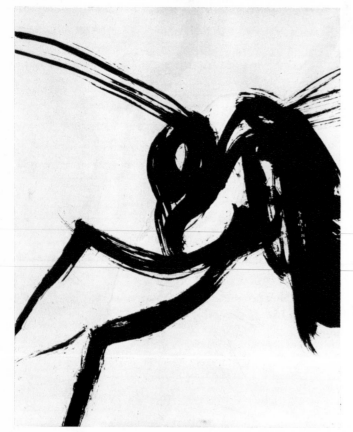

*above left:* 224. MARK FENNESSEY. *Insects V.*
1965–66. Brush and ink.
Collection Yale University, New Haven, Conn.

*above right:* 225. MARK FENNESSEY. *Insects VI.*
1965–66. Brush and ink.
Collection Yale University, New Haven, Conn.

*left:* 226. MARK FENNESSEY. *Insects VII.*
1965–66. Brush and ink.
Collection Yale University, New Haven, Conn.

In response to the criticism, the student produced a series of small drawings, three of which are reproduced (Figs. 224–226). We felt here that the life of the page, the brushwork, and the symbolic content were in a more balanced relationship.

Figure 227, a brush-and-wash drawing on a hard, resistant paper, initiated a change in spatial concepts. The basic idea—crowds in a panoramic space—was sparked by studying the works of James Ensor, Jacques Callot, and, especially in this drawing, the landscapes with figures by Goya. By this time the student, with his acquired experience, was able to compose more naturally.

227. MARK FENNESSEY. *Insects VIII.* 1965–66. Wash. Collection Yale University, New Haven, Conn.

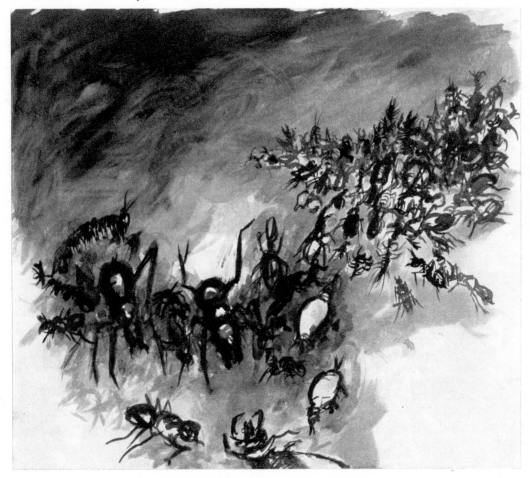

The final group of drawings, done on rice paper, translated
the insect-in-landscape theme into very dark brush groups
in a less obviously propped-up space (Fig. 228). There is
no discernible foreground, middleground, and background. The forms
are closer to the viewer, yet, as they move across the page,
they seem to be leaving the arena of the composition. The insect
forms themselves are more wedded to the brush strokes. Thus, the
entire effect is less descriptive and more suggestive and, therefore,
seems more real as a visual experience. The handling of
the medium is more direct and more important, and the menacing
symbolic content, too, is stronger.

228. MARK FENNESSEY. *Insects IX*. 1965–66. Brush and ink.
Collection Yale University, New Haven, Conn.

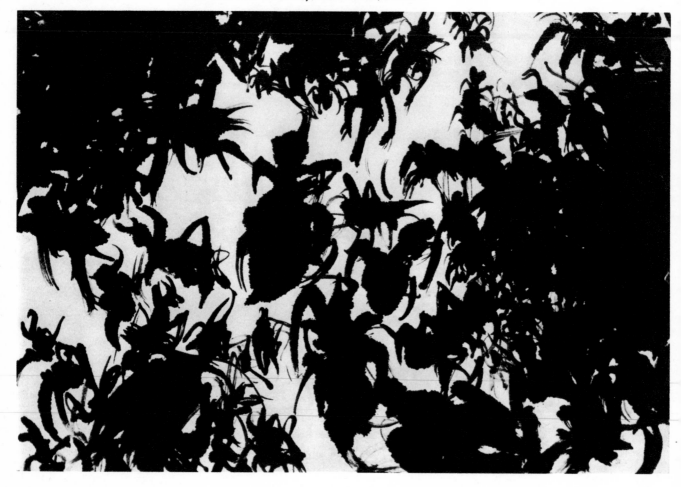

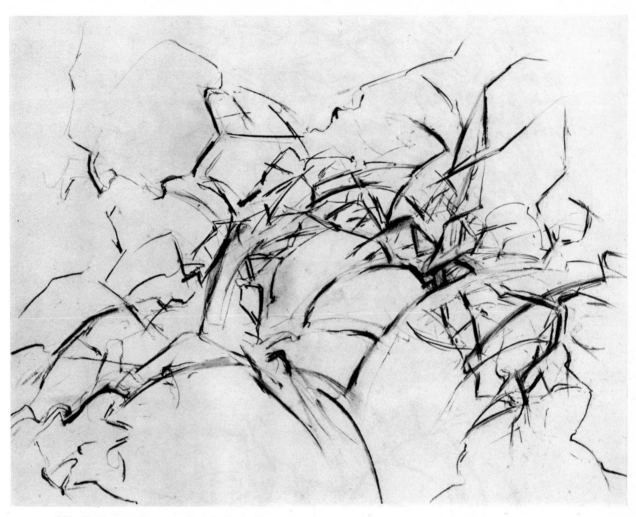

229. H. TURNER BROOKS. *Tree I.* 1965. Charcoal.
Collection Yale University, New Haven, Conn.

## PROJECT II—ONE TREE

The curving posture of one particular tree was the attraction for
the student in this single-semester theme. He employed charcoal
in Figure 229, as throughout the series, to pull together the
whole arched form of the tree in an arrangement of broken planes.
I felt that the rhythmical interruptions were too obviously
balanced, which tended to make the sections cancel out one
another and produced a relatively tensionless space.

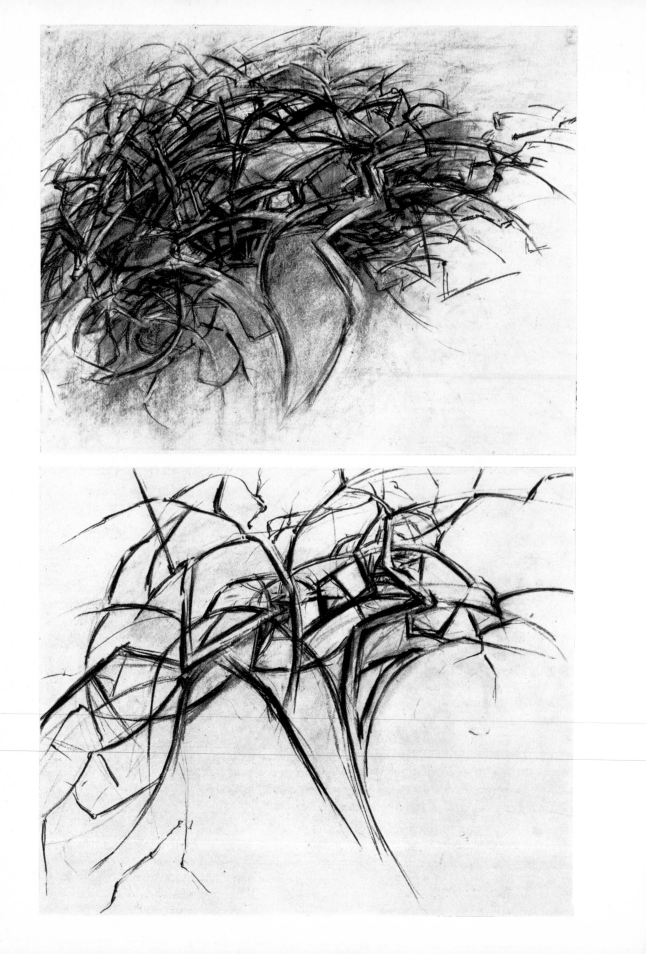

*opposite above:* 230. H. TURNER BROOKS. *Tree II.* 1965. Charcoal.
Collection Yale University, New Haven, Conn.

*opposite below:* 231. H. TURNER BROOKS. *Tree III.* 1965. Charcoal.
Collection Yale University, New Haven, Conn.

*above:* 232. H. TURNER BROOKS. *Tree IV.* 1965. Charcoal.
Collection Yale University, New Haven, Conn.

In Figure 230 the entire structure of the tree becomes one
rounded, spreading volume. We felt that the darks, which were used
to create drama, were not quite in harmony with the forms and
the space around them. Some dark sections, in fact, look as though
dust has been sprayed on top. It was emphasized that the darks
must act in and with the forms that are being presented.

The student was prompted by the criticism to present the same
form arrangement with more reliance on linear elements.
In Figure 231 the manner is not as highly stylized, forms are more
clearly stated, and the white interspaces between and around the lines
function to support these lines in a less obviously designed attitude.

In Figure 232 the broken-plane idea returned, this time with a
sweeping rhythm that again suggested a single sculptured volume.

233. H. TURNER BROOKS. *Tree V.* 1965. Charcoal.
Collection Yale University, New Haven, Conn.

Here the student was very self-critical. He felt that the "style"
produced an almost stained-glass effect, and that the flowing
movement was too obvious. We discussed the idea that transparent
planes suggesting Synthetic Cubism—wherein all the facets of
each plane are visible simultaneously to produce an allover surface
tension—must not appear to be tacked on top of an image.
Instead, the "system" should carry the image.

Figure 233, the final drawing in the series, is an invention
based on the actual experience of the tree. The tension-filled
traffic points in the center gradually expand to hold a plane very
close to the viewer. This frontal plane is represented by
the largest dark strokes circling the edges of the composition. Here
the technique and the constructed space are made to merge.

In this project the student was obviously influenced by
Mondrian's studies of trees (see Pl. 5, p. 93). Nevertheless, he has faced
issues of design versus structure—that is, the structure of the form

234. ROBERT FERRIS. *Landscape I.* 1965. Brush and wash (acrylic tempera).
Collection Yale University, New Haven, Conn.

to be presented should dictate the design, rather than being forced
to fit the limitations of preconceived design elements.

## PROJECT III—ONE LANDSCAPE

In this project the student restricted himself to one place, one tool
(brush), and one medium (tempera—in this case one of the new
commercially prepared plastic acrylic temperas). He drew directly
from the landscape, and, over the course of the year, passed
through three distinct stages. In stage one he elected to stretch
the limits of the amount of dark or light in any one composition. He
produced many very dark, almost black pictures, and some
very light ones.

Figure 234 is one of the relatively dark drawings, though it
does not approach the limits of darkness. The effect of light playing

across the page is housed in a clearly readable space. The heavy
trees in the foreground recede gradually through size
diminution to the background wall of foliage. However,
beyond this obvious spatial plan, the life of the drawing
lies in the action of strokes grouping together and opening to the
light from the back plane. The white interspaces do not
act as a flat background; instead, the white opens to suggest light in
upper right and acts as a plane of gravity in the lower portion.
The white further serves to set off the foliage.

      This drawing was one of the best efforts of several months' work.
Our conversation during this period dealt with amounts of
light and the use of white interspace as line, light, and plane.
Beyond this, we discussed the limitations of the physical space to be
portrayed: How much? How far back? How close to the viewer?

235. ROBERT FERRIS. *Landscape II*. 1965. Brush and wash (acrylic tempera).
Collection Yale University, New Haven, Conn.

The second phase was concerned with a restricted, close-up space for foliage-inspired brush strokes (Fig. 235). It was during this period that the student explored Japanese and Chinese landscapes from the point of view of controlling the directed sequence of events on a page (see Fig. 85). While studying this concept of controlled sequential reading, the artist was faced with the problem of imitating a master's brush strokes. To copy another's handwriting actually prevents one from developing his own natural style. Yet it is the masters we admire who direct our growth in one direction or another.

In stage three the emphasis was on one aspect of Western spatial concepts—the idea of bisecting and intersecting planes that set up tensions (Fig. 236). We are conditioned to this kind of construction from studying some of Cézanne's work, and, more

236. ROBERT FERRIS. *Landscape III.* 1965. Brush and wash (acrylic tempera). Collection Yale University, New Haven, Conn.

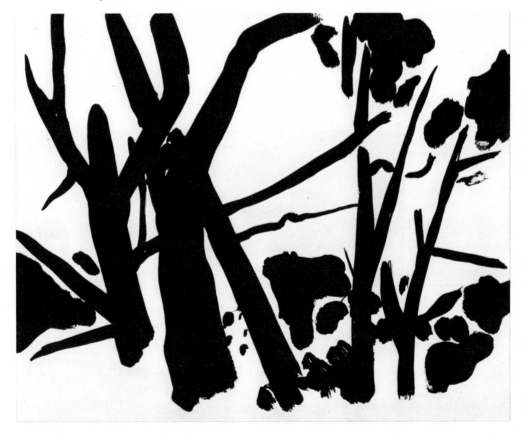

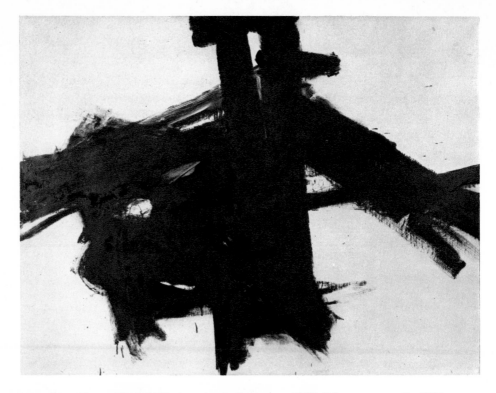

237. Franz Kline (1910–1962; American). *Crosstown*. 1955. Oil on canvas, 4′ x 5′5″.
Collection Columbia Broadcasting System, New York.

238. Leonard Stokes. *Interior I*. 1965–66. Brush and wash
(water-based acrylic paint).
Collection Yale University, New Haven, Conn.

234

recently, the work of Max Beckmann, John Marin (Fig. 60), and Franz Kline (Fig. 237). The heavy tree forms in Figure 236 shift the weight of the drawing to the left, yet balance is maintained by the broken, amorphous shapes at lower and upper right.

## PROJECT IV—ONE INTERIOR

The student developed the theme of this project after several false starts. The place, a deserted studio interior, was initially presented by singling out each item for a separate portrait, thereby losing a feeling of scale and unified light. The media employed varied from soft-focus charcoal rubbings to cross-hatched pen strokes, but these media did not connect with the intention—the feeling of a particular place. It was only with the adoption of a medium that could not distract the artist with small details and prevent him from placing mass against mass that real development began. Figure 238, a small drawing combining watery wash against flat tones ranging from dark gray to black, marked the beginning of success in terms of intention. The student's study of Giorgio Morandi's use of scale—in which bottles could appear as buildings or figures, depending on the grouping—proved helpful in this development.

In Figure 239 the light plane at center acts as both the source of light and the focus of gravity. The dark masses,

239. Leonard Stokes. *Interior II.* 1965–66.
Brush and wash (water-based acrylic paint).
Collection Yale University, New Haven, Conn.

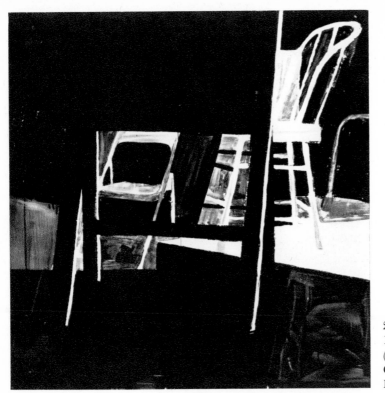

240. LEONARD STOKES. *Interior III.*
1965–66. Brush and wash
(water-based acrylic paint).
Collection Yale University,
New Haven, Conn.

representing tables and easels, press against and cut through this light.
The cropping of forms and the planes poised in opposition combine
with the focus of light to invent a special feeling of place.

Figure 240, the last of the series, is 40 inches high,
the largest drawing attempted. Here the dark mass of the easel
blends and merges into both the frontal plane (lower left)
and the background (upper left). The parallel lines, added in white
tempera, are the clues that make us invent the edges of forms
that are lost in the darkness. As in the previous illustration, the
condensed, cropped forms, moving at opposing angles, are
held together by the triangle of white, which acts as the light source.

These four students, working to find their own answers to their
own problems, produced more than twice the work possible
in an ordinary classroom situation. Their personal search deepened
their own attitudes, and they found it easier to learn what they
did not know, for they discovered their own deficiencies and tried to
master them. The point in a student's progress where
he takes the lead marks the transition between the need for dictated
problems (which unavoidably reflect the personal tastes of the
instructor) and the beginning of individual development.

# DRAWING:
# THE VISION
# OF THE MASTERS

# INSTRUMENTATION AND COPYING

## INSTRUMENTATION

Buying a brush or a new pen can be an exciting event for an artist.
He gets the "feel" of the instrument through making idle
surface marks. He learns how to play his instrument. This random
sketching is often a sensuous experience in itself, and,
ultimately, an image is born that accommodates the experience.
Although a concept may dictate a certain tool, the artist
must always imagine future work within the context of familiar tools
and materials. His instrumentation—the way in which he makes
particular marks with a tool—is shaped by the demands of
both the desired image and his natural handwriting. The dialogue
between the instrument and instrumentation is, for some artists,
a broad one (see Figs. 74, 76), but for others the choice is narrow.
Obviously, it is not the range of virtuosity that measures the
value of a drawing or of a particular artist.

   If "technique" is seen as the interaction between instrument
and instrumentation, then, in its finest sense, it works in the service of
a concept and does not act as a detached or added element. On

the other hand, technique, in its worst sense, is the search for a surface treatment that becomes the main interest of the artist and of the viewer. Tools and their marks, if they are not to become the subject of the drawing, must remain always subservient to the artist's vision, for if one sees how a drawing is made before one perceives the life of its forms, he is seeing only technique.

Many of Rembrandt's drawings exhibit the most spectacular free-flowing surface marks, yet one does not a first see how he made the drawing, for the strokes remain as carriers of form and composition. In this chapter we shall study a series of master drawings and explore the ways in which a particular instrument or the artist's instrumentation was used to serve a vision.

241. GEORGES SEURAT (1859–1891; French). *At the "Concert Européen."* c. 1887. Conté crayon, 12¼ x 9⅜″. Museum of Modern Art, New York (Lillie P. Bliss Collection).

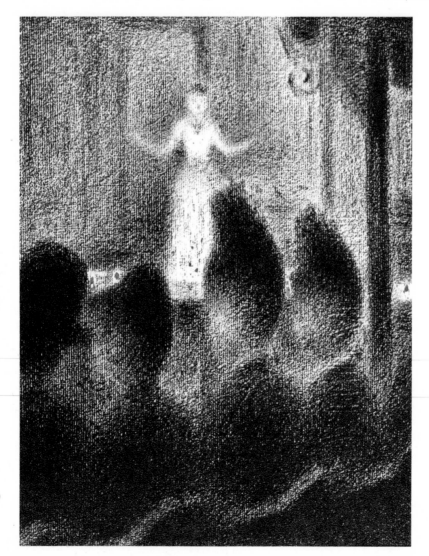

CHALK AND CHARCOAL    The surface quality in Georges Seurat's
*At the Concert* (Fig. 241) derives from the marks of conté crayon that
seem rubbed or forced into the fine, vertical ribs of the
textured paper. This texture breaks down the light into fine
particles, and, at first glance, the effect is similar to that in Seurat's
paintings, where dots of various colors give an additive effect
(for example, red and blue appear as purple when seen from a
distance). The surface treatment actually produces a light that seems
to be emanating from the white figure at center stage.
Here tool and mark serve naturally the visual drama of repeated
circles in a darkened foreground set against a lighted background.
The vertical bar at right stabilizes the composition and helps
to define the space between the heads and the background space.
The tilted, wavy line at the bottom of the composition defines the
frontal plane.

    Most master drawings have a tendency to reveal their
tool marks—even in flowing washes—rather than disguising them by
blending. Seurat's work is a rare exception, for the tooth of
the paper takes the role of the mark.

    In Jean François Millet's *Fagot Carriers* (Fig. 242) the crayon
marks all are visible, and they produce a broad stage for

242. JEAN FRANÇOIS MILLET (1814–1875; French). *Fagot Carriers.* Conté crayon,
$11\frac{3}{8}$ x $18\frac{3}{8}''$. Museum of Fine Arts, Boston (gift of Martin Brimmer).

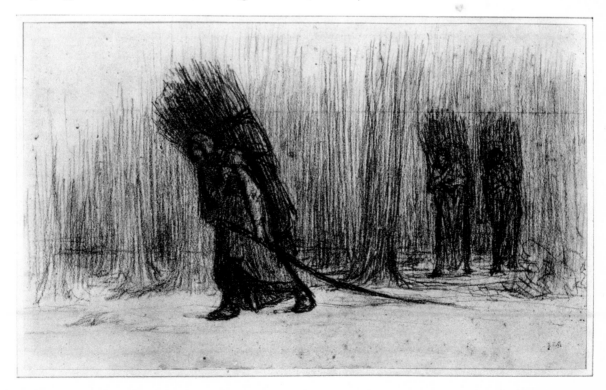

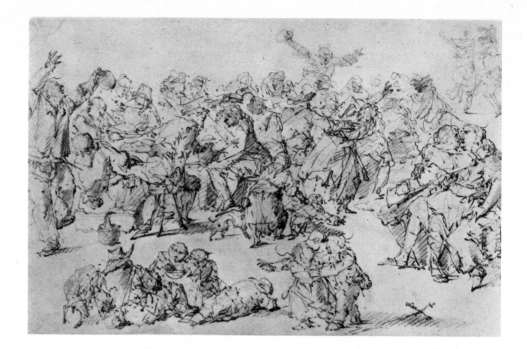

243. MATTHIAS SCHEITS (1625/30–1700; German). *Peasant Carnival.*
(Destroyed in World War II.) Conté crayon. Kunsthalle, Bremen.

groups of sticks. These strokes engulf the figures at right, so that
they become part of the background. The broken light effect,
made by the conté crayon strokes, forms a backdrop for the central
figure, which is presented with the same stroking, thus keeping
the whole drawing in a uniform atmosphere of light.

Matthias Scheits' *Peasant Carnival* (Fig. 243) was produced
with the same kind of tool—chalk or conté. In this work the use of

244. JEAN ANTOINE WATTEAU (1684–1721; French). *Cavalier.*
(Destroyed in World War II.) Conté crayon. Kunsthalle, Bremen.

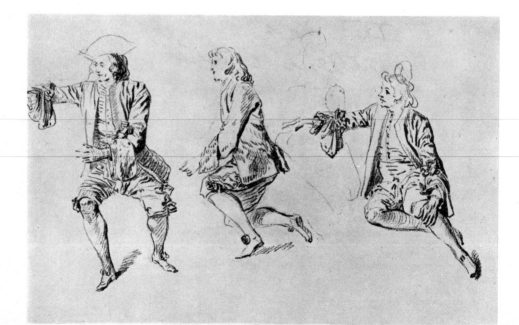

the instrument is clearly dictated by the compositional demands of the theme; allover activity requires a rapid criss-crossing of energy and light.

In Watteau's *Cavalier* (Fig. 244) the figure moves across the page in a cinemalike sequence. One postured gesture blends into another as we read from left to right. The figures seem to exist in a strong side light, which is kept constant. This light causes abrupt dark shadows and highlights in the drapery, and these are depicted with sure, economical marks that stay in place on the form.

PEN AND BRUSH     Since pen lines cannot easily be erased, we do not usually connect pen drawings with "searching"—that is, drawings that may be rehearsals for formal works in other media or which reveal the quest for the particulars of a form or for its spatial location. However, there are exceptions to this rule.

In two *Studies for Christ at the Column* by Andrea Mantegna (Fig. 245) the contours are tentative. We are able to follow

245. ANDREA MANTEGNA (1431–1506; Italian).
*Studies for Christ at the Column.*
Pen and ink, 9⅛ x 5⅝".
Collection Count Antoine Seilern, London.

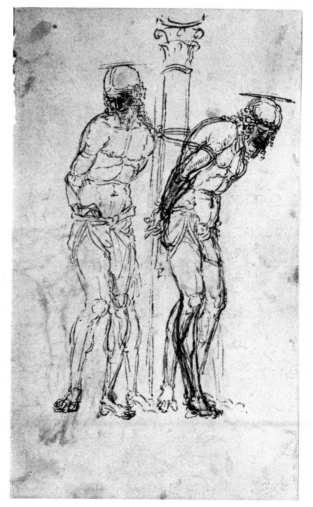

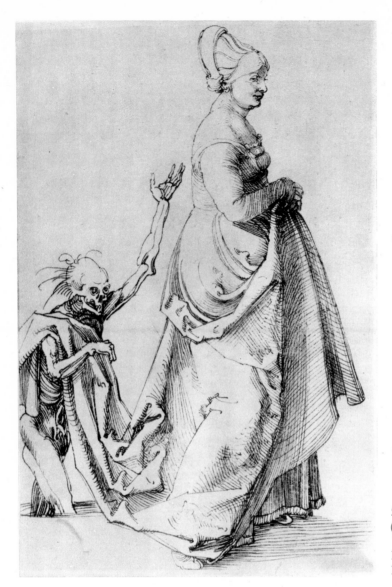

246. Hans Baldung Grien
(1484/5–1545; German).
*Woman with Death as a Partner.*
Pen and ink. Staatliche
Kunstsammlungen, Weimar.

Mantegna's search for final choices of placement. He seeks the
proper position of the legs to conform to the inner rhythm
of the figure and to establish gravity. This probe directs the light,
darting instrumentation of the pen.

    *Woman with Death as a Partner* (Fig. 246), a steel
pen drawing by Hans Baldung Grien, suggests another attitude. The
forms are as clearly defined as those of an engraving, with its
demand of total commitment to a line. The image appears clearly,
instantly, making one suspect that there were rehearsals
for this performance. Especially noteworthy is the delicate line from

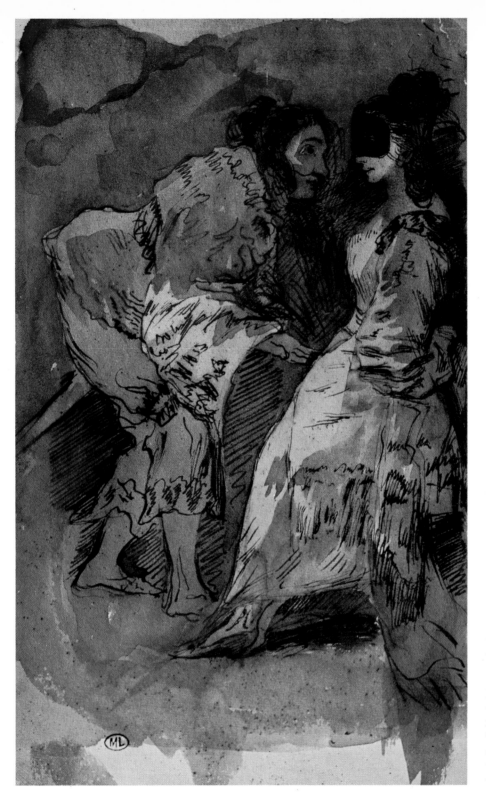

Plate 13. EUGÈNE DELACROIX
(1798–1863; French).
*Masquerade* (after FRANCISCO GOYA,
*Nadie se Conoce*, No. 6,
*Los Caprichos*). c. 1830–40.
Pen and ink with wash,
$8\frac{1}{2}$ x $5\frac{1}{2}$". Louvre, Paris.
In this study after Goya, Delacroix
translates the original etching
medium into swift, wet, washes.
This changes the tempo of the work
and creates a sense of immediacy
that forces the viewer to see all
the actors at once.

245

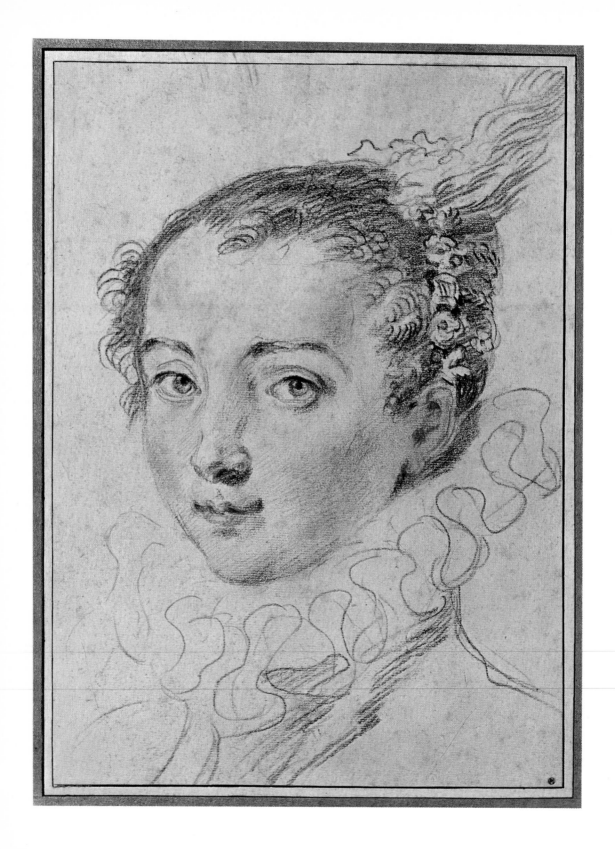

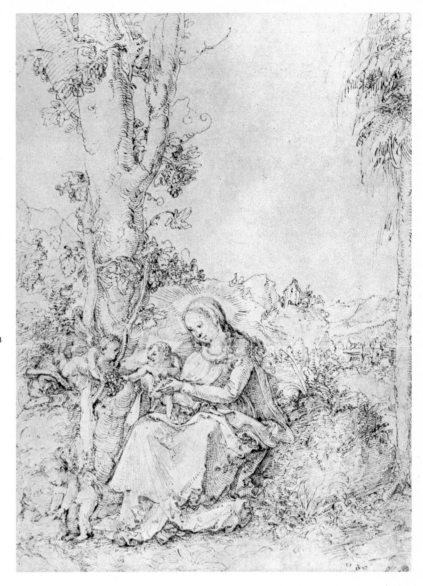

*opposite:* Plate 14.
JEAN-ANTOINE WATTEAU
(1684–1721; French). *Head of a Woman*
(after PETER PAUL RUBENS).
Black and red chalk, 12 x 8⅞″.
Museum Boymans–van Beuningen,
Rotterdam. Watteau transforms a head
by Rubens with his own vibrant
punctuation. Instead of a gradual
transition from light to dark, he
heightens the effect by accenting the
features with swift, dark strokes.
These strokes combine to form a
diagonal axis across the composition.

*right:* 247. Unknown German Master.
*Rest on the Flight into Egypt.*
c. 1520. Pen and ink.
Staatliche Kunstsammlungen, Weimar.

the nape of the woman's neck, as it travels down gradually, picking
up speed as it reaches the drapery below. The line is purposely
light and broken, for if it were dark it would close off the
space around the figure and allow the white of the page to separate
into nothing but an airless backdrop.

In Figure 247, *Rest on the Flight into Egypt* by an unknown
German master, the instrument, a steel pen, is the same as that used
in the previous illustration, but the weaving groups of short strokes
present a more hesitant performance. The drapery around
the feet is the focal point of the drawing, and the short strokes that

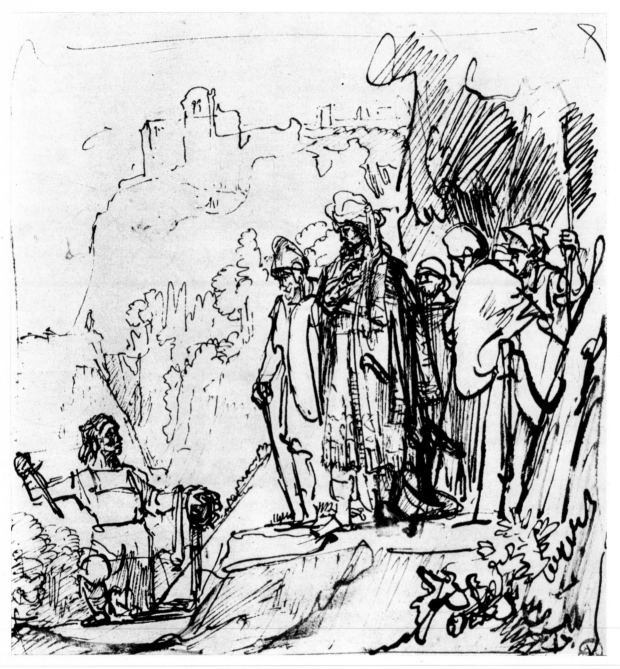

*above:* 248. Rembrandt van Rijn (1606–1669; Dutch). *Religious Scene.*
Quill pen and ink. Whereabouts unknown.

*opposite:* 249. Eugène Delacroix (1798–1863; French). *Study after Rubens.*
Reed pen and ink. Whereabouts unknown.

surround this form break the light into tiny patches of texture. The interweaving of these textured light patches sets up a peculiar atmosphere that engulfs the whole spatial surface.

Rembrandt used a different pen, a quill, and a different kind of instrumentation in *Religious Scene* (Fig. 248). The flowing manipulation of alternately scratchy and fluid lines sets up a hierarchy of pressures, which are strongest at the heaviest concentration of dark lines on the right side of the central figure. The remaining pressure points are clearly secondary: the foliage at lower right and the sketchy mass at upper right. These two areas sandwich the main figure, while the kneeling figure at left counteracts these defined spatial notes. One diagonal line touches this figure's left knee and shoots off obliquely to define the space surrounding the row of figures.

In Delacroix' reed pen *Study after Rubens* (Fig. 249) we witness a strong virtuoso work based on another artist's design. These sensuous yet functional tool marks are not separate from the action of the form. The violent round strokes on the upper leg (far left) force the eye into an upward spiral movement (see Pl. 13, p. 245).

The experience of copying, which is discussed later in this chapter, is well illustrated here, for the artist is reacting to the forms studied in order to heighten his own sensation, rather than rendering the original surface markings (see Pl. 14, p. 246).

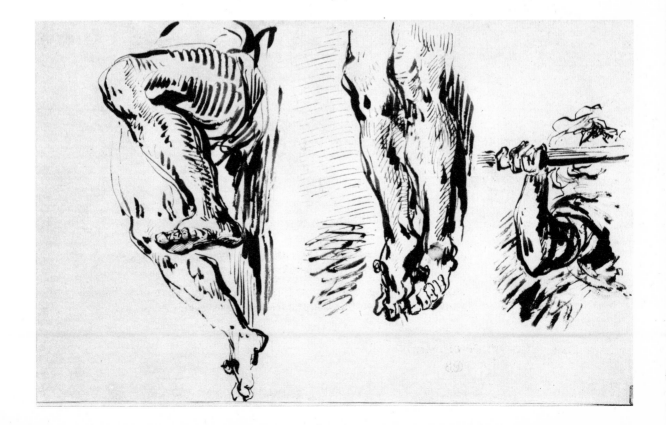

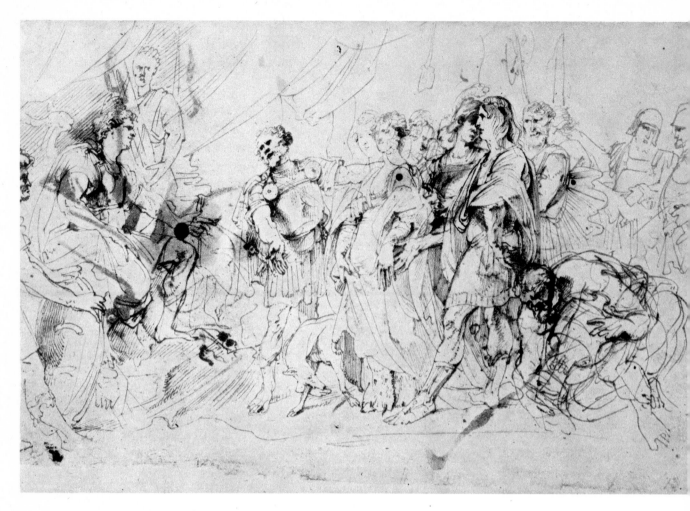

*above:* 250. ANTHONY VAN DYCK (1599–1641; Flemish). *Magnanimity of Scipio Africanus.*
(Destroyed in World War II.) Pen and ink with wash. Kunsthalle, Bremen.

*opposite:* 251. ANTHONY VAN DYCK (1599–1641; Flemish). *Miracle on the Day
of Pentecost.* Brush and ink. Staatliche Kunstsammlungen, Weimar.

    *Magnanimity of Scipio Africanus* by Anthony van Dyck
(Fig. 250) returns us to the searching attitude of Mantegna (Fig. 245).
This drawing is like a notebook sketch in which the artist is
searching for the position of shifting and flowing masses. We sense
this sequence of forms, because the instrumentation is in turn
delicately slow and rhythmically fast. As in all the drawings
reproduced, the instrumentation, beautiful in itself, is the product
of the intention—a search for the clear staging of the actors.

Van Dyck's *Miracle on the Day of Pentecost* (Fig. 251) uses
a different tool, a brush, to achieve a different purpose. The
drawing is not tentative. We do not sense the possible shifting of
masses, but it is nonetheless a spontaneous performance. The
brush strokes are sometimes dry and dragging across the frontal
space, sometimes more fluid as they suggest figures in what seems to
be an instant freezing of a dramatically lit situation. Van Dyck
instinctively picked the most appropriate tool for each concept.

252. Giovanni Battista Tiepolo (1696–1770; Italian). *Beheading of John the Baptist.*
Pen and ink with wash. Whereabouts unknown.

Giovanni Tiepolo's *Beheading of John the Baptist* (Fig. 252) is also a brilliant performance. The pen lines and dark areas seem to have been done at the same instant as were the flowing washes. The action and function of these light washes themselves are exciting. They do not logically describe the planes of each figure, but, rather, they float independently. The wash that covers the man's hand and sword incorporates the column behind it, as does the wash at upper right, which covers three figures. The fluid, watered ink used so skillfully by Tiepolo is the only material that could create this particular effect.

## COPYING

As we have implied, one does not acquire a personal handwriting by emulating a master. The student's goal in copying is not duplication but understanding, in the hope that this insight will help him to develop his own handwriting and his own attitudes toward form.

The intelligent student copyist does not experience a drawing more fully than does the sensitive layman, but he may experience it in a different way. He can perceive the positioning of a particular form in a particular space, or he can divorce a form from its environment for individual study. He can discover that a seemingly straightforward head in an Ingres drawing is actually a very complicated structure. In copying this head with its special attitude, he can discover the uniqueness of its foreshortening and the reasons for the exaggerated tilt in space.

In copying a Tiepolo wash drawing the perceptive student can realize the miracle of suggestion in the master's floating washes, which do not strictly define form in space but, instead, seem to dance from one form to another. Or he can discover the inner pressures of energy in Rembrandt's instrumentation, as these marks simultaneously create light and space for the compositional intent.

Studying the structure of a master work is at least as important as understanding its instrumentation. However, the practice of imposing triangles, circles, and S-curves over great works usually leads to oversimplification, if not to complete boredom. Another dangerous method is to cover a work with enforced surface marks. This has led to such bizarre experiments as applying Mondrian's field of plus and minus signs to a drawing by Titian. The idea, then, is not really to copy but to be aware of how the instrument and its instrumentation act as carriers of ideas and attitudes.

253. BARRY SCHACTMAN. *Copy after Ingres.*
1959. Graphite pencil. Collection
Yale University, New Haven, Conn.

*Student Response*

In the study of master works the students were encouraged to use the
copying experience directly by first making a free copy and
then attempting their own drawings with the same attitude in mind.
No specific instructions were given.

One student began by making a copy (Fig. 253) of an Ingres
portrait. As a copy it was well done, but the student felt there was
little experience extracted. He explained that he had chosen Ingres
as a personal challenge, because his own tendencies were
quite different. He then experimented with some freely invented
studies after Poussin's figure compositions in wash (Fig. 254). These
were much more in keeping with his own interests. During the
next few weeks he produced a series of reactions to Poussin,
of which Figures 255 and 256 are examples. This was copying for a
purpose. Months later the student's own work, done independently of

*above:* 254. Nicolas Poussin (1594–1665; French). Study for *Rape of the Sabines*.
Pen and ink with wash. Devonshire Collection, Chatsworth
(reproduced by permission of the Trustees of the Chatsworth Settlement).

*below left:* 255. Barry Schactman. *Study after Poussin.* 1959.
Brush and ink with wash. Collection Yale University, New Haven, Conn.

*below right:* 256. Barry Schactman. *Study after Poussin.* 1959.
Brush and ink with wash. Collection Yale University, New Haven, Conn.

255

*right:* 257. BARRY SCHACTMAN.
*Figure-ground Interplay.*
1959. Brush and ink.
Collection Yale University,
New Haven, Conn.

*below left:* 258. WILLIAM CUDAHY.
*Study after Ingres.* 1961.
Graphite pencil.
Collection Yale University,
New Haven, Conn.

*below right:* 259. WILLIAM CUDAHY.
*Study after Ingres.* 1961.
Graphite pencil.
Collection Yale University,
New Haven, Conn.

class study, revealed an interplay of figure and ground—that is, a harmony of interspaces and dark shapes (Fig. 257). In these studies the personal expression forms the composition.

Four studies after Ingres (Figs. 258–261) illustrate several kinds of investigation. In Figures 258 and 259 the position of the figure in space is presented without the main interest—the head form. In studying these secondary shapes, this almost bland underpinning, we see Ingres' seemingly sketchy but firmly stated figure. In the original, with its insistence on the face, one is hardly aware of the firm structure that supports it.

In Figures 260 and 261 the copyist exaggerates the way in which Ingres stretched the eyes and mouth around the sphere of the head. This stretching, which we normally associate with a more sumptuous, "expressive" instrumentation and attitude, is beautifully

*left:* 260. WILLIAM CUDAHY. *Study after Ingres.* 1961. Graphite pencil. Collection Yale University, New Haven, Conn.

*right:* 261. WILLIAM CUDAHY. *Study after Ingres.* 1961. Graphite pencil. Collection Yale University, New Haven, Conn.

262. Sister Mary Frei. *Rembrandt Studies.* 1960. Graphite pencil (*top* and *center*); pen and ink with wash (*bottom*). Collection Yale University, New Haven, Conn.

understated with a hard yet delicate pencil line. The student copyist, of course, is studying rather than imitating.

The next group of drawings (Fig. 262), a series of studies after Rembrandt, presents another attitude. The original pen strokes are not imitated; in fact, three of the five drawings were done in lead

pencil. The studies try to reveal the way energy is directed in the space, rather than imitating the actual strokes of the original.

The strongest form is the violent L-shaped brush mark surrounding the bent elbow of the lower figure. This meeting of two planes in opposition creates a kind of visual noise and causes the form to advance. The secondary emphasis is the swiftly brushed wash between the two figures, which both contains and stabilizes them.

The next two examples (Figs. 263–264) are studies of the density and flow of masses in which a group of figures is woven together. In Figure 263 an attempt has been made to simplify the planes and to slow down the rhythmic action of the drapery in the original. The movement actually appears to be in slow motion. In Figure 264, on the other hand, the original tempo is exaggerated in all its baroque twisting.

*left:* 263. JONGSOON PARK CHUNG. *Deposition Study.* 1962. Pen and ink. Collection Yale University, New Haven, Conn.

*right:* 264. JONGSOON PARK CHUNG. *Deposition Study.* 1962. Pen and ink. Collection Yale University, New Haven, Conn.

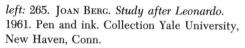

*left:* 265. Joan Berg. *Study after Leonardo.*
1961. Pen and ink. Collection Yale University,
New Haven, Conn.

*below:* 266. Leonardo da Vinci (1452–1519; Italian).
*Five Grotesque Heads.* Pen and brown ink,
10¼ x 8½″. Royal Collection, Windsor
(copyright reserved).

The student carefully emphasizes the space between the heads in this copy (Fig. 265) of a famous Leonardo (Fig. 266), and these spaces seem to be woven out of tiny pen strokes.

The transfer of form attitudes from one master to another makes us acutely aware of different modes of perceiving. From a section of a Rembrandt etching, *Diana at the Bath* (Fig. 267), one student isolated the turning head of a woman and tried to capture the

267. REMBRANDT VAN RIJN (1606–1669; Dutch). *Diana at the Bath*. Etching. Rijksmuseum, Amsterdam.

268. ROBERT S. DEALEY. *Copy after Rembrandt.* 1969. Graphite pencil.
Collection Yale University, New Haven, Conn.

attitude of Jacques Villon (Figs. 66, 206). In Figure 268 the softly
modeled and rounded planes of Rembrandt have been transformed
into sharp angles that are gently stretched in opposing directions.

In this chapter we have emphasized tool marks and their
relationship to form. We have seen that with the same instrument
many kinds of instrumentation are possible, depending on
the concept and the form attitude. There is beauty in the way marks
move to encompass and release forms. The life of lines themselves—
their speed, weight, and movement orchestrated in a personal
way—is a natural by-product of the search for form.

Plate 15. JOAN MIRÓ (1893–   ; Spanish-French). *The Beautiful Bird Revealing the Unknown to a Pair of Lovers.* 1941. Gouache, 18 x 15″. Museum of Modern Art, New York (acquired through the Lillie P. Bliss Bequest). The grouping of forms in this composition produces undulating vibrations, with the largest shapes acting as magnets to keep the field together.

Plate 16. MARK TOBEY (1911–   ; American). *Broadway.* c. 1935. Tempera, 26 x 19¼″.
Metropolitan Museum of Art, New York (Arthur H. Hearn Fund, 1942). Individual strokes of the
brush, some sharp, some soft-edged, merge to disclose the glitter and bustle of Broadway. One
can read this work in two ways: as a flat field of vibrating marks or as a scene in perspective.

# 13
## ATTITUDES AND SUMMARY

In this final chapter we shall try to reinforce some of the ideas
developed throughout the book, using master drawings as illustrations,
and we shall attempt to explore still further the possibilities that
exist in the art of drawing.

The first four drawings are concerned with the same subject,
a single female figure, but each is conceived within a distinct vision
that directs the style, the touch, and the spatial arrangement.
The purpose gives birth to the idea.

Picasso's straightforward portrait of Dr. Claribel Cone (Fig. 269)
is a complete graphic work in itself. It is not, as far as we know,
a study that was to be executed in another medium. In this
period (1922) Picasso, following Ingres' lead, focused with
penetrating clarity on the head, and, in particular, on the facial
features. The artist also suggested, in an understated way,
the character of the hands, the folds of the dress, and so forth.
Yet the whole figure is rather like a piece of sculpture on a pedestal,
seen from one fixed, foreshortened position. The projection of the

skull into three-dimensional space is clear, as are the transitions
from the shoulder to the bust and from the knee to the pad
on the floor. The unified projection of related forms could be
translated into sculpture from this seemingly offhand line drawing.

By contrast, Georges Seurat's conté crayon study for
*Les Poseuses* (Fig. 270) confronts us with one dark, dramatic profile.
The first impression is of pure silhouette, beautifully settled on the

269. PABLO PICASSO (1881–   ; Spanish-French). *Portrait of Dr. Claribel Cone.*
Pencil, 9½ x 8³⁄₁₆". Baltimore Museum of Art (Cone Collection).

page. The edges of the drawing, which crop the top of the head, seem to suggest a window in which the figure is set against the radiant light of the background. But after we adjust our eyes to the sharp contrast in the light, we begin to perceive the character of the head, the slightly open mouth, and the distinctly formed features. Thus, our initial awareness of one large shape broadens into an understanding of the particular form.

270. GEORGES SEURAT (1859–1891, French). *Une Poseuse Habillée*. c. 1887 (destroyed in the fire at the Gare des Batignolles, Paris). Conté crayon, 12½ x 9½".

271. HANS HOLBEIN THE YOUNGER (1497/8–1543; German). *Portrait of Anna Meyer.*
Colored chalks, 13⅞ x 10⅝″. Kupferstichkabinett, Basel.

Holbein's *Portrait of Anna Meyer* (Fig. 271) also presents a
silhouette. The figure is set in a softly focused but intense
light, and differences in the texture of skin, hair, and dress are fully
realized. The figure forms a triangle that easily fills the whole
space. The viewer is very close to the transfixed model, who seems
unaware of the intrusion. From this close range, we are directed
to study what the artist wants us to see.

272. Matthias Grünewald (Mathis Gothart Neithart, 1470/75–1528; German). *Lamenting Woman with Clasped Hands*. Black chalk with white highlights, 15⅝ x 11¾″. Collection Oskar Reinhart am Römerholz, Winterthur.

*Lamenting Woman* by Matthias Grünewald (Fig. 272) also forms a triangle, and it fills its space with the same components—hair, skin, and dress. But whereas the Holbein model is immobile, Grünewald's all-encompassing movements of form keep the viewer's eye moving through them. The tightly clasped hands act within these rhythms and connect the bodice to the hair at right. The head, twisting sharply in space, is distorted to make us see what seems impossible—the far

side of the face. It is as if these spiraling rhythms, based in the two lower corners, gather momentum as they pulsate to the apex of the triangle, the head. In their speed, they seem to gain pressure and push the forms of the far side of the head toward us.

273. VINCENT VAN GOGH (1853–1890; Dutch-French). *The Cornfield.* 1889. Reed pen and ink, 18⅛ x 24″. Collection G. Serigiers, Brussels.

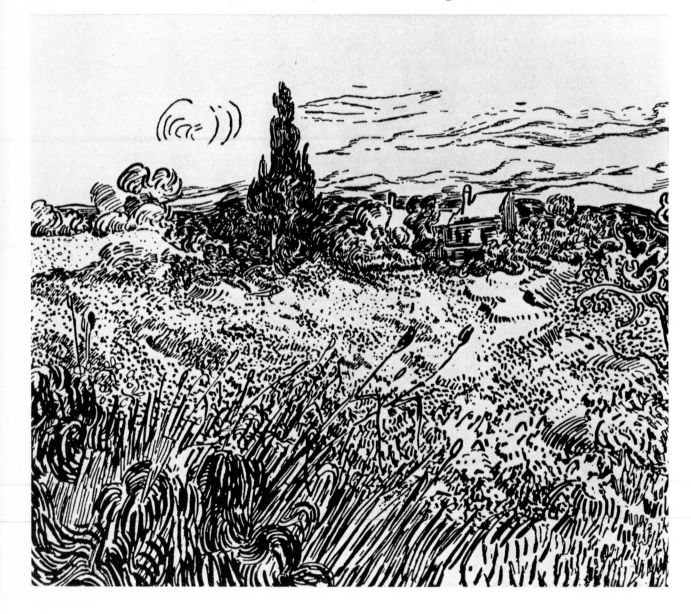

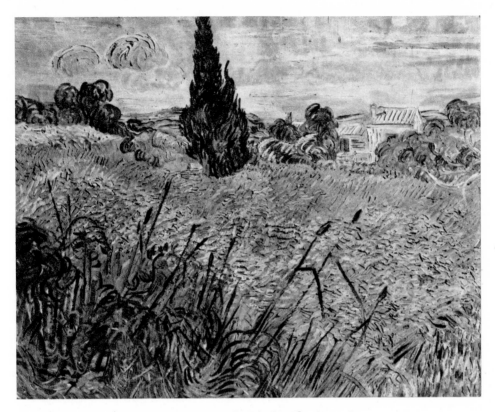

274. Vincent van Gogh (1853–1890; Dutch-French). *The Green Rye*.
Oil on canvas, 28⅝ x 36⅛". National Gallery, Prague.

These four drawings, which are all single-feature subjects, have
some similarities, but they reveal how each concept dictates its own
space, rhythms, focus, and instrumentation, all to reinforce the
individual concept. Picasso and Holbein work from a fixed point with
particular models; Seurat constructs one dark shape that houses a
distinctly characterized head; and Grünewald's figure writhes under
pressure from an all-embracing movement.

Van Gogh's *Cornfield* (Fig. 273) illustrates a motif drawn
directly from nature. Nevertheless, this landscape drawing, filled
as it is with rich and complicated detail, is not a faithful
description of natural forms. The emphasis is on horizontal bands
of tool marks, pulsating across the page, and these patterned
brush strokes contain the natural references.

This drawing was a preliminary study for a painting (Fig. 274).
Van Gogh, who is often thought of as a wild expressionist, carefully

transcribed the dot-and-dash pulsation of the drawing into a vibrant color scheme. The drawing itself, however, stands as a complete work of art.

A more generalized style is that of Rembrandt in Figure 275, a small work in pen and wash. The brief, quickly sketched marks explain the whole space in a miraculous manner. We are pulled into the composition by the dark frontal post of the fence, which then recedes, drawing us even farther into depth. We are returned to the frontal plane by the clash of horizontal and vertical strokes on the right. Here again is a complete artistic statement.

Paolo Veronese's *Madonna and Child with Cherubs* (Fig. 276) is obviously an invention, and the drawing is visually composed to complement this concept. The largest shape, the circular area that contains the Virgin, demands our attention first, because it is the dominant mass. It acts as a magnet to attract the flying cherubs, who are irresistably drawn to it. The same pair of intertwined cherubs is repeated four times in a diagonal movement toward the circle.

*below:* 275. REMBRANDT VAN RIJN (1606–1669; Dutch). *Winter Landscape.* Quill pen and ink with wash. Fogg Art Museum, Harvard University, Cambridge, Mass.

*opposite:* 276. PAOLO VERONESE (c. 1528–1588; Italian). *Madonna and Child with Cherubs.* Pen and ink with wash. Whereabouts unknown.

277. Unknown Florentine Master. *Studies after Masterpieces in Florence.*
c. 1500. Pen and brown ink, 12⅜ x 7½". Kunsthalle, Hamburg.

278. Michelangelo Buonarroti (1475–1564; Italian). *Anatomical Study.*
Pen and ink, $8\frac{3}{8}$ x $10\frac{3}{8}$". Uffizi, Florence.

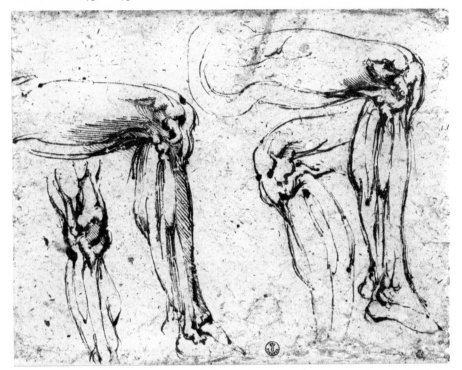

Figure 277, a notebook page, is a pen drawing by an unknown sixteenth-century Florentine artist. There is no single theme, nor is there a dominant shape to hold and direct our eye. Instead, we witness scenes flashing on and off in succession, as our eyes rove the page. In this case we are reading an artist's notes not intended for publication or exhibition. This work, therefore, illustrates the art of drawing in its planning capacity.

Michelangelo's *Anatomical Study* (Fig. 278) reveals, as the title suggests, a study of facts. But there is more than mere structural information in this study. The page, whether by design or by instinct, is carefully composed. The leg forms are held in mutual tension, interlocked and interdependent. The grouping of these forms thus takes on a separate life, distinct from the problems of anatomical study.

Throughout this book we have emphasized the need to commit the forms of nature, man, and man's environment to memory as a basis for individual interpretation. In this context it is appropriate to

279. Hieronymus Bosch (1450–1516; Dutch). *Tree Man in a Landscape.*
Pen and brown ink, 10¹⁵⁄₁₆ x 8³⁄₈". Albertina, Vienna.

280. FRANCISCO GOYA (1746–1828; Spanish). *Bobalicón* (preparatory drawing for No. 4 in the *Disparates* series). Wash. Prado, Madrid.

reproduce Hieronymus Bosch's *Tree Man* (Fig. 279), a fantasy creation made up of remembered forms from nature. In center stage Bosch places his star, a creature both grotesque and whimsical.

Goya, too, creates a stage for his invented characters (Fig. 280). The bottom line acts as one step of the stage to support the minor character, while the second line, parallel to the first, provides a base for the main figure. Unlike Bosch, who makes us see the whole stage from afar, Goya places us in front row center.

## SUMMARY

Compared to other visual media, drawing is a magical act. In no other medium can we go so directly from thought process to image, unencumbered by materials or extensive preparation. We are able, with experience, to refine our thoughts in a direct way, without complicated techniques. With this immediacy, drawing can

accommodate all attitudes, whether we are reacting directly to the forms around us, refining forms from memory, inventing new forms, or even planning complicated relationships (see Pls. 15–16, pp. 263–264).

Whether their purpose is the transformation of forms from the environment or inventions for the sake of plastic action alone, great drawings have a built-in economy of conception and performance. This economy is often deceiving to beginners, who may not be aware of the selecting process and the boiling down to essence that gave birth to a particular experience, and who may misread it as simplicity of conception.

The practice of slavishly imitating a master's work leads to frustration and, ultimately, to sterility, for the touch of the master's hand that we admire is the product of natural tendencies of both his personality and his particular development, as well as his genius. This accumulation of experience and personality builds a unique vision that transmits his message naturally. The young draftsman should, from the beginning, try to experiment with all modes of drawing, constantly trying on different suits to find out what fits him before considering the polished technical performance. What we like initially in the masters changes with experience. Even mature artists admire what is not natural to themselves: A "baroque" artist may like Mondrian, or a "minimal" artist may like Rubens. It is important to study rather than to duplicate, for understanding fosters natural development, while emulation may lead to a parody of mannerisms.

It is dangerous to use a bit of "master technique" to dress up a work or to conceal a lack of formal invention. What we must extract from the masters is the kind of thinking that was employed and the growth of an ability to select, for we cannot start directly where someone else left off. A lifetime's experience that has developed an attitude cannot be obtained by mere imitation. Still, it is the work of the masters that puts us on the right track, that makes us see the world of forms and our own environment in a new way and inspires us to develop our own ways of seeing and, just possibly, of inventing our own world of form life.

Forms from our imagination or from the physical environment, which we can call *life forms*—such as a tree in nature or demons in the mind of a Bosch—are transmitted by the artist's vision and skill to create something new—a *form life*. This cycle from life form to form life begins in drawing when the artist, haunted by an image or an idea, puts his pencil to paper.

# INDEX

References are to page numbers, except for color plates and black-and-white illustrations, which are identified by figure and plate numbers.

acrylic tempera, 231
*Adam and Eve,* Dürer, 54–55, Fig. 47
Albers, Josef, 57–58
 *Structural Constellation,* 57–58, Fig. 52
Albright, Ivan Le Lorraine, 202–203
 *Three Love Birds,* 202–203, Fig. 204
*Alpine Landscape,* Bruegel, 118–119, Fig. 114
*Ambiguous Space,* Cudahy, 130–131, Fig. 124
*Anatomical Study,* Michelangelo, 275, Fig. 278
animal skulls, 159–166
animals, 181–191
*Architectural Fantasy,* Piranesi, 128, Fig. 122
Arp, Jean (Hans), 6–9, 11
 *Automatic Drawing,* 6–9, Fig. 5
*At the Concert,* Seurat, 240–241, Fig. 241
*Atmospheric Haze,* Lam, 156–157, Fig. 155
attitudes and summary, 265–278
Audette, Anna Held, *Light on Form,* 214–215, Fig. 216
*Automatic Drawing,* Arp, 6–9, Fig. 5

*Back View of a Nude,* Dufy, 197–198, Fig. 199
*Bags as Mountains,* Lent, 154–155, Fig. 154
*Bags in Panoramic Space,* Farrell, 157–158, Fig. 157
Baguskus, Eugene, *Football Shoe,* 134–135, Fig. 129
Baldung Grien, Hans, 244–245
 *Woman with Death as a Partner,* 244–245, Fig. 246
ball-point pen, 39
*Bamboo,* Okyo, 92, 233, Fig. 85
bamboo pen, 43
Bandinelli, Baccio, 200
 *Two Male Nudes,* 200, Fig. 202
*Baptism of Christ,* Bellini, 120–122, Fig. 116
Barbash, Stephen, *Self-portrait,* 176–177, Fig. 179
*Barn in a Valley (Sepham Farm),* Palmer, 92, Pl. 6, p. 94

Bartolommeo, Fra, della Porta, 198–199
 *Two Studies of John the Baptist,* 198–199, Fig. 200
*Battle of the Sea Gods,* Mantegna, 69, Fig. 64
Beal, Joanna, *Landscape with Diagonal Tree,* 99–100, Fig. 92
*Beautiful Bird Revealing the Unknown to a Pair of Lovers, The,* Miró, 278, Pl. 15, p. 263
Beckmann, Max, 235
*Beheading of John the Baptist,* Tiepolo, 252–253, Fig. 252
Bellini, Jacopo, 120–122, 148
 *Baptism of Christ,* 120–122, Fig. 116
 *Two Buildings,* 148, Fig. 146
Berg, Joan, *Study after Leonardo,* 260–261, Fig. 265
Birmelin, Robert, *Fantastic Mountain Landscape,* 124–125, Fig. 120
 *Landscape with Oblique Horizon,* 98–99, Fig. 91
 *Overlapping Forms,* 213, Fig. 214
 *Self-portrait,* 179, Fig. 181
Bittleman, Arnold, *Sculptural Essence of the Skull,* 166, Fig. 166
 *Slouching Shoe,* 135–136, Fig. 130
Bloem, Matheus, 32–33
 *Group of Old Trees,* 32–33, Fig. 27
Bloom, Hyman, 44
 *Fish Skeletons,* 44, Fig. 38
Bloomer, Kent, *Sculptural Tree,* 95, Fig. 86
*Bobalicón,* preparatory drawing, No. 4, *Disparates* series, Goya, 277, Fig. 280
Bonnard, Pierre, 9, 11
 *Canaries,* 9, Fig. 7
*Boots,* Hartley, 132–133, Fig. 128
*Boots with Laces,* Van Gogh, 132–133, Fig. 127
Bosch, Hieronymus, 276–278
 *Tree Man in a Landscape,* 276–277, Fig. 279
Botticelli, Sandro, 36
 *Inferno XXXIII,* Dante's *Divine Comedy,* 36, Fig. 32
Boxer, Deborah, *Undefined Shoe Forms,* 144–145, Fig. 142
Boyer, Ernest, *Self-portrait,* 176, Fig. 177
*Bridge Perspective,* Steinberg, 10, Fig. 8

Bril, Paul, 37
    *Landscape with Horseman,* 37, Fig. 33
*Broadway,* Tobey, 278, Pl. 16, p. 264
Brooks, H. Turner, *Tree,* 227–231, Figs. 229–233
Bruegel, Pieter, the Elder, 118–119
    *Alpine Landscape,* 118–119, Fig. 114
    *Landscape with Rocky Mountains,* 118–119,
        Fig. 113
brush, 45–49, 251
*Bulging Sneaker,* student drawing, 136, Fig. 131
*Bullfight (Two Groups of Picadors Rolled Sub-
        sequently by a Single Bull),* No. 32,
        *Tauromaquía* series, Goya, 32–33, Fig. 28
*Burial of Count Orgaz, The,* El Greco, 76–77,
        Fig. 71
Buytewech, Willem, the Elder, 48
    *Gentleman,* 48, Fig. 42

*Café in Arles,* Van Gogh, 126–128, Fig. 121
Callot, Jacques, 225
*Camels,* Rembrandt, 181–183, Fig. 183
Canaletto, 66–67
    *View of the Canal,* 66–67, Fig. 61
*Canaries,* Bonnard, 9, Fig. 7
casein, 28
*Cast of a Greek Sculpture,* 34, Fig. 30
*Cavalier,* Watteau, 242–243, Fig. 244
Cézanne, Paul, 6, 59–61, 78, 85–86, 233
    *The Clockmaker,* 78, Fig. 73
    *Foliage,* 59, Pl. 4, p. 60
    *Sketch of a Tree,* 85–86, Fig. 77
    *Tree and House,* 6, 61, Fig. 54
chalk, 28–33, 241–243
Chaplin, George, *Study of Skulls,* 174–175,
        Fig. 175
charcoal, 33–35, 241–243
*Charcoal Study,* Kozlowski, 149–150, Fig. 147
Chase, Gordon, *Nude in an Environment,*
        208–209, Fig. 211
Chelminski, Michael, *Saturated Landscape,*
        103, Fig. 97
Chinese white, 28
*Christ Carrying the Cross,* Rembrandt, 23, 25,
        Fig. 20
*Christ in the Temple,* unknown German master,
        146–147, Fig. 145
*Christ with Mary Magdalen,* Delacroix, 24–25,
        Fig. 21
Chung, Jongsoon Park, *Deposition Study,* 259,
        Figs. 263–264

Cinnamon, Gerald, *Interacting Bag Forms,*
        157–158, Fig. 156
*Clockmaker, The,* Cézanne, 78, Fig. 73
Coburn, Ralph, 54, 56–57
    *Variable I,* 54, 56–57, Figs. 48–51
Cohen, John, *Pressure Points of a Skull,* 161–
        163, Fig. 160
    *Roots in Tension,* 116–117, Fig. 111
    *Shoe Quartet,* 138–139, 142, Fig. 134
*Coming of Autumn, The,* Hung-Jen, 120–122,
        Fig. 115
composition, 53–78
*Composition in Black and White,* Mondrian, 6,
        Fig. 3
Constable, John, 86–87
    *Study of Clouds,* 86–87, Fig. 78
conté crayon, 28–33
*Copse of Birches,* Leonardo, 84–86, Fig. 76
*Copy after Ingres,* Schactman, 254, Fig. 253
*Copy after Rembrandt,* Dealey, 262, Fig. 268
copying, 249, 253–262
*Cornfield, The,* Van Gogh, 270–272, Fig. 273
*Cottages Among High Trees,* Rembrandt, 39,
        Fig. 35
Coughlin, Patricia, *Study of Animals,* 186–187,
        Fig. 189
*Courtyard of a Palace,* Guardi, 40, Fig. 36
Covington, Paul, *Self-portrait,* 178–179,
        Fig. 180
    *Textured Landscape,* 100–101, Fig. 94
Cranach, Lucas, the Elder, 184
    *Wild Boar Facing Left,* 184, Fig. 186
Cranach, Lucas, the Younger, 18
    *Portrait of Princess Elizabeth of Saxony,* 18,
        Fig. 15
crayon, conté, 28–33
    lithographic, 29, 31
*Crosstown,* Kline, 234–235, Fig. 237
Cudahy, William, *Ambiguous Space,* 130–131,
        Fig. 124
    *Masses and Joints,* 209–210, Fig. 212
    *Study after Ingres,* 256–258, Figs. 258–261
Cummings, Walter T., *Gloves: Articulation of
        Joints,* 141–142, Fig. 138
*Cylindrical Growth,* Strand, 106–108, Fig. 100
*Cypresses,* Van Gogh, 21–22, 43, Fig. 18

*Dancer,* Degas, 196–197, Fig. 198
*Danseuses Roses,* Degas, 50, 52, Fig. 45, Pl. 1,
        p. 41

Dante, *Divine Comedy*, Botticelli illustration, 36, Fig. 32

da Sesto, Cesare, 82
*Tree*, 81–82, Fig. 74

Dealey, Robert S., *Copy after Rembrandt*, 262, Fig. 268

*Death of Meleager, The*, Poussin, 74–75, Fig. 70

*Death of Sardanapalus*, Delacroix, 53–54, Fig. 46

de Chirico, Giorgio, 68–69
*The Mystery and Melancholy of a Street*, 68–69, Fig. 63

*Deer Skull*, Snook, 163, 165, Fig. 162

Degas, Edgar, 41, 50, 52, 196–197, 200–202
*Dancer*, 196–197, Fig. 198
*Danseuses Roses*, 50, 52, Fig. 45, Pl. 1, p. 41
*Study for a Nude*, 200–202, Fig. 203

de Gheyn, Jacob, 43
*Orpheus in the Underworld*, 43, Fig. 37

de Kooning, Willem, 8–9, 11
*Figure and Landscape*, 8–9, Fig. 6

Delacroix, Eugène, 24–25, 53, 245, 248–249
*Christ with Mary Magdalen*, 24–25, Fig. 21
*Death of Sardanapalus*, 53–54, Fig. 46
*Masquerade*, (after Goya, *Nadie se Conoce*, No. 6, *Los Caprichos* series), 249, Pl. 13, p. 245
*Study after Rubens*, 248–249, Fig. 249

*Delicate Shoe*, Reid, 136–137, Fig. 132

*Deposition Study*, Chung, 259, Figs. 263–264

Derman, Asher, *Three Studies of Roots*, 116, Fig. 109

Devine, John E., *Valley of Folds*, 152–153, Fig. 151

*Diana at the Bath*, Rembrandt, 261, Fig. 262

directions, 3–11

*Disasters of War* series, Goya, 48–50, Fig. 43

*Disparates* series, Goya, 277, Fig. 280

distortions, 77–78

*Divine Comedy*, Dante, Botticelli illustration, 36, Fig. 32

*Dog Curled Up*, Flannagan, 31, Fig. 26

Draper, Susan, *Skeleton of a Dinosaur*, 188–190, Fig. 193

drawing, defined, 25

*Drooping Flower Forms*, Whipple, 106–107, Fig. 99

dry media, 27–34

Dufy, Raoul, 90, 197–198
*Back View of a Nude*, 197–198, Fig. 199
*Wheat*, 90, Fig. 82

Dürer, Albrecht, 54–55, 73, 83, 167–168, 170–171, 195–196, 198, 207
*Adam and Eve*, 54–55, Fig. 47
*Four Heads*, 167–168, Fig. 168
*Head of a Child*, 170–171, Figs. 170–172
*Landscape with a Fort Near the Sea*, 73, Fig. 68
*Nude Woman*, 195–196, Fig. 197
*Two Young Riders*, 83, 115, Fig. 75

Ecklund, Jacqueline, *Goat Skull*, 161, Fig. 159

Economos, Michael, *Gesticulating Roots*, 114–115, Fig. 106
*Menacing Skull*, 162–163, Fig. 161
*Seated Nude*, 214–215, Fig. 215

*Elephant*, Persian drawing, 184–185, Fig. 187
Rembrandt, 184–186, Fig. 188

*Elephants*, Reimann, 186–187, Fig. 190

Emerson, Charles, *Glove in Repose*, 140–141, Fig. 137
*Menacing Glove Form*, 140–141, Fig. 136

Ensor, James, 225

expressive means of drawing, 12–25

*Eye Structure of the Skull*, Rosenthal, 164–165, Fig. 163

*Fagot Carriers*, Millet, 241–242, Fig. 242

*Fantastic Mountain Landscape*, Birmelin, 124–125, Fig. 120

*Farm in the Forest*, Rembrandt, 90–92, Fig. 84

Farrell, W. R., *Bags in Panoramic Space*, 157–158, Fig. 157

Felton, Frederic, *Writhing Branches*, 115–116, Fig. 108

*Female Nude*, Picasso, 58, Fig. 53

Fennessey, Mark, *Insects*, 219–226, Figs. 218–219, 221, 223–228

Ferris, Robert, *Landscape*, 231–233, 235, Figs. 234–236

*Figure and Landscape*, de Kooning, 8–9, Fig. 6

figure drawing, 194–216

*Figure-ground Interplay*, Schactman, 256–257, Fig. 257

figure-ground relationships, 54–58

*Figure Sketch*, Rodin, 14, Figs. 10–11

*Filles*, Rouault, 203–204, Fig. 205

*Fish Skeletons*, Bloom, 44, Fig. 38

*Five Grotesque Heads*, Leonardo, 260–261,
Fig. 266
Flannagan, John, 31
*Dog Curled Up*, 31, Fig. 26
*Flowers: Space and Interspace*, Szasz, 108–
109, Fig. 102
*Flowers Suspended in Still Air*, Ford, 108–110,
Fig. 103
*Flowing Surface*, Szasz, 152, Fig. 150
*Foliage*, Cézanne, 59, Pl. 4, p. 60
*Football Shoe*, Baguskus, 134–135, Fig. 129
Ford, Harold, *Flowers Suspended in Still Air*,
108–110, Fig. 103
*Interior: Diagonal Thrust*, 132–133,
Fig. 126
form, 25
forms from nature, 104–125
*Four Female Nudes*, Pisanello, Pl. 9, p. 193
*Four Heads*, Dürer, 167–168, Fig. 168
*Four Views of a Nude*, Slate, 208–209, Fig.
210
Frazer, John, *Group of Lobsters*, 190–191,
Fig. 194
*Panoramic Landscape*, 100, Fig. 93
*Self-portrait*, 176–177, Fig. 178
Frei, Sister Mary, *Rembrandt Studies*, 258–
259, Fig. 262

*Gentleman*, Buytewech, 48, Fig. 42
*Gesticulating Roots*, Economos, 114–115,
Fig. 106
Giacometti, Alberto, 38–39, 168–170,
204–205
*Head of a Man*, 38–39, Fig. 34
*Nude in a Room*, 204–205, Fig. 207
*Self-portrait*, 168–170, Fig. 169
*Glove in Repose*, Emerson, 140–141, Fig. 137
*Gloves: Articulation of Joints*, Cummings,
141–142, Fig. 138
*Goat Skull*, Ecklund, 161, Fig. 159
*Gondolas and View of Venice*, Guardi, 66–67,
Fig. 62
Gorky, Arshile, 42, 50
*Landscape*, 50, Pl. 2, p. 42
Goya, Francisco, 32–33, 48–50, 225, 277
*Bobalicón*, preparatory drawing, No. 4,
*Disparates* series, 277, Fig. 280
*Bullfight* (*Two Groups of Picadors Rolled
Subsequently by a Single Bull* ), No. 32,
*Tauromaquia* series, 32–33, Fig. 28

Goya, Francisco (*cont.*)
*Disasters of War* series, 48–50, Fig. 43
*Disparates* series, 277, Fig. 280
*Nada, ello dirá, Disasters of War* series,
48–50, Fig. 43
*Tauromaquia* series, 32–33, Fig. 28
graphite pencil, 13–16
*Gray Tree, The*, Mondrian, 81, 230, Pl. 5,
p. 93
Greco, El, 76–78, 88–89
*The Burial of Count Orgaz*, 76–77, Fig. 71
*The Holy Family*, 76–77, Fig. 72
*View of Toledo*, 88–89, Fig. 80
*Green Rye, The*, Van Gogh, 271–272, Fig. 274
ground, 25
*Group of Lobsters*, Frazer, 190–191, Fig. 194
*Group of Old Trees*, Bloem, 32–33, Fig. 27
*Group Portrait of Shoes*, Kieffer, 144, Fig. 141
Grünewald, Matthias, 269–270
*Lamenting Woman with Clasped Hands*,
269–270, Fig. 272
Guardi, Francesco, 40, 66–67, 69
*Courtyard of a Palace*, 40, Fig. 36
*Gondolas and View of Venice*, 66–67, 69,
Fig. 62

Hahn, Gerald, *Undulating Tree Form*, 97,
Fig. 89
Hartley, Marsden, 132–133
*Boots*, 132–133, Fig. 128
*Head of a Child*, Dürer, 170–171, Figs. 170–
172
*Head of an Infant*, Ubertini, 20, Fig. 17
*Head of a Maiden*, Watteau, 28–29, Fig. 23
*Head of a Man*, Giacometti, 38–39, Fig. 34
*Head of a Woman*, Matisse, 34–35, Fig. 31
Verrocchio, 58, Pl. 3, p. 59
Watteau (after Rubens), 249, Pl. 14,
p. 246
*Hippopotamus*, Kieffer, 188–189, Fig. 192
*Hippopotamus Skull*, Marcellino, 164–165,
Fig. 164
Hokusai, Katsushika, 45
*Woman Fixing Her Hair*, 45, Fig. 39
Holbein, Hans, the Younger, 5, 17, 268–269,
271
*Lord Wentworth*, 17, Fig. 14
*Portrait of Anna Meyer*, 268, Fig. 271
*Holy Family, The*, El Greco, 76–77, Fig. 72
human skull, 166–180

Hung-Jen, 120–121
*The Coming of Autumn*, 120–122, Fig. 115

individual projects, 217–236
*Inferno XXXIII*, Dante's *Divine Comedy*,
Botticelli illustration, 36, Fig. 32
Ingres, Jean-Auguste-Dominique, 13–14, 18–19,
43, 172–173, 199, 253–254, 257, 265
*Portrait of Leclèrc and Provost*, 172–173,
Fig. 173
*Portrait of Lethière's Son*, 18–19, Fig. 16
*Seated Female Nude*, 198, Fig. 201
*Study for Stratonice*, 13–14, 43, Fig. 9
*Insects*, Fennessey, 219–226, Figs. 218–219,
221, 223–228
instrumentation, 239–253
instrumentation and copying, 239–262
*Interacting Bag Forms*, Cinnamon, 157–158,
Fig. 156
*Interacting Flower Forms*, Kola, 113, Fig. 105
*Interior*, Stokes, 234–236, Figs. 238–240
*Interior: Diagonal Thrust*, Ford, 132–133,
Fig. 126
interiors, 126–132
interiors and man-made objects, 126–158
interspace, 61–63
introduction to the figure, 194–216

Kandinsky, Wassily, 63–64
*Untitled Drawing*, 63–64, Figs. 56–57
Keshian, Harry, *Mountains in the Distance*,
122–123, Fig. 117
Kieffer, Stephanie, *Group Portrait of Shoes*,
144, 158, Fig. 141
*Hippopotamus*, 188–189, Fig. 192
*Suggested Environment*, 131, Fig. 125
Kinscherf, Richard, *Study of Skeletons*, 206–
207, Fig. 208
Klee, Paul, 47, 104
*Young Man at Rest (Self-portrait)*, 47, Fig. 41
Klein, Louis, *Postures of Roots*, 118, Fig. 112
Kline, Franz, 234–235
*Crosstown*, 234–235, Fig. 237
Kola, Vaino, *Interacting Flower Forms*, 113,
Fig. 105
*Lighted Interior*, 129–130, Fig. 123
*Paper Bags: Architectural Form*, 152–154,
Fig. 152
Kozlowski, Edward, *Charcoal Study*, 149–150,
Fig. 147

*Lady Clown*, Toulouse-Lautrec, 30–31, Fig. 25
Lam, Jeanette, *Atmospheric Haze*, 156–157,
Fig. 155
*Weighted Mountain Forms*, 123, Fig. 118
*Lamenting Woman with Clasped Hands*,
Grünewald, 269–271, Fig. 272
landscape, 81–103
*Landscape*, Ferris, 231–233, 235, Figs. 234–236
Gorky, 50, Pl. 2, p. 42
*Landscape Conceived Geometrically*, Schact-
man, 100–102, Fig. 95
*Landscape: The Harvest*, Van Gogh, 43, 62–63,
Fig. 55
landscape space, 97–103
*Landscape with the Burial of Phocion*,
Poussin, 89, Fig. 81
*Landscape with Churches*, Seghers, 87, Fig. 79
*Landscape with Dancing Rhythm*, Raffaele,
102, Fig. 96
*Landscape with Diagonal Tree*, Beal, 99–100,
Fig. 92
*Landscape with a Fort Near the Sea*, Dürer,
73, Fig. 68
*Landscape with Horseman*, Bril, 37, Fig. 33
*Landscape with Oblique Horizon*, Birmelin,
98–99, Fig. 91
*Landscape with Rocky Mountains*, Bruegel,
118–119, Fig. 113
Leete, William, *Shoes: Expression of Character*,
138–139, Fig. 133
Léger, Fernand, 72
*The Smoker*, study, 72, Fig. 67
Lent, Donald, *Bags as Mountains*, 154–155,
Fig. 154
*Trees: Tension and Rhythm*, 97, Fig. 90
Leonardo da Vinci, 81–82, 84–86, 106, 112,
260–261
*Copse of Birches*, 84–86, Fig. 76
*Five Grotesque Heads*, 260–261, Fig. 266
*Lily*, 106, Pl. 8, p. 112
*Tree*, 81–82, Fig. 74
Lewis, Arne, *Weight on Contour*, 215–216,
Fig. 217
*Light on Form*, Audette, 214–215, Fig. 216
*Lighted Interior*, Kola, 129–130, Fig. 123
*Lily*, Leonardo, 106, Pl. 8, p. 112
line, 12–16
defined, 12
liquid media, 36–49
lithographic crayon, 29, 31

*Lord Wentworth,* Holbein, 17, Fig. 14
*Lower Manhattan,* Marin, 66, Fig. 60

*Madonna and Child with Cherubs,* Veronese, 272–273, Fig. 276
*Maelbeke Madonna,* Van Eyck, 70–71, Fig. 65
*Magnanimity of Scipio Africanus,* Van Dyck, 250, Fig. 250
*Male Nude,* School of Michelangelo, 200, Pl. 11, p. 211
Mangam, Susan, *Weights and Counterweights,* 154–155, Fig. 153
man-made objects: the paper bag, 147–158
man-made objects: shoes and gloves, 132–145
Mantegna, Andrea, 69, 72, 243–244, 250
    *Battle of the Sea Gods,* 69, Fig. 64
    *Studies for Christ at the Column,* 243–244, 250, Fig. 245
Marcellino, Fred, *Hippopotamus Skull,* 164–165, Fig. 164
Marin, John, 66, 235
    *Lower Manhattan,* 66, Fig. 60
*Mario the Musician,* Modigliani, 14–16, Fig. 12
Markman, Ronald, *Studies of Shellfish,* 190–191, Fig. 195
*Masquerade,* Delacroix, (after Goya, *Nadie se Conoce,* No. 6, *Los Caprichos*), 249, Pl. 13, p. 245
*Masses and Contours,* Moscatt, 210, Fig. 213
*Masses and Joints,* Cudahy, 209–210, Fig. 212
Matisse, Henri, 4–5, 34–35, 46–47
    *Head of a Woman,* 34–35, Fig. 31
    *Nude in the Studio,* 4, Fig. 1
    *The Pineapple,* 46–47, Fig. 40
    *The Plumed Hat,* 4–5, Fig. 2
Matz, Elizabeth, *Skeleton of an Animal,* 188, Fig. 191
Mazur, Michael, *Parts of the Skull,* 175, Fig. 176
    *Reciprocal Pressures,* 116, Fig. 110
    *Shoe Landscape,* 142–143, 157, Fig. 140
media, 26–52
    dry, 27–34
    liquid, 36–49
    mixed, 49–50
memory drawings, 104–108, 123–125, 148, 209
*Menacing Glove Form,* Emerson, 140–141, Fig. 136
*Menacing Skull,* Economos, 162–163, Fig. 161
Michelangelo Buonarroti, 275

Michelangelo Buonarroti (*cont.*)
    *Anatomical Study,* 275, Fig. 278
Michelangelo, School of, *Male Nude,* 200, Pl. 11, p. 211
Millet, Jean François, 241–242
    *Fagot Carriers,* 241–242, Fig. 242
Milton, Peter, *Study from a Model,* 180, Fig. 182
*Miracle on the Day of Pentecost,* Van Dyck, 250–251, Fig. 251
Miró, Joan, 50–51, 263, 278
    *The Beautiful Bird Revealing the Unknown to a Pair of Lovers,* 278, Pl. 15, p. 263
    *Self-portrait,* 50–51, Fig. 44
mixed media, 49–50
Modigliani, Amedeo, 14–16
    *Mario the Musician,* 14–16, Fig. 12
    *Portrait of Mme. Zborowska,* 16, Fig. 13
Mondrian, Piet, 6–7, 11, 81, 93, 230, 253, 278
    *Composition in Black and White,* 6, Fig. 3
    *The Gray Tree,* 81, 230, Pl. 5, p. 93
    *The River Amstel in the Evening,* 6–7, Fig. 4
Moore, Henry, 220–221
    *Tube Shelter Perspective,* 220–221, Fig. 220
Morandi, Giorgio, 235
Moscatt, Paul, *Masses and Contours,* 210, Fig. 213
*Mountains in the Distance,* Keshian, 122–123, Fig. 117
*Mule,* Pisanello, 182–184, Fig. 184
*Mystery and Melancholy of a Street, The,* de Chirico, 68–69, Fig. 63

*Nada, ello dirá, Disasters of War* series, Goya, 48–50, Fig. 43
negative space, 61–63
Nolde, Emil, 106, 111
    *Red Poppies,* 106, Pl. 7, p. 111
*Nude in an Environment,* Chase, 208–209, Fig. 211
*Nude in a Room,* Giacometti, 204–205, Fig. 207
*Nude in the Studio,* Matisse, 4, Fig. 1
*Nude Woman,* Dürer, 195–196, 207, Fig. 197

Okyo, Maruyama, 92
    *Bamboo,* 92, 233, Fig. 85
*Opening of a Bag, The,* Reid, 150–152, Fig. 149
*Organic Root Forms,* student drawing, 114–115, Fig. 107

*Organic Shoe Forms,* student drawing, 142–143, Fig. 139

*Orpheus in the Underworld,* de Gheyn, 43, Fig. 37

*Overlapping Forms,* Birmelin, 213, Fig. 214

*Overlapping Shoe Forms,* Whipple, 139–140, 142, Fig. 135

Palmer, Samuel, 92, 94
  *Barn in a Valley (Sepham Farm),* Pl. 6, p. 94

*Panoramic Landscape,* Frazer, 100, Fig. 93

*Paper Bags: Architectural Form,* Kola, 152–154, Fig. 152

*Parts of the Skull,* Mazur, 175, Fig. 176

pastel, 28, 50

*Patterns of Growth,* student drawing, 110, Fig. 104

*Peasant Carnival,* Scheits, 242–243, Fig. 243

pen and ink, 36–45, 243–253

pen, ball-point, 39
  bamboo, 43
  quill, 39
  reed, 43

pencil, graphite, ("lead"), 13–16

Persian drawing, 184–185, Fig. 187

perspective, 66–72

Picasso, Pablo, 58, 173–174, 265–266, 271
  *Female Nude,* 58, Fig. 53
  *Portrait of Dr. Claribel Cone,* 265–266, Fig. 269
  *Portrait of Renoir,* 173–174, Fig. 174

picture plane, 25

*Pineapple, The,* Matisse, 46–47, Fig. 40

Piranesi, Giovanni Battista, 64–65, 128
  *Architectural Fantasy,* 128, Fig. 122
  *Sketch of a Construction,* 64–65, Figs. 58–59

Pisanello, Antonio Pisano, 105–106, 118, 182–184, 192–193
  *Four Female Nudes,* 192, Pl. 9, p. 193
  *Mule,* 182–184, Fig. 184
  *Studies of Flowers,* 105–106, 118, Fig. 98

*Place de la Concorde, Winter,* Seurat, 90–91, 100, Fig. 83

plants, 105–114

*Plumed Hat, The,* Matisse, 4–5, Fig. 2

Pontormo, Jacopo, 29, 31, 212, 216
  *Study of Legs,* 29, 31, Fig. 24
  *The Three Graces,* 216, Pl. 12, p. 212

*Portrait of Anna Meyer,* Holbein, 268, Fig. 271

*Portrait of Dr. Claribel Cone,* Picasso, 265–266, Fig. 269

*Portrait of Leclèrc and Provost,* Ingres, 172–173, Fig. 173

*Portrait of Lethière's Son,* Ingres, 18–19, Fig. 16

*Portrait of Mme. Zborowska,* Modigliani, 16, Fig. 13

*Portrait of Princess Elizabeth of Saxony,* Cranach, 18, Fig. 15 '

*Portrait of Renoir,* Picasso, 173–174, Fig. 174

*Postures of Roots,* Klein, 118, Fig. 112

Poussin, Nicolas, 74–75, 89, 254–255
  *Death of Meleager, The,* 74–75, Fig. 70
  *Landscape with the Burial of Phocion,* 89, Fig. 81
  *Rape of the Sabines,* study, 254–255, Fig. 254

pressure, 63–66

*Pressure Points of a Skull,* Cohen, 161–163, Fig. 160

*Prisoner, The,* Redon, 33, Fig. 29

Ptaszynski, Andrzej, *Shoes: Continuous Line,* 145, Fig. 143

quill pen, 39

Raffaele, Joseph, *Landscape with Dancing Rhythm,* 102, Fig. 96

*Rape of the Sabines,* study, Poussin, 254–255, Fig. 254

real space, 74–75

*Reciprocal Pressures,* Mazur, 116–117, Fig. 110

*Red Poppies,* Nolde, 106, Pl. 7, p. 111

Redon, Odilon, 33, 222
  *The Prisoner,* 33, Fig. 29
  *The Spider,* 222, Fig. 222

reed pen, 43

Reid, Sylvia, *Delicate Shoe,* 136–137, Fig. 132
  *The Opening of a Bag,* 150–152, Fig. 149

Reimann, William, *Elephants,* 186–187, Fig. 190
  *Tree: Line and Volume,* 96, Fig. 88

*Religious Scene,* Rembrandt, 248–249, Fig. 248

*Rembrandt Studies,* Frei, 258–259, Fig. 262

Rembrandt van Rijn, 23, 25, 39, 90–92, 150, 181–187, 240, 248–249, 253, 258, 261, 272
  *Camels,* 181–183, Fig. 183
  *Christ Carrying the Cross,* 23, 25, Fig. 20

Rembrandt van Rijn (*cont.*)
  *Cottages Among High Trees*, 39, Fig. 35
  *Diana at the Bath*, 261, Fig. 267
  *Elephant*, 184–186, Fig. 188
  *Farm in the Forest*, 90–92, Fig. 84
  *Religious Scene*, 248–249, Fig. 248
  *Winter Landscape*, 272, Fig. 275
Renoir, Pierre Auguste, 192, 194
  *Study of a Nude*, 192, Pl. 10, p. 194
*Rest on the Flight into Egypt*, unknown German
    master, 247, 249, Fig. 247
*Rhinoceros Head*, Robinson, 191, Fig. 196
*River Amstel in the Evening, The*, Mondrian,
    6–7, Fig. 4
Robinson, Elton, *Rhinoceros Head*, 191, Fig. 196
rocks as mountains, 119–125
*Rocky Crags*, student drawing, 124, Fig. 119
Rodin, Auguste, 14
  *Figure Sketch*, 14, Figs. 10–11
roots, 114–118
*Roots in Tension*, Cohen, 116–117, Fig. 111
Rosenthal, Stephen, *Eye Structure of the Skull*,
    164–165, Fig. 163
Rouault, Georges, 203–204
  *Filles*, 203–204, Fig. 205
Rubens, Peter Paul, 278
Russom, J. Michael, *Shoes: Broken Light*, 145,
    Fig. 144

*Saturated Landscape*, Chelminski, 103, Fig. 97
scale, 73
Schactman, Barry, *Copy after Ingres*, 254,
    Fig. 253
  *Figure-ground Interplay*, 256–257, Fig. 257
  *Landscape Conceived Geometrically*, 100–102,
    Fig. 95
  *Study after Poussin*, 254–255, Figs. 255–256
Scheits, Matthias, 242–243
  *Peasant Carnival*, 242–243, Fig. 243
*Sculptural Essence of the Skull*, Bittleman,
    166, Fig. 166
*Sculptural Tree*, Bloomer, 95, Fig. 86
*Seated Female Nude*, Ingres, 198, Fig. 201
*Seated Nude*, Economos, 214–215, Fig. 215
Seghers, Hercules, 87
  *Landscape with Churches*, 87, Fig. 79
*Self-portrait*, Barbash, 176–177, Fig. 179
  Birmelin, 179, Fig. 181
  Boyer, 176, Fig. 177
  Covington, 178–179, Fig. 180

*Self-portrait* (*cont.*)
  Frazer, 176–177, Fig. 178
  Giacometti, 168–170, Fig. 169
  Klee, 47, Fig. 41
  Miró, 50–51, Fig. 44
  Villon, 71–72, Fig. 66
Seurat, Georges, 90–91, 100, 240–241, 266–
    267, 271
  *At the Concert*, 240–241, Fig. 241
  *Place de la Concorde, Winter*, 90–91, Fig. 83
  *Une Poseuse Habillée*, 266–267, Fig. 270
*Shoe Landscape*, Mazur, 142–143, 157, Fig. 140
*Shoe Quartet*, Cohen, 138–139, 142, Fig. 134
*Shoes: Broken Light*, Russom, 145, Fig. 144
*Shoes: Continuous Line*, Ptaszynski, 145, Fig.
    143
*Shoes: Expression of Character*, Leete, 138–139,
    Fig. 133
Siegel, Ethel, *Study of Legs*, 207, 209, Fig. 209
silverpoint, 27–28
*Skeleton of an Animal*, Matz, 188, Fig. 191
*Skeleton of a Dinosaur*, Draper, 188–190,
    Fig. 193
*Sketch of a Construction*, Piranesi, 64–65,
    Figs. 58–59
*Sketch of a Tree*, Cézanne, 85–86, Fig. 77
skull, diagram, 159, Fig. 158
skull, human, 166–180
*Skull of a Horse*, Wilson, 165–166, Fig. 165
skulls, 159–180
  animal, 159–166
*Skulls*, Vesalius, 167, Fig. 167
Slate, Joseph, *Four Views of a Nude*, 208–209,
    Fig. 210
*Slouching Shoe*, Bittleman, 135–136, Fig. 130
*Smoker, The*, study, Léger, 72, Fig. 67
Snook, Herman, *Deer Skull*, 163, 165,
    Fig. 162
space, 25
  landscape, 97–103
  negative, 61–63
  real, 74–75
*Spider, The*, Redon, 222, Fig. 222
*Standing Horse*, Toulouse-Lautrec, 183–184,
    Fig. 185
*Standing Nude with Arms in the Air*, Villon,
    204, Fig. 206
*Starry Night*, Van Gogh, 74, Fig. 69
Steinberg, Saul, 10–11
  *Bridge Perspective*, 10, Fig. 8

Stokes, Leonard, *Interior*, 234–236, Figs. 238–240

Strand, Mark, *Cylindrical Growth*, 106–108, Fig. 100

*Texture and Volume*, 108, Fig. 101

*Structural Constellation*, Albers, 57–58, Fig. 52

*Structure of a Paper Bag*, Superior, 150, Fig. 148

*Studies after Masterpieces in Florence*, unknown Florentine master, 274–275, Fig. 277

*Studies for Christ at the Column*, Mantegna, 243–244, Fig. 245

*Studies of Flowers*, Pisanello, 105–106, 118, Fig. 98

*Studies of Shellfish*, Markman, 190–191, Fig. 195

*Study after Ingres*, Cudahy, 256–258, Figs. 258–261

*Study after Leonardo*, Berg, 260–261, Fig. 265

*Study after Poussin*, Schactman, 254–255, Figs. 255–256

*Study after Rubens*, Delacroix, 248–249, Fig. 249

*Study for a Nude*, Degas, 200–202, Fig. 203

*Study for Stratonice*, Ingres, 13–14, 43, Fig. 9

*Study from a Model*, Milton, 180, Fig. 182

*Study of Animals*, Coughlin, 186–187, Fig. 189

*Study of Clouds*, Constable, 86–87, Fig. 78

*Study of Legs*, Pontormo, 29, 31, Fig. 24
Siegel, 207, 209, Fig. 209

*Study of a Nude*, Renoir, 192, Pl. 10, p. 194

*Study of Skeletons*, Kinscherf, 206–207, Fig. 208

*Study of Skulls*, Chaplin, 174–175, Fig. 175

*Suggested Environment*, Kieffer, 131, Fig. 125

Superior, Roy, *Structure of a Paper Bag*, 150, Fig. 148

support, 25

Synthetic Cubism, 230

Szasz, Joel, *Flowers: Space and Interspace*, 108–109, Fig. 102

*Flowing Surface*, 152, Fig. 150

*Tauromaquia* series, Goya, 32–33, Fig. 28

Tchelitchew, Pavel, 27–28

*Two Figures*, 27–28, Fig. 22

tempera, 44
acrylic, 231

texture, 20–25

*Texture and Volume*, Strand, 108, Fig. 101

*Textured Landscape*, Covington, 100–101, Fig. 94

*Three Graces, The*, Pontormo, Pl. 12, p. 212

*Three Love Birds*, Albright, 202–203, Fig. 204

*Three Studies of Roots*, Derman, 116, Fig. 109

Tiepolo, Giovanni Battista, 252–253

*Beheading of John the Baptist*, 252–253, Fig. 252

Tobey, Mark, 264, 278

*Broadway*, 278, Pl. 16, p. 264

tonal watercolor, 50

tone and value, 17–20

Toulouse-Lautrec, Henri de, 30–31, 183–184

*Lady Clown*, 30–31, Fig. 25

*Standing Horse*, 183–184, Fig. 185

*Tree*, Brooks, 227–231, Figs. 229–233
Leonardo, or da Sesto, 81–82, Fig. 74

*Tree and House*, Cézanne, 6, 61, Fig. 54

*Tree: Line and Volume*, Reimann, 96, Fig. 88

*Tree Man in a Landscape*, Bosch, 276–277, Fig. 279

*Trees Intertwined*, student drawing, 95–96, Fig. 87

*Trees: Tension and Rhythm*, Lent, 97, Fig. 90

*Tube Shelter Perspective*, Moore, 220–221, Fig. 220

*Two Buildings*, Bellini, 148, Fig. 146

*Two Figures*, Tchelitchew, 27–28, Fig. 22

*Two Male Nudes*, Bandinelli, 200, Fig. 202

*Two Studies of John the Baptist*, Fra Bartolommeo, 198–199, Fig. 200

*Two Young Riders*, Dürer, 83, 115, Fig. 75

Ubertini, Francesco, 20

*Head of an Infant*, 20, Fig. 17

*Undefined Shoe Forms*, Boxer, 144–145, Fig. 142

*Undulating Tree Form*, Hahn, 97, Fig. 89

*Une Poseuse Habillée*, Seurat, 266–267, Fig. 270

*Untitled Drawing*, Kandinsky, 63–64, Figs. 56–57

*Valley of Folds*, Devine, 152–153, Fig. 151

value, 17–20

van Dyck, Anthony, 250–251

*Magnanimity of Scipio Africanus*, 250, Fig. 250

*Miracle on the Day of Pentecost*, 250–251, Fig. 251

van Eyck, Jan, 70–71
  *Maelbeke Madonna*, 70–71, Fig. 65
van Gogh, Vincent, 21–23, 43, 62–63, 74, 126–128, 132–133, 270–272
  *Boots with Laces*, 132–133, Fig. 127
  *Café in Arles*, 126–128, Fig. 121
  *The Cornfield*, 270–272, Fig. 273
  *Cypresses*, 21–22, 43, Fig. 18
  *The Green Rye*, 271–272, Fig. 274
  *Landscape: The Harvest*, 43, 62–63, Fig. 55
  *Starry Night*, 74, Fig. 69
  *The Zouave*, 22–23, Fig. 19
*Variable I*, Coburn, 54, 56–57, Figs. 48–51
Veronese, Paolo, 272–273
  *Madonna and Child with Cherubs*, 272–273, Fig. 276
Verrocchio, Andrea del, 58–59
  *Head of a Woman*, 58, Pl. 3, p. 59
Vesalius, Andreas, 167, 174
  *Skulls*, 167, 174, Fig. 167
*View of the Canal*, Canaletto, 66–67, Fig. 61
*View of Toledo*, El Greco, 88–89, Fig. 80
Villon, Jacques, 71–72, 204, 262
  *Self-portrait*, 71–72, Fig. 66
  *Standing Nude*, 204, Fig. 206

watercolor, 50

Watteau, Jean-Antoine, 28–29, 242–243, 246, 249
  *Cavalier*, 242–243, Fig. 244
  *Head of a Maiden*, 28–29, Fig. 23
  *Head of a Woman*, (after Rubens), 249, Pl. 14, p. 246
*Weight on Contour*, Lewis, 215–216, Fig. 217
*Weighted Mountain Forms*, Lam, 123, Fig. 118
*Weights and Counterweights*, Mangam, 154–155, Fig. 153
*Wheat*, Dufy, 90, Fig. 82
Whipple, Sandra, *Drooping Flower Forms*, 106–107, Fig. 99
  *Overlapping Shoe Forms*, 139–140, Fig. 135
*Wild Boar Facing Left*, Cranach, 184, Fig. 186
Wilson, Sybil, *Skull of a Horse*, 165–166, Fig. 165
*Winter Landscape*, Rembrandt, 272, Fig. 275
*Woman Fixing Her Hair*, Hokusai, 45, Fig. 39
*Woman with Death as a Partner*, Baldung Grien, 244–245, Fig. 246
*Writhing Branches*, Felton, 115–116, Fig. 108

*Young Man at Rest (Self-portrait)*, Klee, 47, Fig. 41

*Zouave, The*, Van Gogh, 22–23, Fig. 19

# PHOTOGRAPHIC SOURCES

References are to figure numbers unless indicated Pl. (plate).